I0235609

IMAGES
of America

NORTHFIELD

ON THE COVER: Northfield students at the Sunset Ridge School pose for a class portrait in 1943. Northfield is part of the northern suburbs of Chicago, Illinois. (Courtesy Sunset Ridge School.)

IMAGES
of America

NORTHFIELD

ArLynn Leiber Presser

ARCADIA
PUBLISHING

Copyright © 2010 by ArLynn Leiber Presser
ISBN 978-1-5316-5570-9

Published by Arcadia Publishing
Charleston, South Carolina

Library of Congress Control Number: 2010931333

For all general information, please contact Arcadia Publishing:
Telephone 843-853-2070
Fax 843-853-0044
E-mail sales@arcadiapublishing.com
For customer service and orders:
Toll-Free 1-888-313-2665

Visit us on the Internet at www.arcadiapublishing.com

To Joseph, Eastman, and Edwin

CONTENTS

ACKNOWLEDGMENTS

A book about a village is written by a village, and that is exactly what has happened here. So thank you to the village—as in village president Fred Gougler, village manager Stacy Sigman, community development director Anne Kane, assistant to the village manager Linda Gittel, police chief Bill Lustig, retired police commander Kenneth E. Smith, fire chief Michael Nystrand, assistant chief Thomas Burke, schools superintendent Linda J. Vieth, school board president Phoebe S. Raymond, and the staff of the Library of Sunset Ridge School, Srs. Priscilla Burke and Anita Marie Gutierrez of the Holy Spirit Missionary Sisters, Judy Tunsky and Mrs. "Lotto" of the Middlefork Tennis Club, James Petersen of the Sunset Ridge Country Club, Gary Smith and Helaine Raskin of the Josselyn Center, Rev. Duayne Meyer and Judy Hertelendy of the Northfield Community Church, Dr. Eliot Lefkovic of the Am Yisrael Conservative Congregation of the North Shore, Libby Fischer Hellmann and Mary Rhodes of the Northfield Historical Society, Carolyn Collins, Barbara Wick, Damon Frahler of the Christian Heritage Academy, Tony and Carolyn Kambich of the Glenview Montessori School, Jordan Luhr, Kathleen Geraghty, and Loryn Kogan of the North Shore Senior Center, Tony Smith of the College of American Pathologists, Carl Calkins of the Lions Club, Kimberly Reishus of the *Chicago Tribune*, Chris Peterson of the *Winnetka Talk*, the staff and genealogists of the Winnetka-Northfield Library District, Therese Anne Happ Selzer, Dave Selzer, the Happ family, the Selzer family, Mike and Charlie Seul, Bill Seymour, Robin and George Gemeinhardt, LouAnn and Dan Monckton, Pat Karr, Judy McDaniel, Charles Horder Seymour and his trusty camera, and editor Jeff Ruetsche. If I have inadvertently left out your name, let me take you to Seul's to buy you a drink!

INTRODUCTION

If travelers to Chicago take the Edens Expressway north about 19 miles out of the city, get off at the Willow Road West exit, they will find a delightful treasure. Overlooked by the typical commuter rushing off to important business or anxious to get home, it is nonetheless a town worth dawdling over. It is just 3 square miles, and as of the start of the 21st century, it has only approximately 5,000 residents. Northfield is affluent and well educated. Its children attend Middlefork and Sunset Ridge Public Schools, or maybe they are in the Glenview or Avoca Districts; perhaps they favor Christian Heritage Academy. The houses are cozy Cape Cods or split levels, and travelers who take a side street or two will suddenly find themselves amongst some gorgeous Italianate mansions and sturdy center-hall Colonials.

Most local people have heard the story of the Happ family from Trier, Germany. John Happ, a blacksmith, set up shop in Winnetka in the mid-1800s, but with the railroad and gentrification of Winnetka, Happ took his wife and nine children and headed west across the Skokie Swamp to find enough land to be what he wanted to be—a simple blacksmith and farmer. His children became friends with children of other farmers—the Selzer family, the Leverniers, the Metzs, the Bracktendorfs, and the Seuls. Sometimes the families intermarried. Even today, a Selzer might have a tough time explaining exactly how he is related to someone else with the last name Selzer and an even tougher time explaining how he is related to someone else with the last name Happ—but the family connections are there.

The farmers may have thought their way of life would be a gift that they could give their children and their children's children, but change was to come to Northfield in the form of an electric train. Samuel Insull, born in England and a one-time personal secretary to Thomas Edison, came to Chicago to create a utility company. The electricity would power the trains he planned to build between Chicago and Milwaukee, but while many investors in his company thought he was planning a freight line, he was onto a different idea: he would use the trains to attract the middle class who were feeling squeezed in their Chicago neighborhoods. He would offer them land—he was smart enough to buy a lot of land, including a significant amount in Northfield—and then, when they built their houses, he would sell them the electricity to run their lights and their appliances. Insull seemed to have it all figured out, and though the Great Depression hit the community, its investors, and Insull himself pretty hard, time did prove that he had the right idea. In the second quarter of the 20th century, Northfield was part farm community, part suburb—and tied to Chicago by a railroad.

After World War II, the Edens Expressway replaced the railroad. Commuters could afford cars, and it was more convenient and liberating to drive one's vehicle to the city and back. The Edens Expressway divided the community into west and east Northfield, and it was not so convenient to walk to a neighbor's house on the other side of what started as a four-lane highway. Within 15 years of the laying out of the Edens Expressway, the rail line connecting Northfield to Chicago was dismantled, although freight traffic would continue for years after. The expressway may have

initially seemed a quick way to get to the city and back, but it was not. With people from the northwest suburbs taking the Willow Road exit off the Edens Expressway to cut through Northfield on their way home, traffic became a challenge. At the beginning of the 21st century, the Illinois Department of Transportation wanted to widen Willow Road in key places to streamline traffic, but many Northfield residents resisted: a four-lane Willow Road dividing their town into north and south Northfield does not seem to be what John Happ anticipated or wanted when he crossed the Skokie Swamp and said goodbye to Winnetka.

Northfield has many challenges as it faces the future, but it has many resources: its people are friendly and hardworking. They come together as a community for fellowship and worship. They have a strong, well-organized village government. They have several large corporate residents—the Stepan Company and Kraft International Foods—as well as such family-owned businesses as Seul's Tavern and Bess Hardware. This little treasure to the north of Chicago will shine just as brightly in the 21st century as it has in the past.

The community was originally called Waubun (or Wau Bun), a name that means "dawn" in the Ojibway language and was also the name of a Potawatomi chief of the 1700s. It is a surprisingly apt name, because Northfield is at the dawn of its best days.

One

THE SKOKIE SWAMP AND
THE HORSERADISH KINGS

In the middle of the 1800s, Northfield was not a village; neither were Glenview, Northbrook, Wilmette, or any of the other towns that now border Northfield. It was not much of a community, but rather a muddy swamp occasionally punctuated by a farmhouse or a barn. The record of the people who lived in the area is confusing and contradictory, and sometimes it just does not exist. Historians do know a lot about one early settler, John Happ, whose family joined with other families to clear the land, to wrest a living from the mud, and to build schools, churches, and—perhaps most necessary to a farmer's happiness—a tavern.

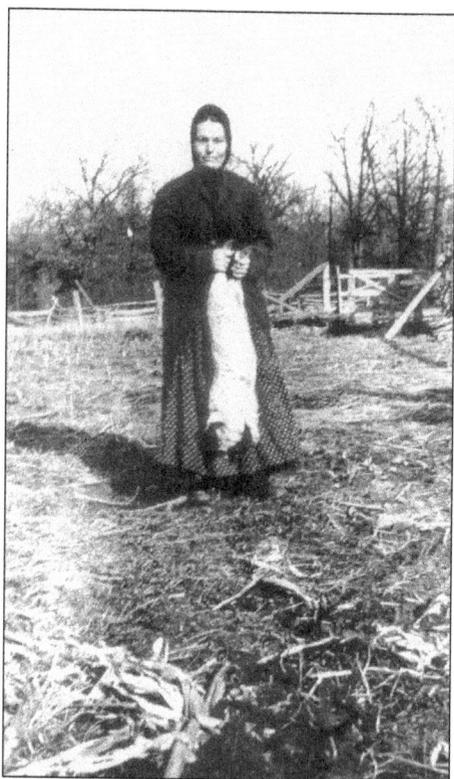

In the 1800s, Northfield was a collection of family farms. Many farmers had left Winnetka, the village to the east, when the Chicago Northwestern Railroad was built and it had become a commuter town with soaring property values. Farmers in the Northfield area sometimes referred to their own community as the Skokie Swamp. Here Jetta Nadir (in some records, the family name is spelled Nadiar) holds a pig on her farm. (Courtesy Northfield Historical Society.)

Farmers in Northfield worked at many crops, which included horseradishes, hay, mushrooms, grains, and packing straw culled from the Skokie Swamp. Here Carl Ahrens plows land on the Metz farm on what is now Somerset Lane. While people today think of horseradish as a condiment, it was considered useful for treating toothaches and was an ingredient in cough syrup. (Courtesy Northfield Historical Society.)

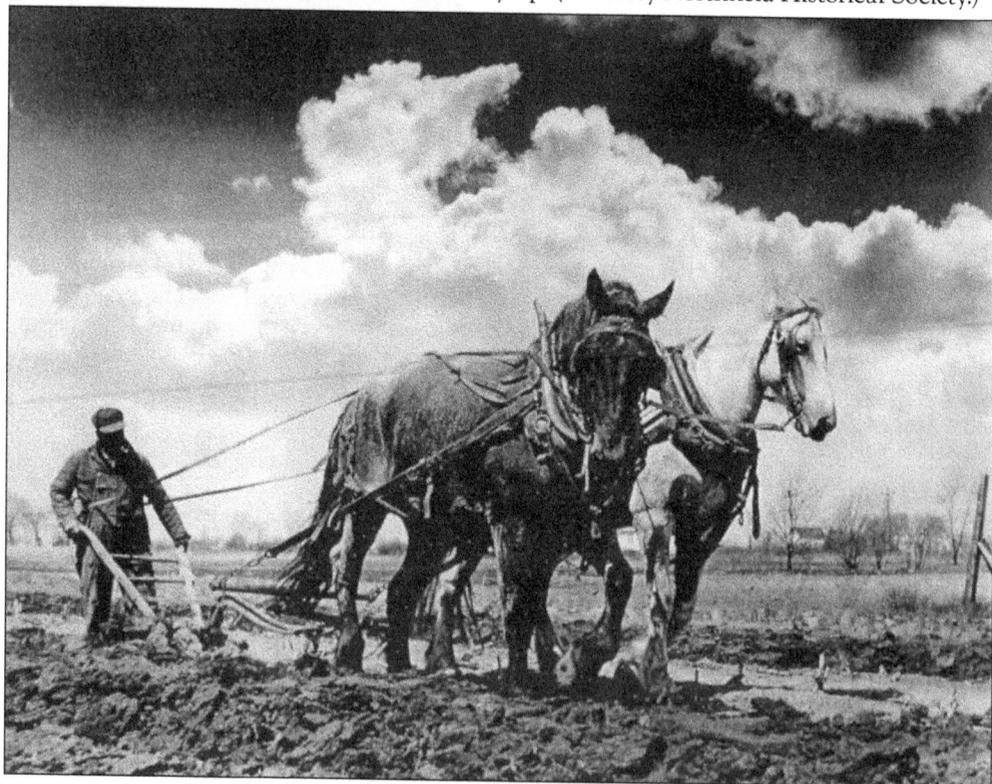

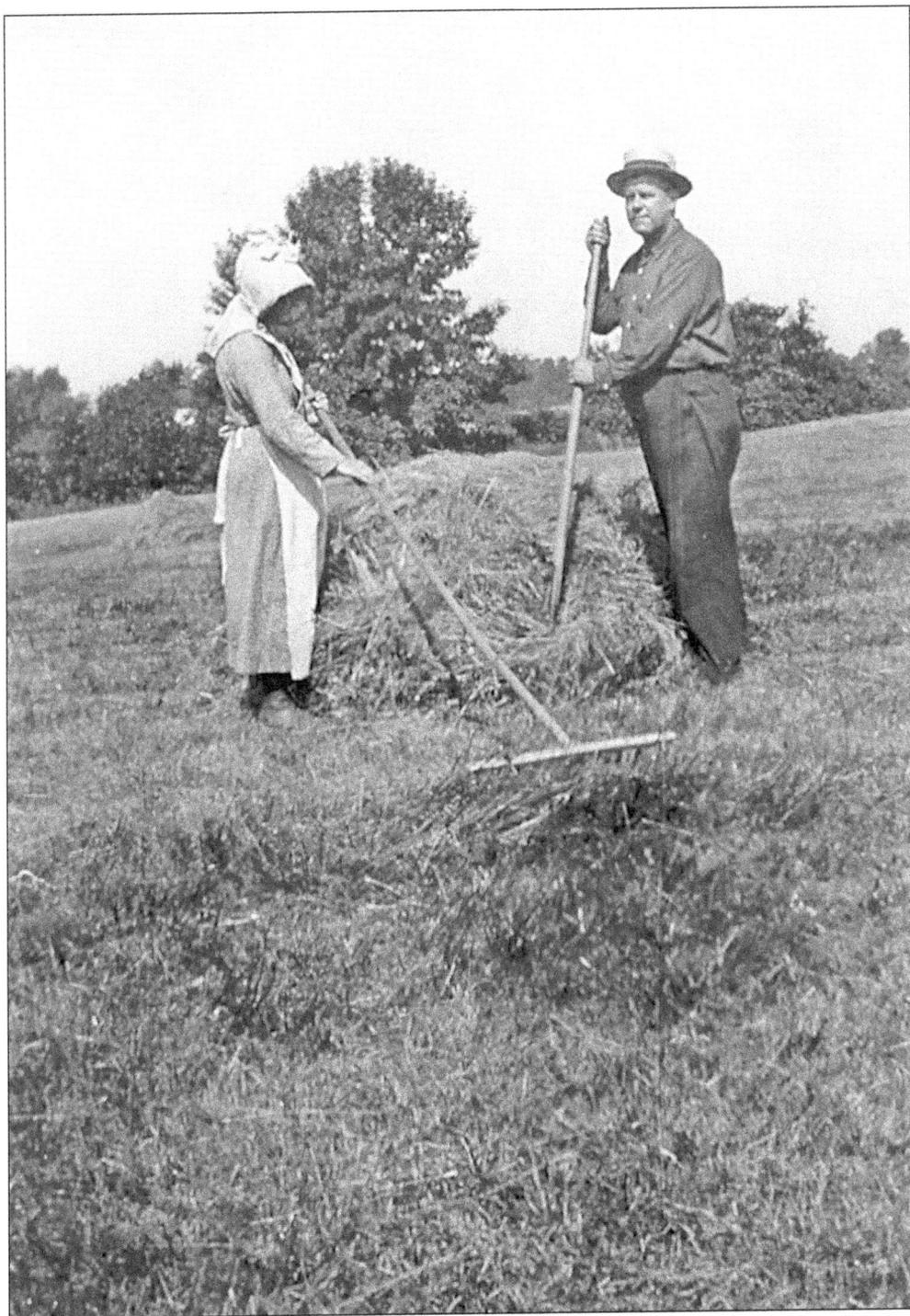

Oddly, one of the area's most successful crops could be found free because of the wet Skokie Swamp. Packing straw, the Styrofoam peanuts of yesteryear, was used in shipping fragile items such as china and glassware. In Northfield, farming was a year-round occupation. (Courtesy Northfield Historical Society.)

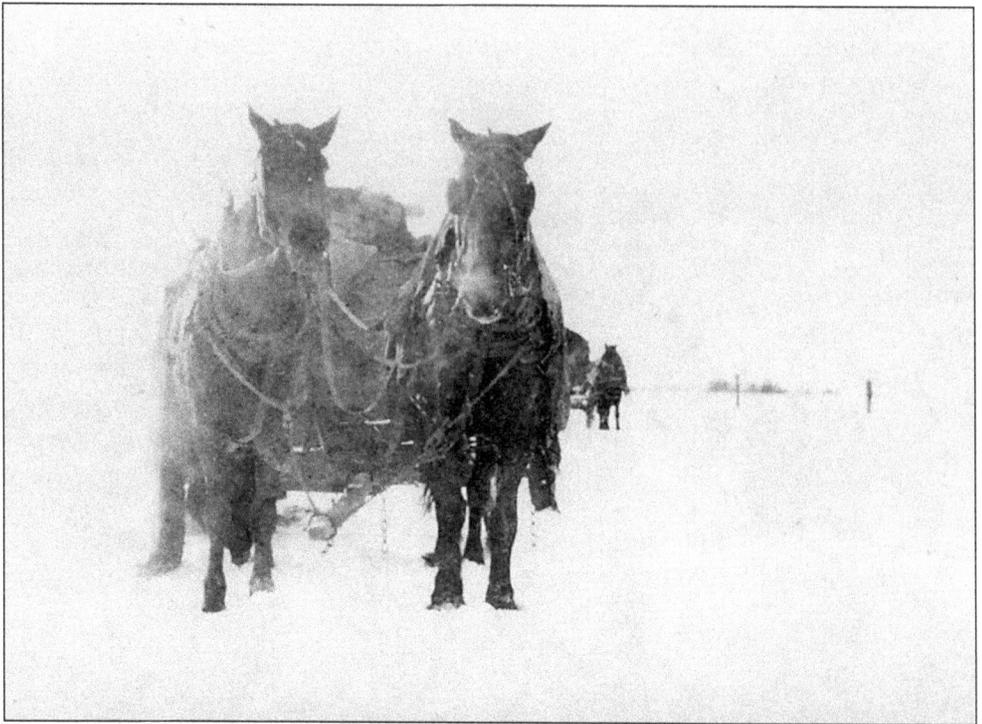

Northfield summers might be brutally hot, with humidity from the Skokie Swamp only adding to the discomfort. Still, winters were worse, with bitter winds and daunting snows. These horses struggle here to pull their loaded wagons along what is now Wagner Road. (Courtesy Northfield Historical Society.)

These farmers have completed their harvest and are taking a break. Grains such as oats were allowed to dry in bundles called "shocks" before being stacked. Stacks could be between 20 and 25 feet in diameter at the bottom, tapering to a point at a height of 15 feet. The grain heads were typically turned in so that the grains would stay dry. (Courtesy Northfield Historical Society.)

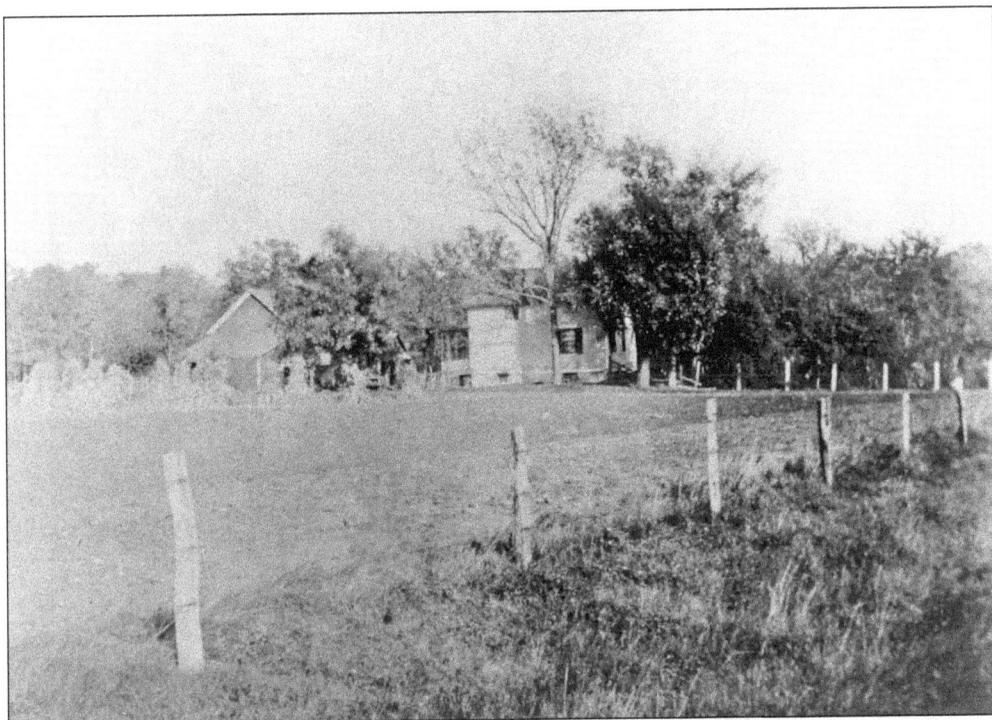

Carl Metz emigrated from Reinshager, Germany, and purchased a 13-acre farm in 1862. He continued to buy more lots during the next decades, but the economy turned rough, and the family was forced to sell off individual acres to pay property taxes. By 1933, the Metz-Ahren farm consisted of just 3 acres. Nonetheless, the family was known for its produce stand on Willow Road, which remained open until the 1950s. (Courtesy Northfield Historical Society.)

A father's sacrifice has paid off. Carl's son Fred is shown here dressed for business or possibly Sunday services outside the family farm. Fred was successful at farming and able to afford some luxuries, including a 1910 Model T Ford, which often had to be pushed out of ditches along Northfield's dirt roads. (Courtesy Northfield Historical Society.)

13

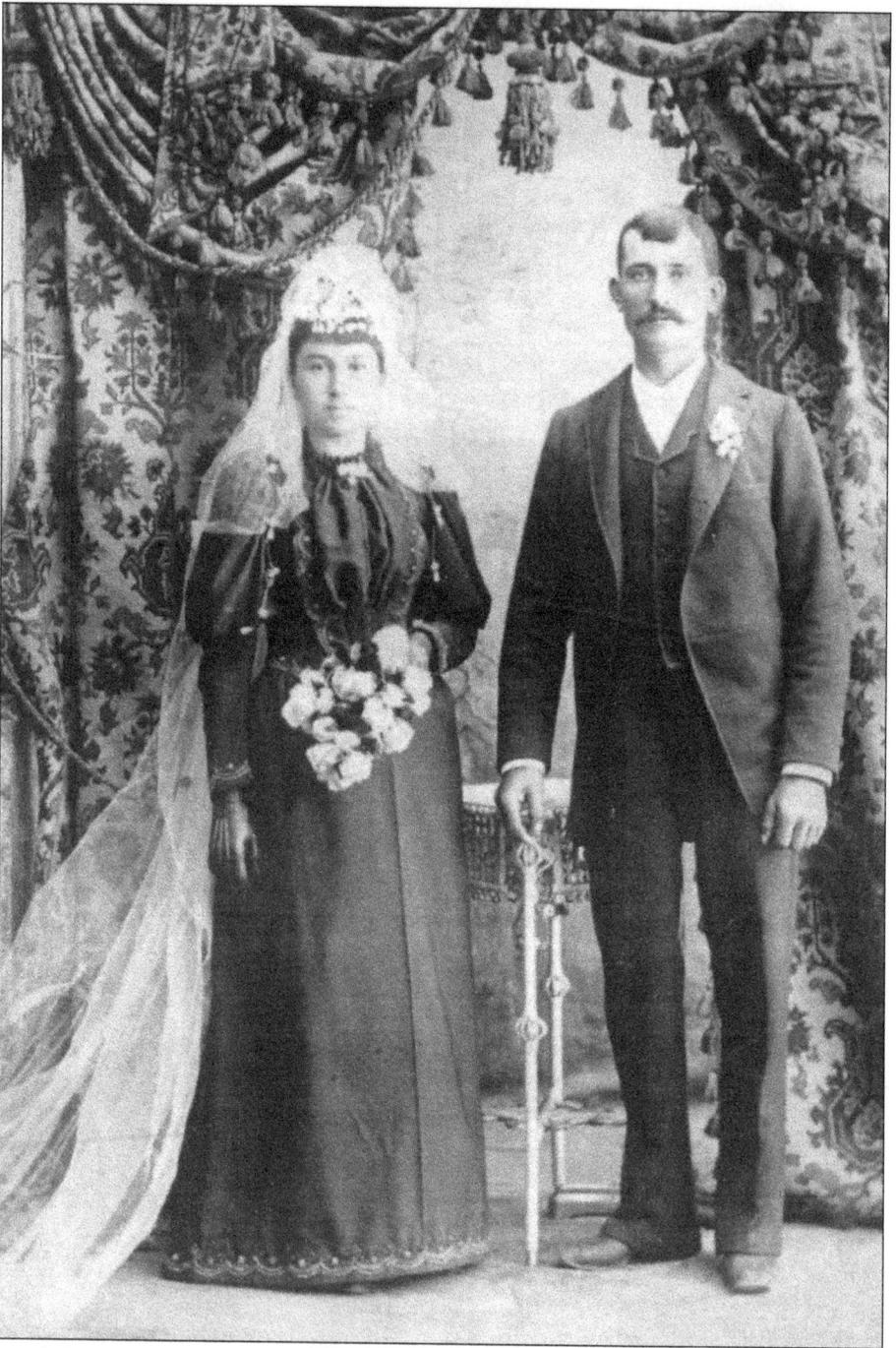

John and Gertrude Happ emigrated from Trier, Germany, and settled first in Winnetka where John worked as a blacksmith. When Winnetka became a stop on the railroad between Chicago and Milwaukee, there was not much need for blacksmiths, so he brought his family across the Skokie Swamp. It was Gertrude who suggested that the township be named New Trier, because so many families in the area came from Trier. Their grandson John P. Happ is shown here on his wedding day with his bride, Annie Seul, in 1893. (Courtesy Therese Anne Happ Selzer.)

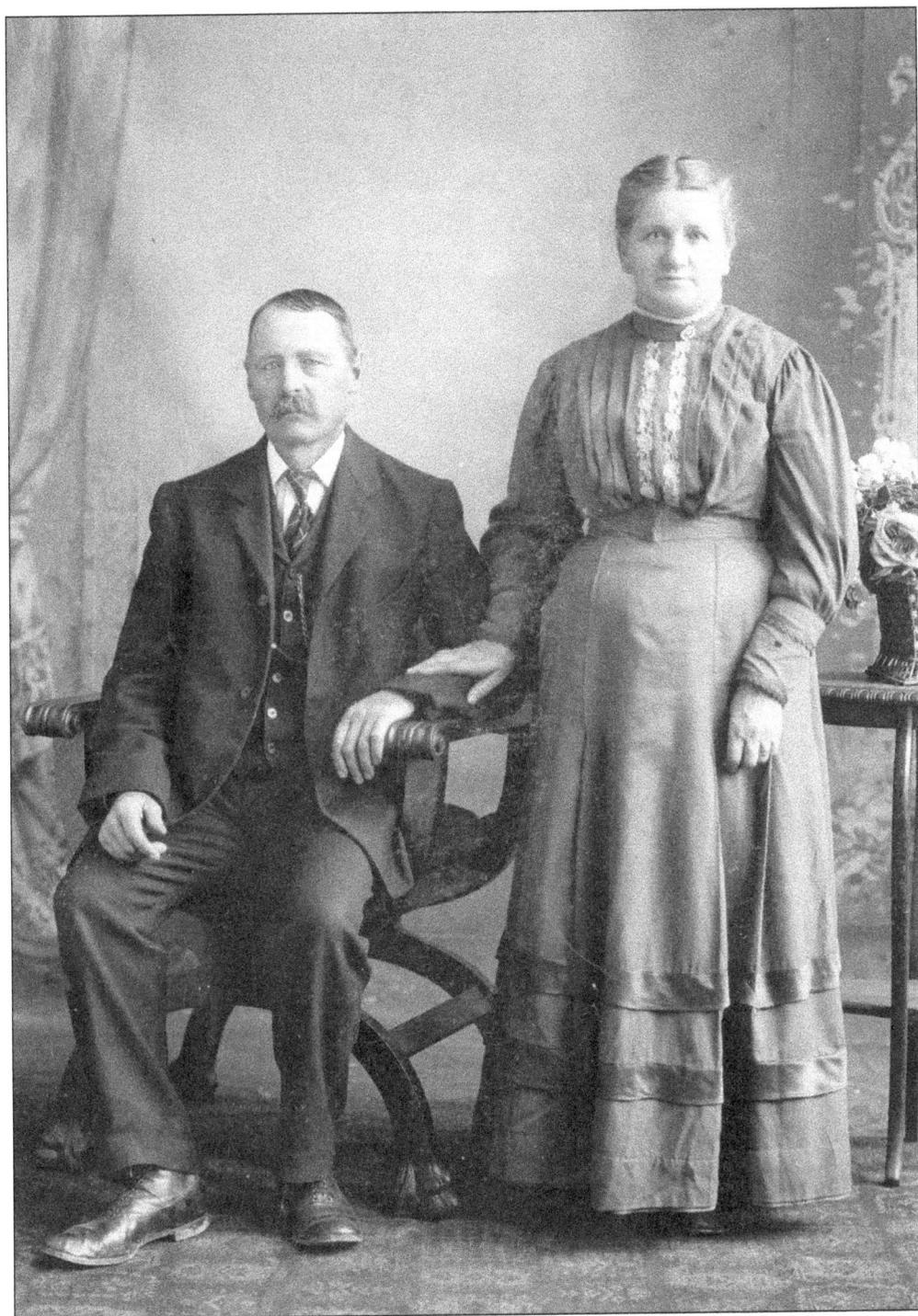

John Happ's son Bertram and Josephine (Barengrugge) Happ were a loving couple. Tragedy struck when Josephine died, but Bertram quickly remarried so that someone could watch over his children. Sadly no record exists of this second wife's name, and there is no evidence that Bertram and his new wife had children together. (Courtesy Therese Anne Happ Selzer.)

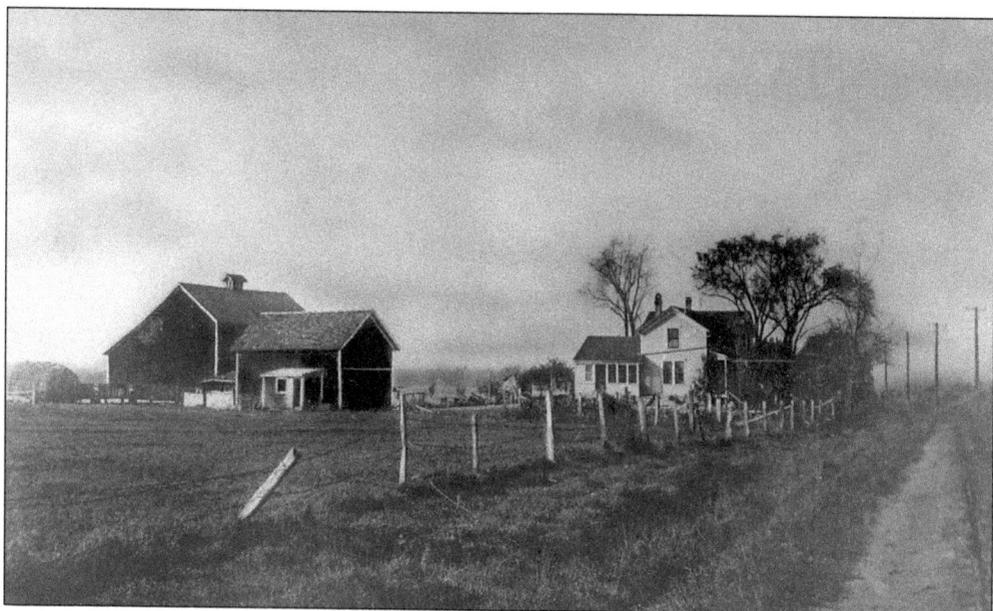

John P. Happ, grandson of John Happ, grew up in this home at what is now 840 Happ Road. He would become Northfield's first village president. (Courtesy Therese Anne Happ Selzer.)

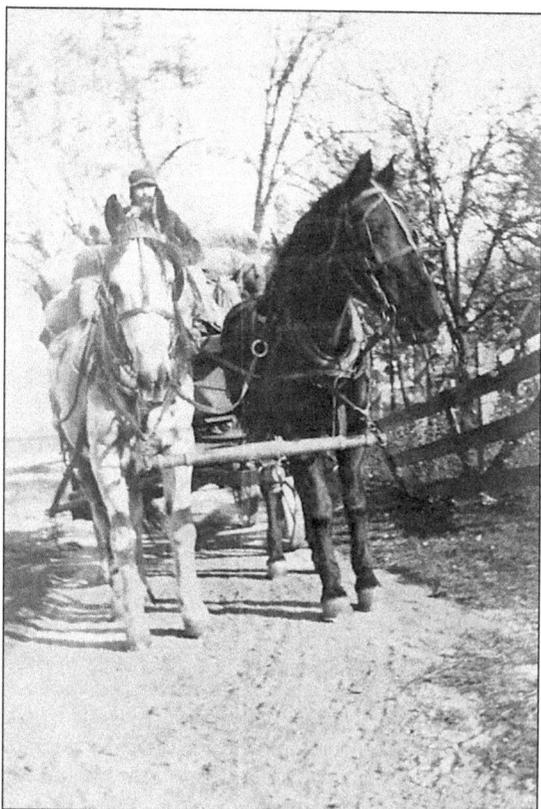

Farmer John Efflant is seen here driving a horse-drawn wagon on Kotz Road, which would later be named Sunset Ridge Road. While dirt roads were cleared in the early 1900s, it would not be until 1925 that work began on paving them. (Courtesy Northfield Historical Society.)

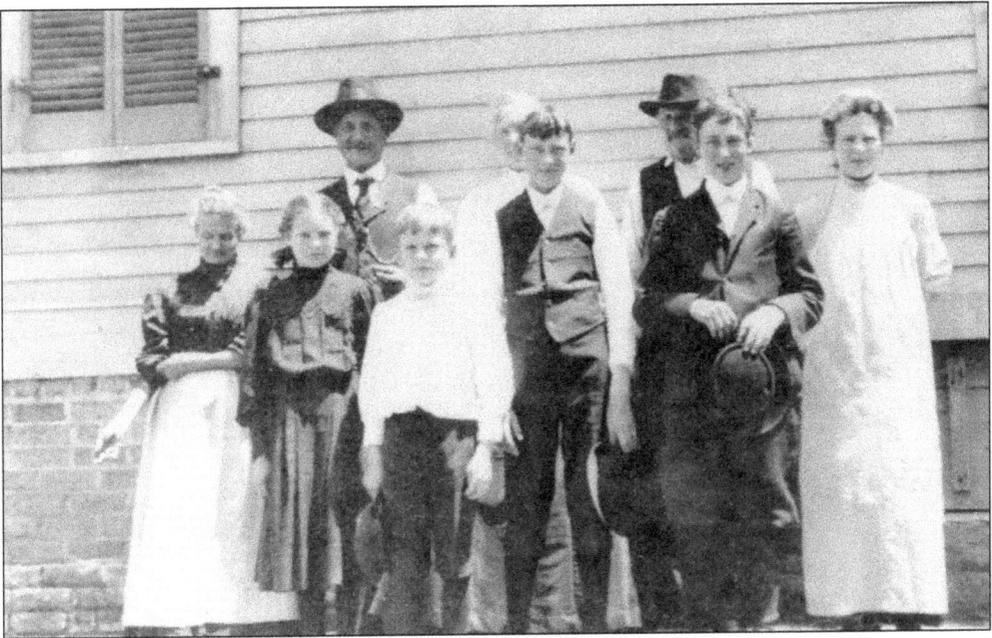

The Selzer family emigrated from the town of Oppen in Prussia and quickly became a part of Northfield life. Here the family poses for a 1910 portrait. From left to right they are (first row) Anne, Marge, an unidentified cousin, Joe, Pete, and Lily Selzer; (second row) James, Margaret (nee Balmes), and Peter Selzer. The Selzers were sometimes referred to as the "Horseradish Kings" because of their success at raising the crop that they sold at the South Water Street Market in Chicago. (Courtesy Therese Anne Happ Selzer.)

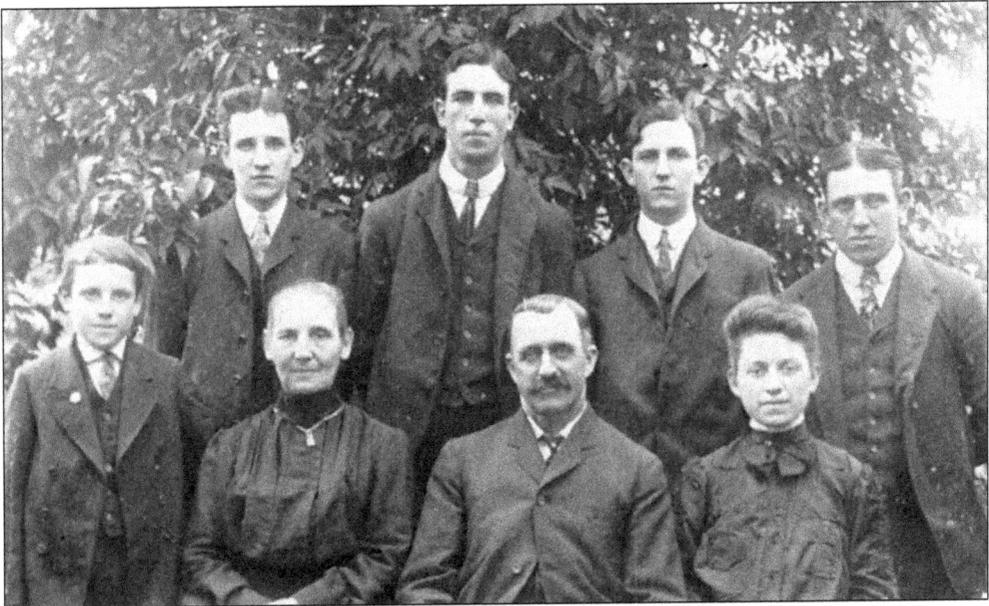

Members of the Peter M. Happ family similarly pose for a portrait in the early 1900s. From left to right they are (seated) Mary (Kotz), Peter M., and Ella Happ; (standing) Edward, Peter, Matthew, Honorius, and George Happ. The Happs and Selzers would several times marry into each other's family. (Courtesy Holy Spirit Missionary Sisters.)

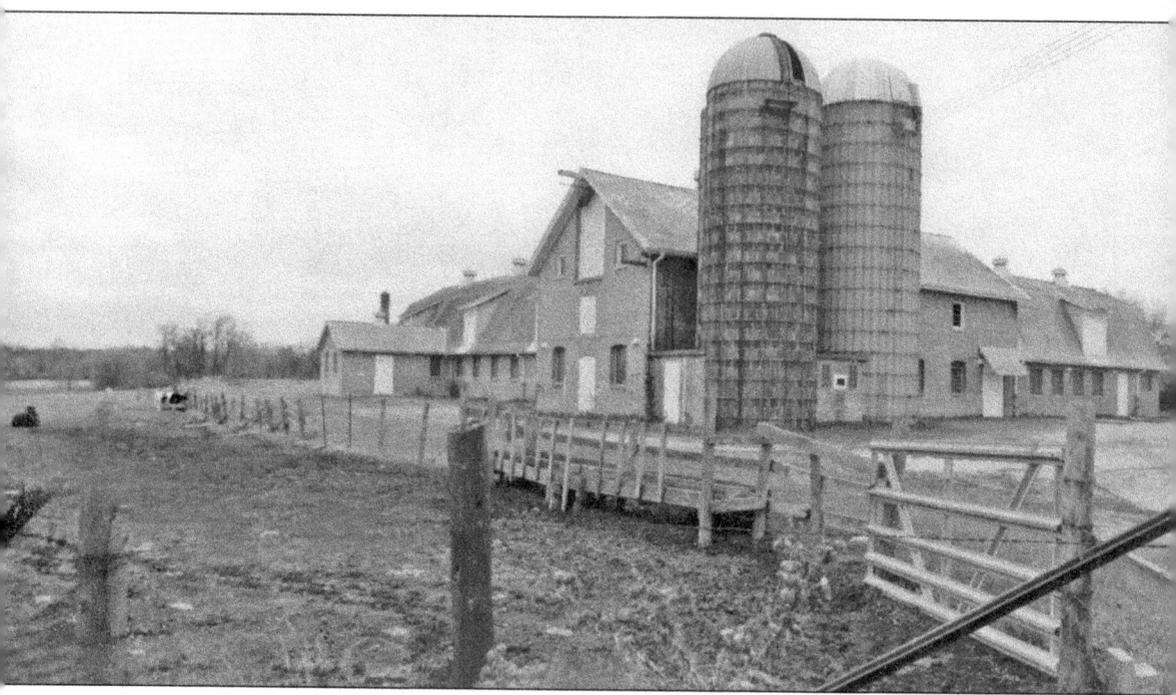

Just outside of Northfield, Techny is the home of the Divine Word Missionaries, followers of St. Arnold Janssen. Techny was founded in 1896, and later the community established the St. Mary's Mission Seminary. St. Mary's was the first seminary focused on training men for foreign missions. Divine Word Missionaries primarily focus on Asia and stress self-sufficiency. Techny Farm was managed by the priests of the Divine Word, but they sometimes hired young men and women to help with farming. This farm was closed in the mid-1980s to make way for Kraft International Food Company. (Courtesy Carolyn Collins.)

Matthias Happ, son of the original settler John Happ, and his wife, Therese (Selzer) Happ, were generous friends to the Holy Spirit Missionary Sisters, who arrived in what was then Shermerville, near Northfield, in 1901. Matthias and Therese sold the sisters land on the southwestern corner of Waukegan and Willow Roads. The nuns built a convent on the land and lived there from 1915 to 2000, allowing the Happ couple to stay on the property in their own cottage. After Therese died, Matthias moved into the convent. He died on November 5, 1937, on what would have been the 100th birthday of St. Arnold Janssen. (Courtesy Holy Spirit Missionary Sisters.)

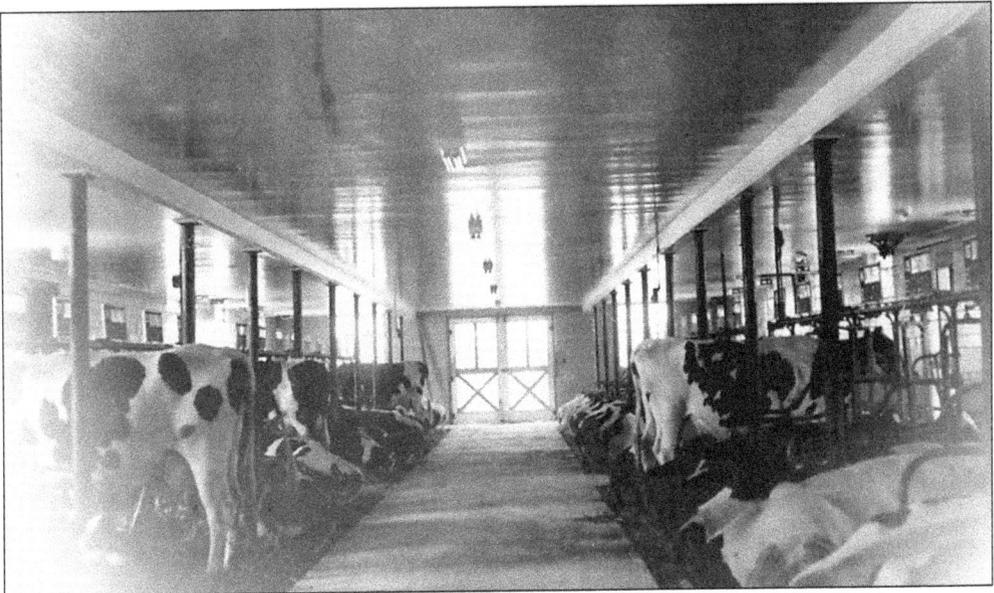

The Missionary Sisters were self-sufficient with their own farm. They also ran a boarding school for novices—young girls with an interest in taking holy vows. Here is the dairy cow barn on the sisters' farm. (Courtesy Holy Spirit Missionary Sisters.)

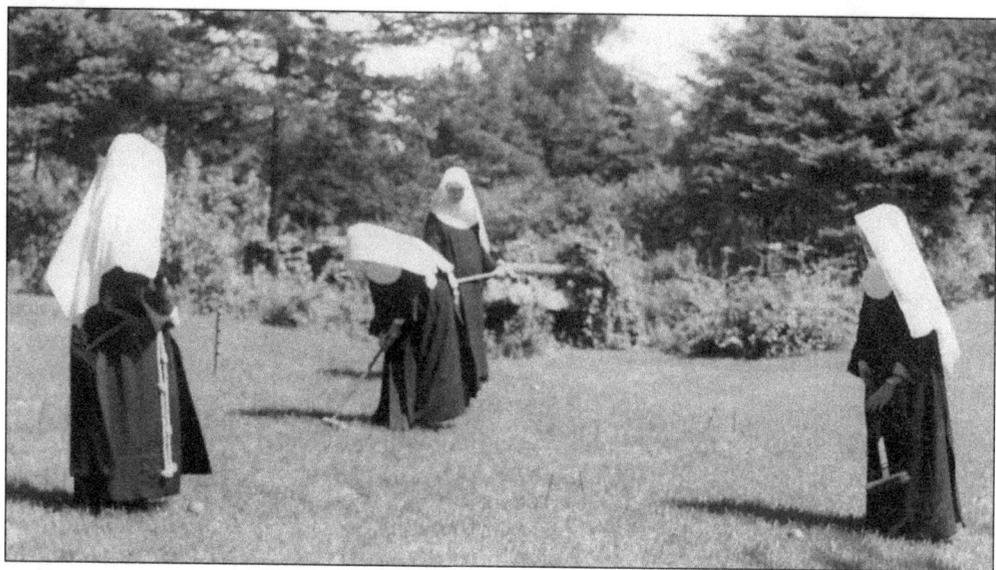

Novices participated in the full canonical hours, manual labor on the farm, and special classes to instruct them in the religious life of the order. In this late-1930s photograph, novices play croquet. Their white veils distinguish them from sisters who have taken vows. The life of a sister was one of travel and challenge: beginning in 1906, the sisters founded schools for African Americans in Mississippi and Arkansas as well as missions all over the world. (Courtesy Holy Spirit Missionary Sisters.)

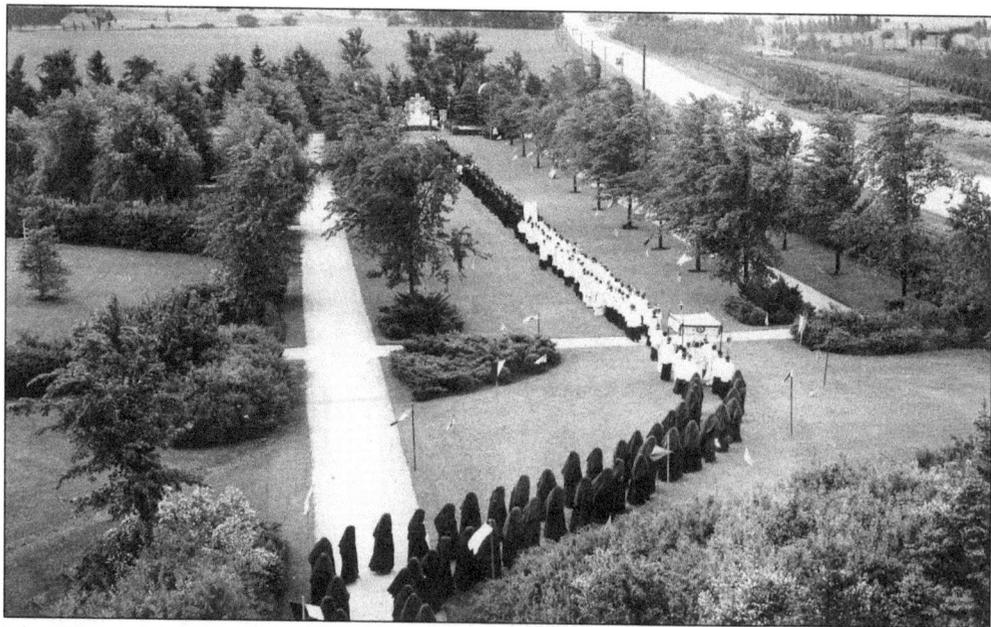

The Corpus Christi procession, shown here in 1930, included both priests of the Divine Word ministries and the Holy Spirit Missionary Sisters. It was a great draw for Catholics of the North Shore. Corpus Christi is traditionally celebrated on the Sunday after Trinity Sunday. It is now generally referred to in the Catholic faith as the Solemnity of the Most Holy Body and Blood of Christ—a celebration of the Eucharist. It is celebrated by Anglicans and Lutherans as well. To the right of the picture is Willow Road. (Courtesy Holy Spirit Missionary Sisters.)

20

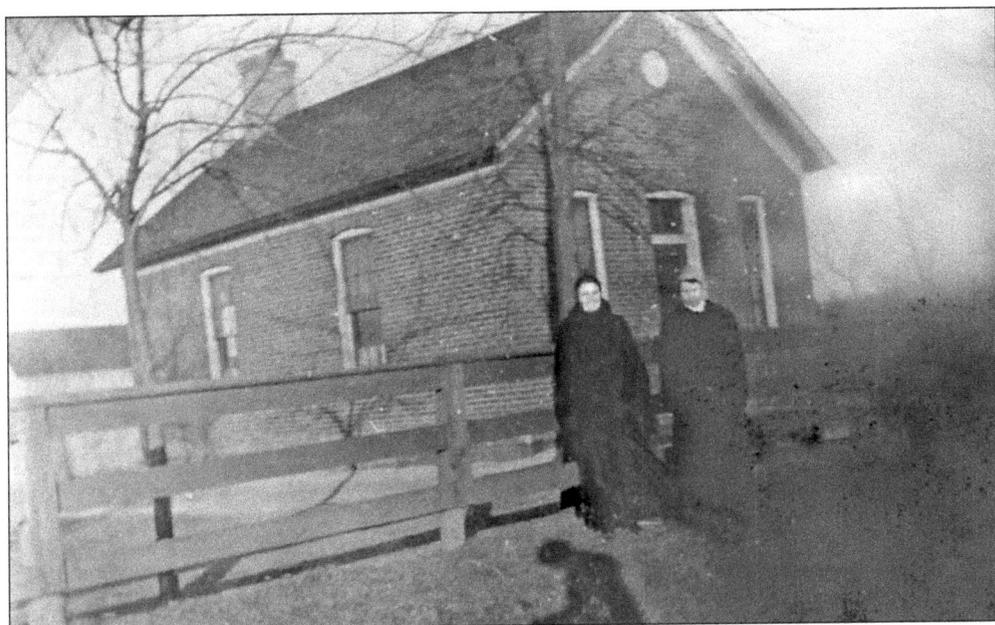

The Brown School is shown here in winter during the early 1900s. Brown was a one-room schoolhouse, with no indoor plumbing, and the teacher boarded with Julia Donovan, who lived across the street. The land was donated by farmer John Brown in 1878, but the school was not completed until 1892. Some parents who wanted a public school education for their children sent them to Winnetka schools; others sent their children to neighboring Northbrook. (Courtesy Northfield Historical Society.)

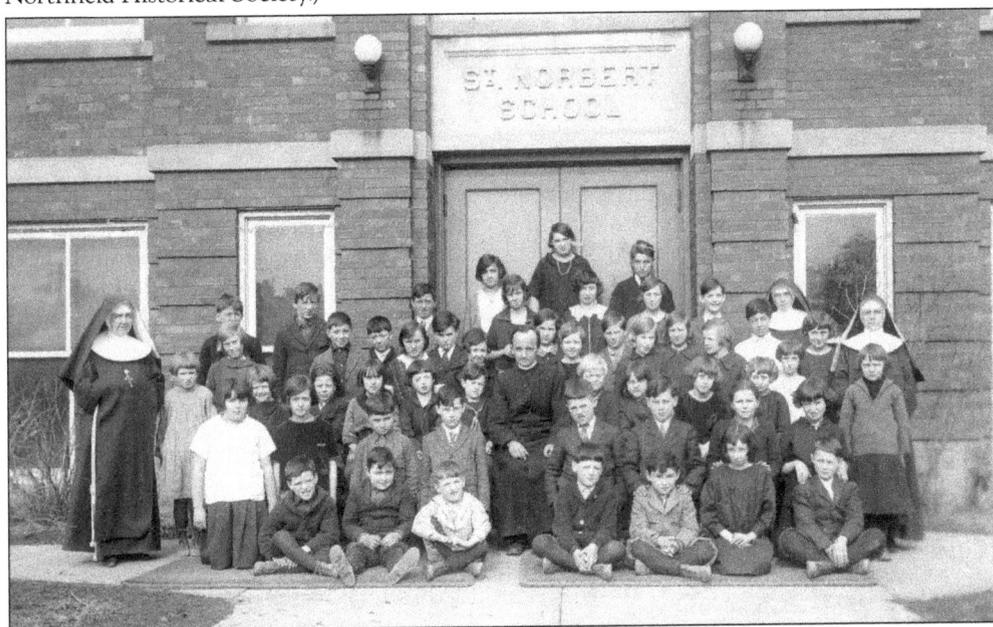

Northfield parents who wanted their children to have a Catholic education relied on St. Norbert School, which was run by the Missionary Sisters of the Holy Ghost. Many Happs, Selzers, and other Northfield families are represented in this school picture from the 1920s. (Courtesy Happ family.)

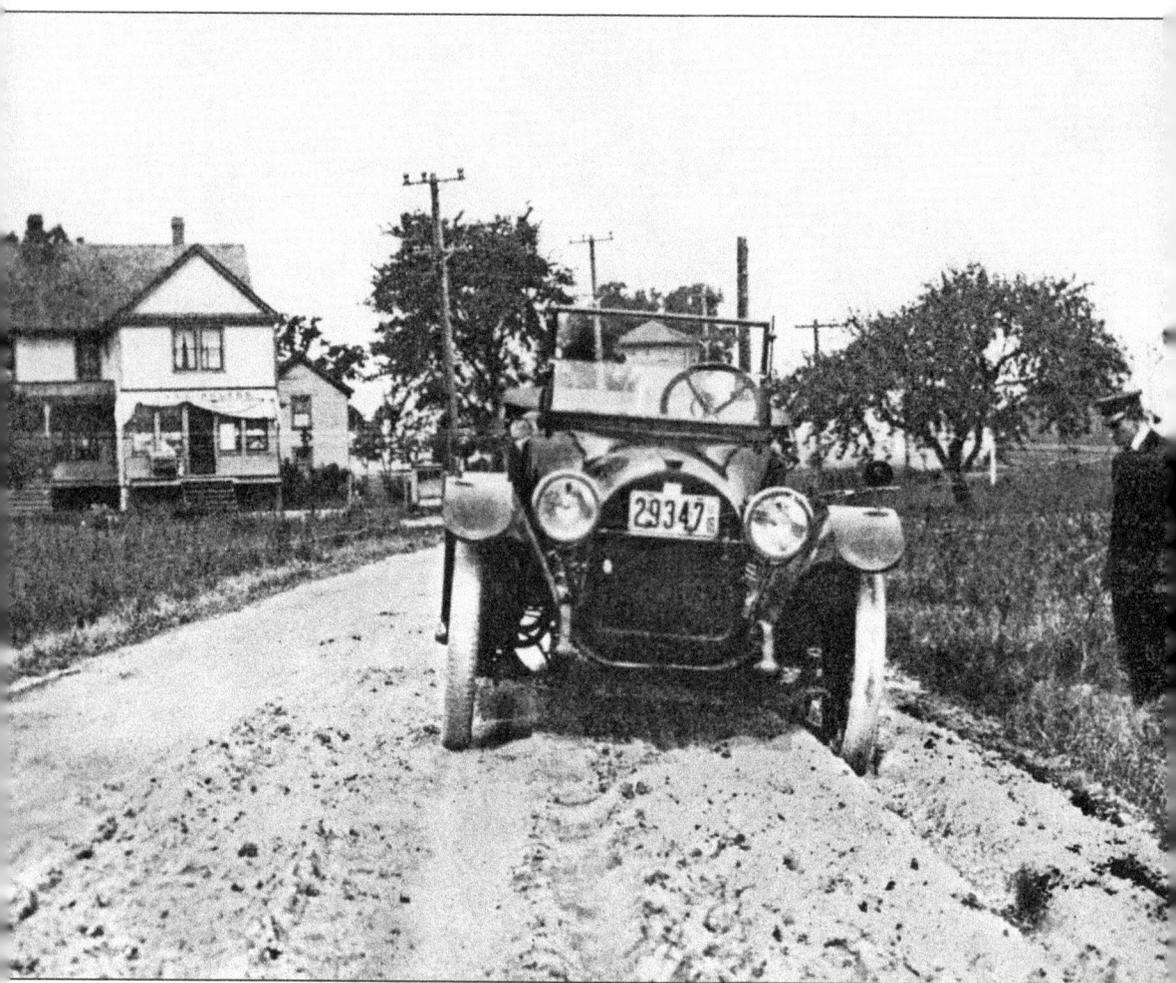

Francis "Frank" Selzer and Mathilde (Happ) Selzer owned the Selzer store, the town's first grocery and general store, shown here in 1913 with what possibly is Fred Metz's car parked (or stuck) out front. The Selzers sold the store to Alex "Al" Levernier, and he added a tavern. It was here that the first village meetings were held. (Courtesy Selzer family.)

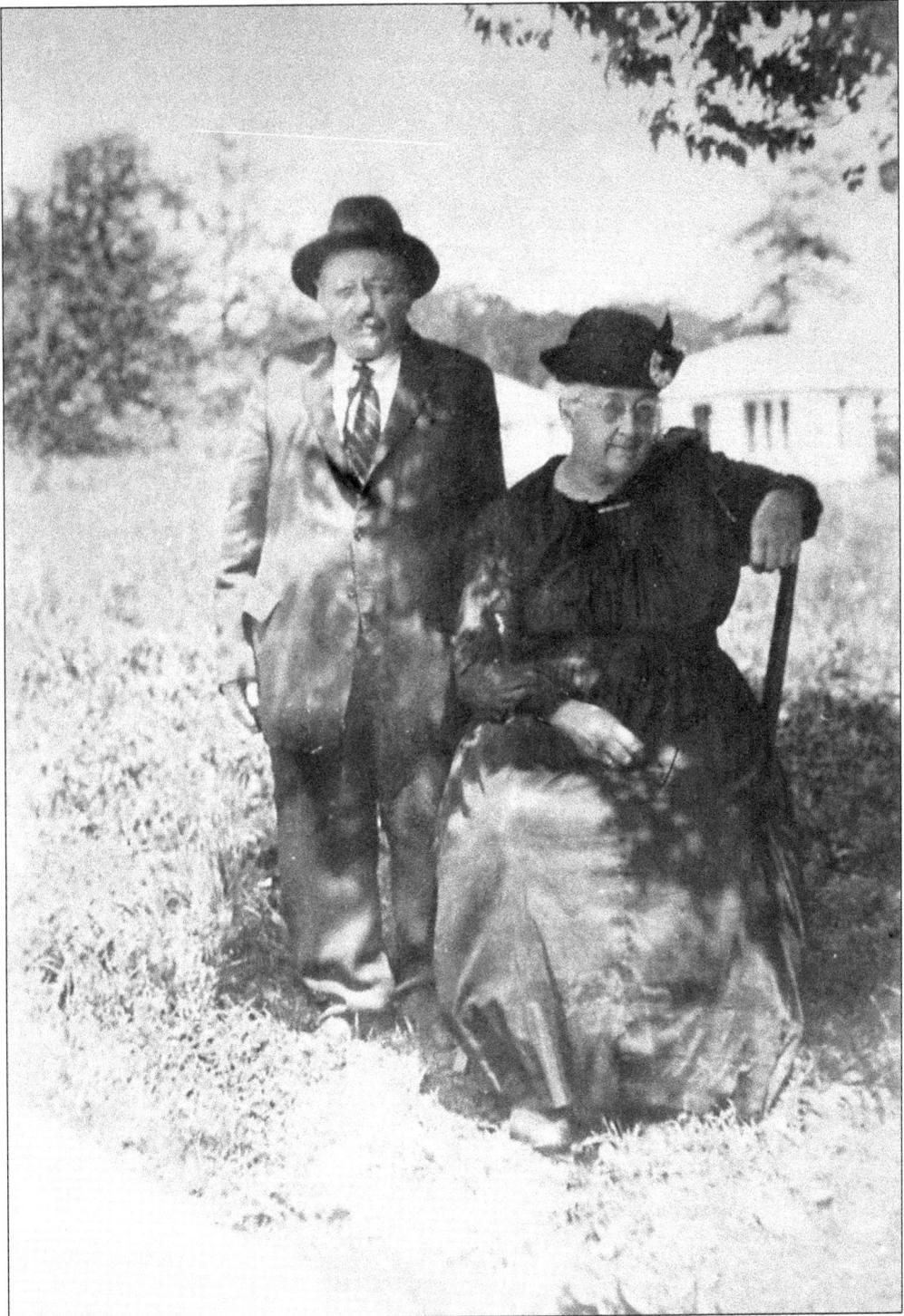

Alex "Al" and Mary (Happ) Levernier are seated outside for a formal portrait. The Leverniers were a popular couple in the community, and Al would serve as village president immediately after John P. Happ. (Courtesy Northfield Historical Society.)

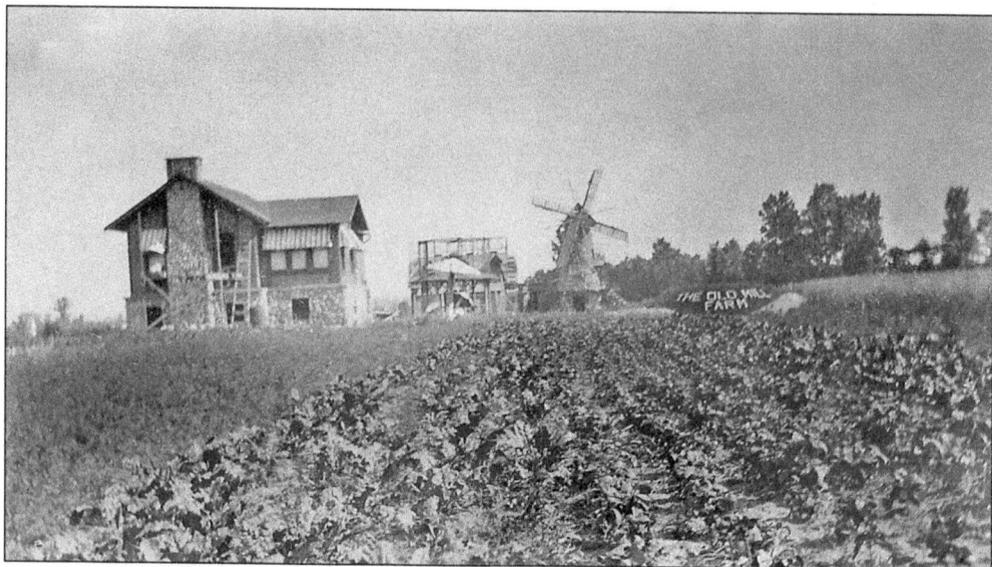

The Old Mill Farm, near what is now Dickens Road, raised horseradish, asparagus, mushrooms, and grain among other crops. (Courtesy Northfield Historical Society.)

In 1920, as flappers bobbed their hair, daringly raised their skirts, and smoked cigarettes without any sense of decorum, Anna Clavey is having some fun. She is shown here dressed as a young boy in cap and knickers. (Courtesy Northfield Historical Society.)

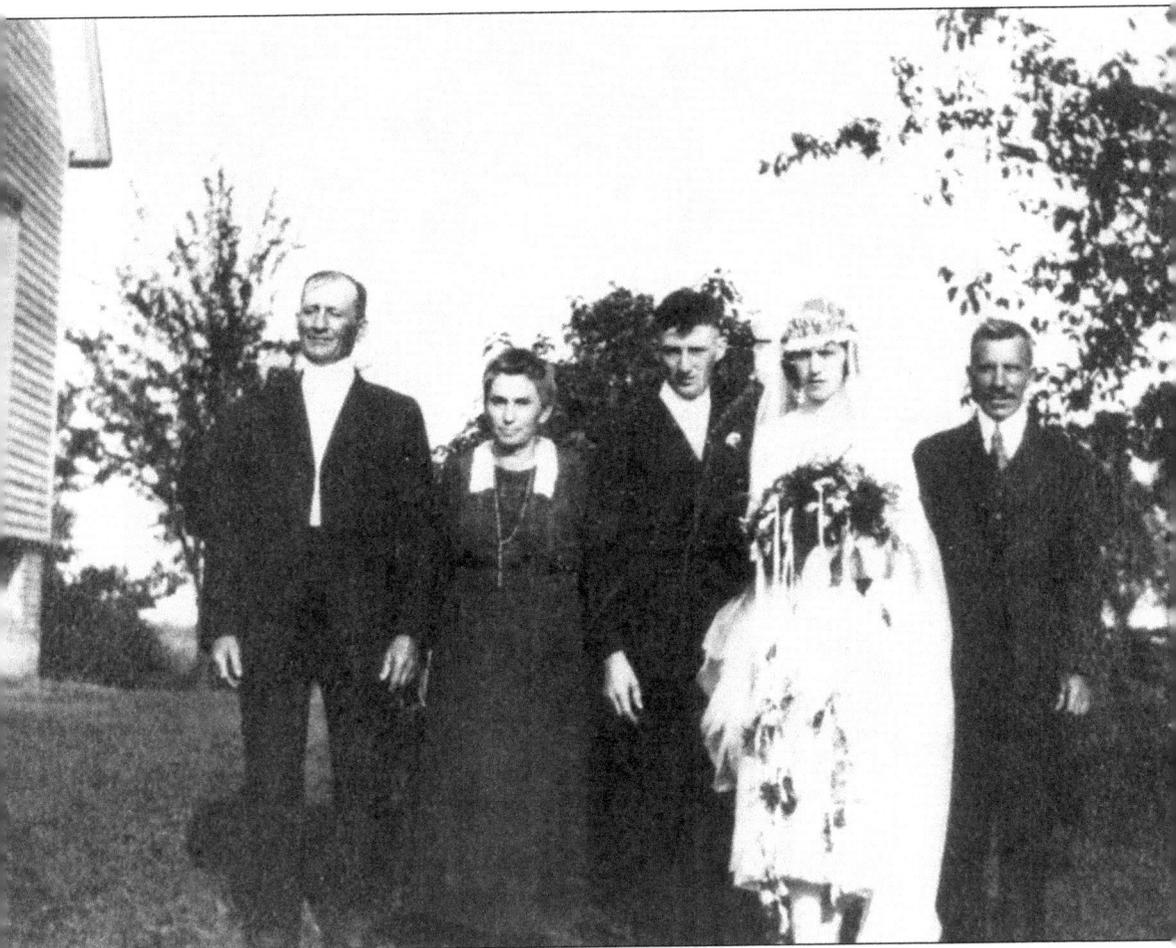

In 1921, a wedding joined the Straub and Happ families. Shown here from left to right are John P. Happ, Annie (Seul) Happ, groom Henry Happ, bride Julia (Straub) Happ, and father of the bride George Straub, a farmer. (Courtesy Therese Anne Happ Selzer.)

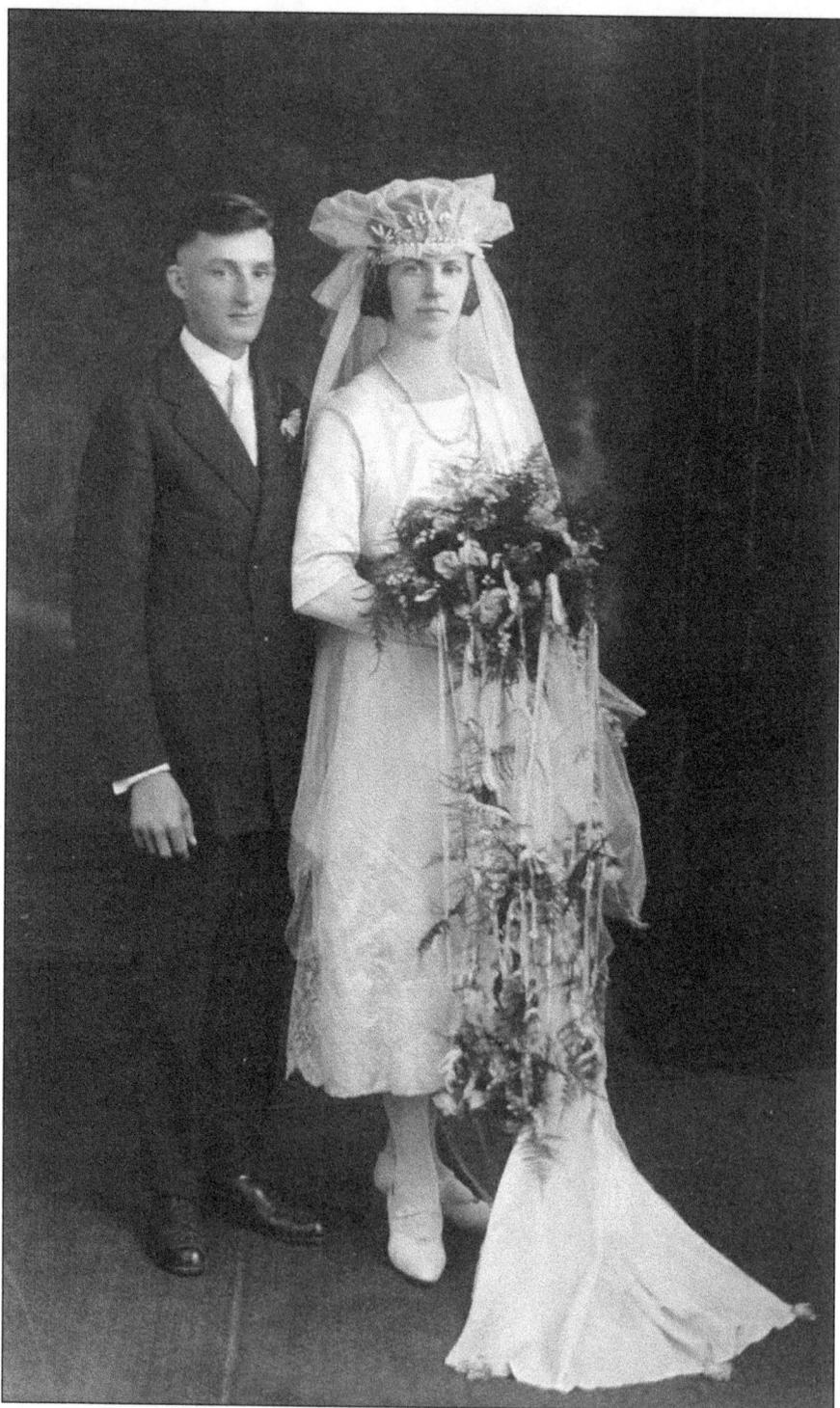

Here is a formal wedding portrait of Henry "Heinie" Happ and Julia Straub. Henry would take a job in building supplies until he was struck by a car. He then became an auto-parts salesman and finished his career working as a bartender at Seul's Tavern. (Courtesy Therese Anne Happ Selzer.)

Is this man a visionary or villain? London-born utility innovator Samuel Insull built the Skokie Valley line of the North Shore Line interurban railroad. It was powered by electricity, which he would also sell to those living along the route. He purchased a significant amount of real estate along the railroad, financed through small investors throughout the Midwest, most of whom would never be repaid. He was married to the stage actress Gladys Wallis, and her disastrous singing career is said to be the basis for some scenes in the movie *Citizen Kane*. (Courtesy U.S. Department of the Interior, National Park Service, Edison National Historic Site.)

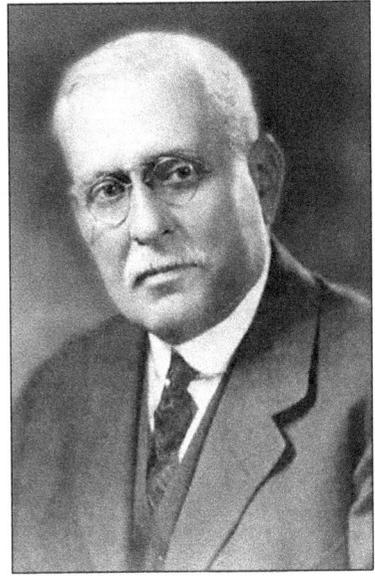

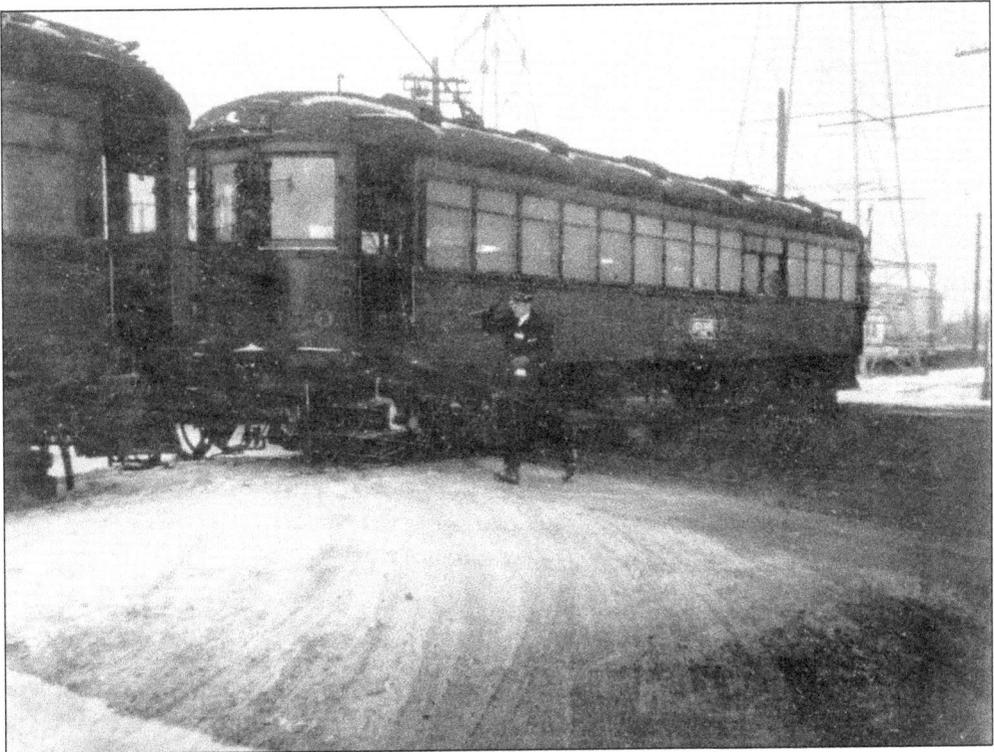

A conductor dashes to his train on the Skokie Valley line. Northfield benefited from the railroad, but Insull and his many investors were not to see the fruits of his labors. He lost his fortune during the Great Depression, fled to Paris and then Greece, was tried but acquitted of fraud in Chicago, and died alone, felled by a heart attack in a Paris subway station as he purchased a ticket. (Courtesy Northfield Historical Society.)

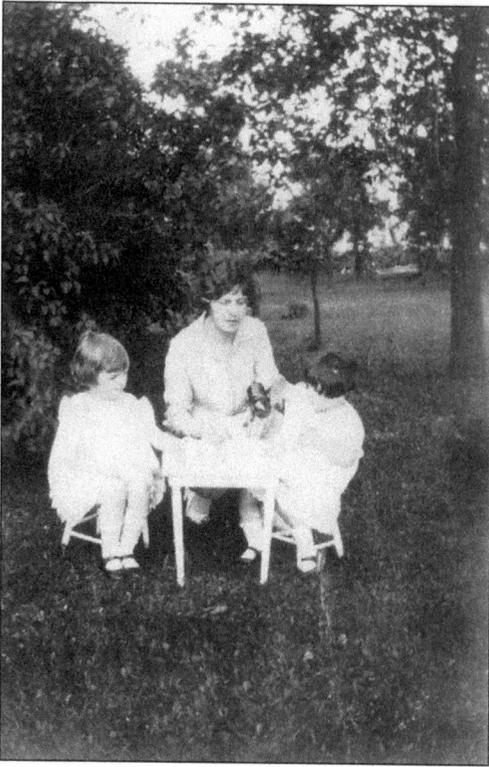

In this mid-1920s photograph, Julia (Straub) Happ and her daughters Dorothy (left) and Louise enjoy some family time on the lawn. Dorothy would marry and move to Wisconsin, but Louise would marry into Northfield's Schwall family. Julia would go on to have five more children: Dorothy, Louise, Robert, Theresa (who married Frank Selzer, once again placing the Happ and Selzer families into relationship), Rosalee, Irene, and Marilyn. Northfield was growing rapidly, with large families and enough land to accommodate everyone. (Courtesy Selzer family.)

John P. Happ was the first village president of what was then called Waubun. In 1926, Insull held a contest to determine the best name for the village and station on his railroad. The name Waubun was the winning entry, but the people of Northfield hated the name, preferring Skokie Swamp. Insull did not want a stop on the rail line to be named for a swamp, as he thought it would make home buyers hesitate. Happ is pictured here just before his death in 1951. When he was elected, Al Kutz was elected as clerk, and Bernard Schildgen was elected as the first police magistrate. George Selzer, Pete Selzer, John Seul, William Boetsch, Leo Retzsinger, and Alex Levernier all were co-opted to volunteer for service as trustees to the new village government. (Courtesy Therese Anne Happ Selzer.)

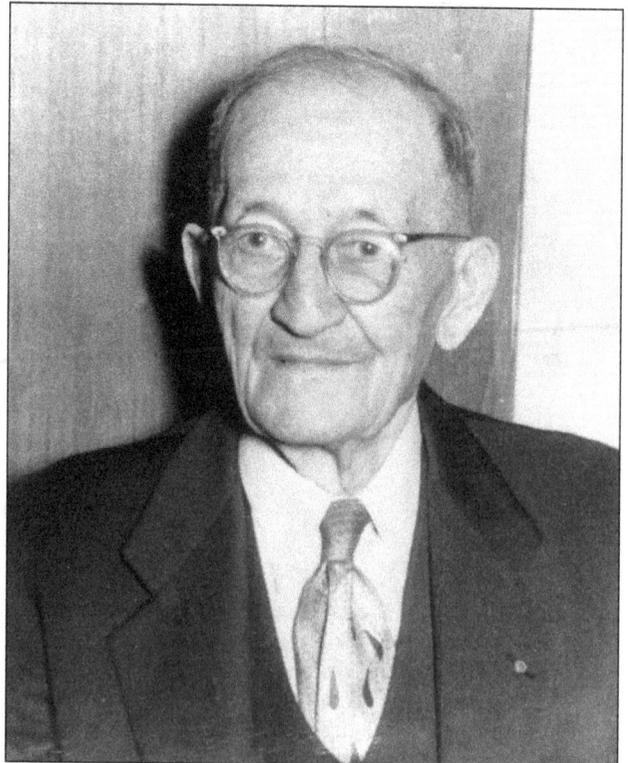

28

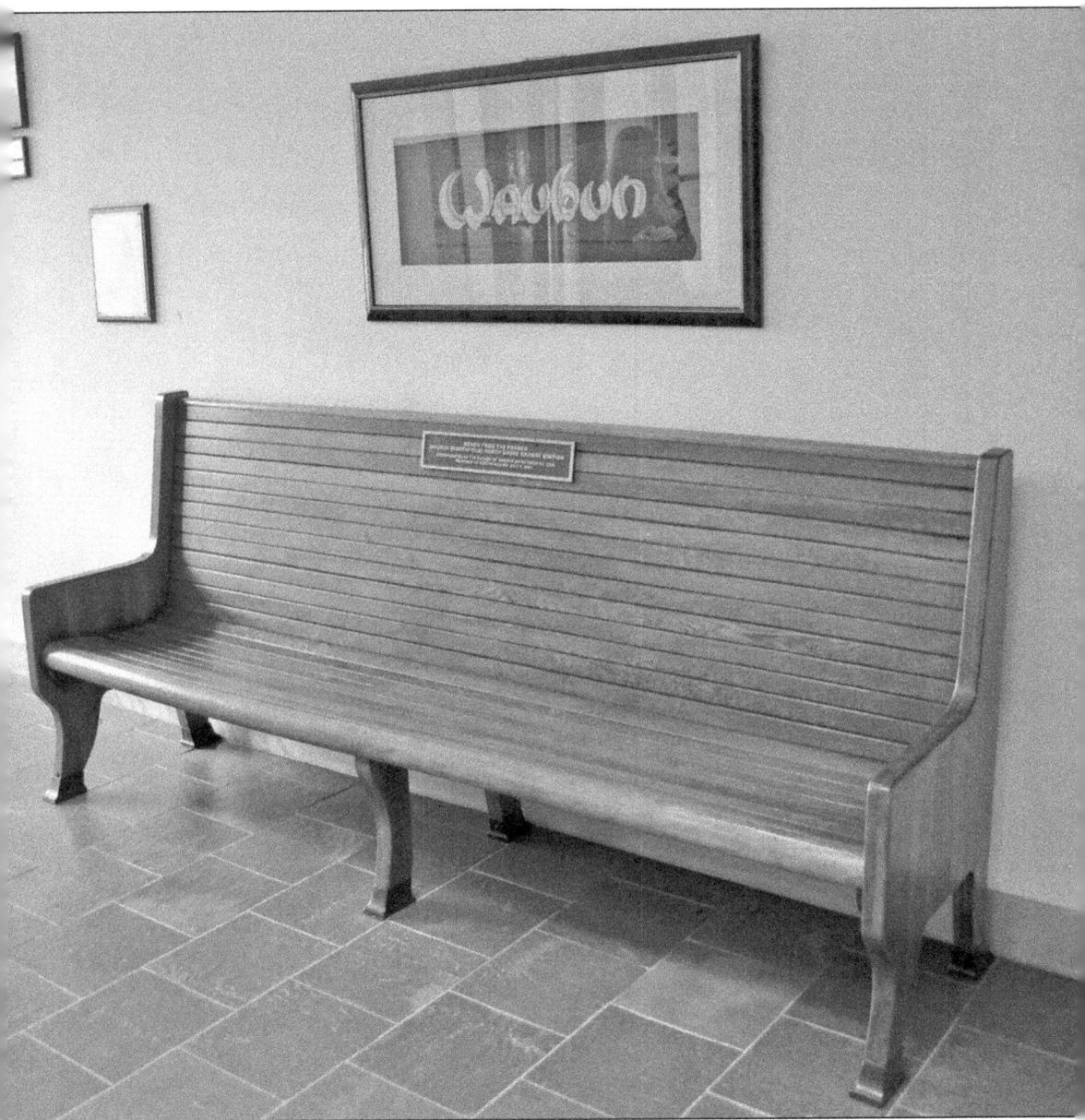

Three years later, Insull was broke—as he rode into the Waubun station, he noticed the "Wau" part of the word on the station sign had been changed to "Hot." He asked his associate George Nixon to find a better name for the village and the station stop. The name Northfield was considered a good choice because it perfectly described the town's location in relationship to Chicago. The residents later voted to adopt the name. Here in the village hall, the original Waubun sign is framed and hanging over a bench from the Northfield station. (Courtesy Charles Seymour.)

Insull understood that plenty of land presented an opportunity for a wise investor to make money. Unfortunately Insull lost all his fortune in the Great Depression. Many people who invested in his companies (including Northfield residents) lost their money as well. In this early 1920s photograph, a boy plays in a field with his faithful cow. A generation later, the land seen here would be converted into a strip mall or a suburban mansion. (Courtesy Northfield Historical Society.)

In the 1920s, the railroad turned farming families into middle-class families with aspirations. Pete and Ella Selzer are pictured here with their children, from left to right, Marian, Jamie, and John. Pete worked at the North Shore Line railroad and enjoyed a lifestyle far different from that of his farming father. (Courtesy Selzer family.)

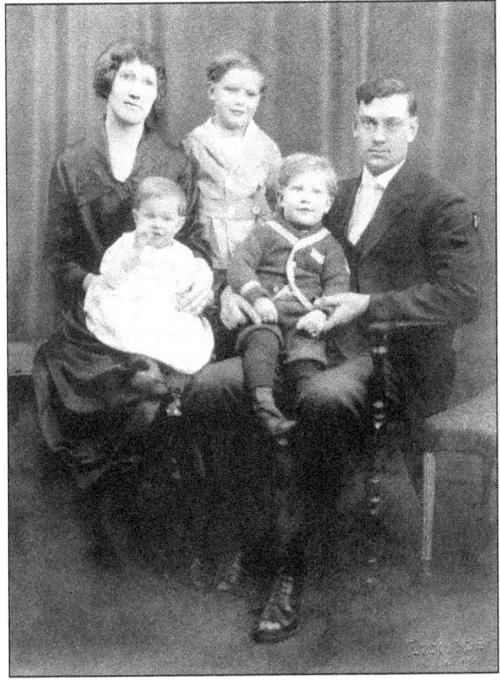

"Kansas" Pete Selzer, possibly so named because he had experienced a rough time of it in Kansas City, was a distant cousin not directly related to "Horseradish King" Peter Selzer and his sons. He came to Northfield looking for a more congenial, family-friendly atmosphere in which to raise a family. He built three homes, one for each of his three daughters, on Happ Road. Since it was the Great Depression, people were resourceful about building materials. Each of the homes is constructed with paving bricks normally used for building roads; they were therefore of the most substantial fortitude. (Courtesy Charles Seymour.)

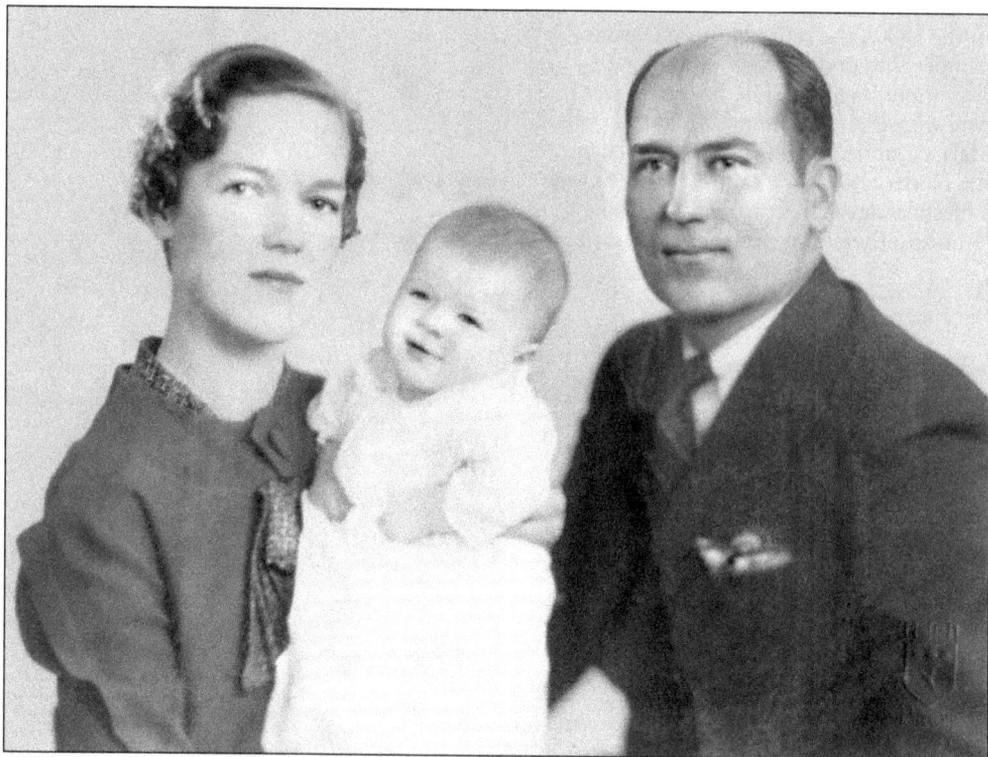

Bertram "Barney" and Bernice (Kassner) Happ are shown here with their oldest daughter, Bernice. They would go on to have five more children. Bertram, in his capacity as a state road commissioner, was the first to suggest the naming of Happ Road, Northfield's major artery, because there were so many Happs (and Selzers, Leverniers, Seuls, and Straubs married to Happs) on the road. The couple lived at 779 Happ Road. (Courtesy Happ family.)

In the 1930s, Wagner Road, one of the major arteries through Northfield, was still unpaved. When farmers could not pay their property taxes, they would sometimes volunteer their time to pick up gravel in their trucks and scatter it along the roads, thereby relieving Cook County of the responsibility of caring for the roads. Their taxes would then be forgiven. (Courtesy Northfield Historical Society.)

Even the best cars could get stuck in the muck, as this family discovered. Winnetkans, even before the Great Depression, started to look to Northfield as a place to take a Sunday drive. The Sunset Ridge Country Club was a great draw with its golf course and dining, particularly as Winnetka's Indian Hill Country Club membership was capped. (Courtesy Northfield Historical Society.)

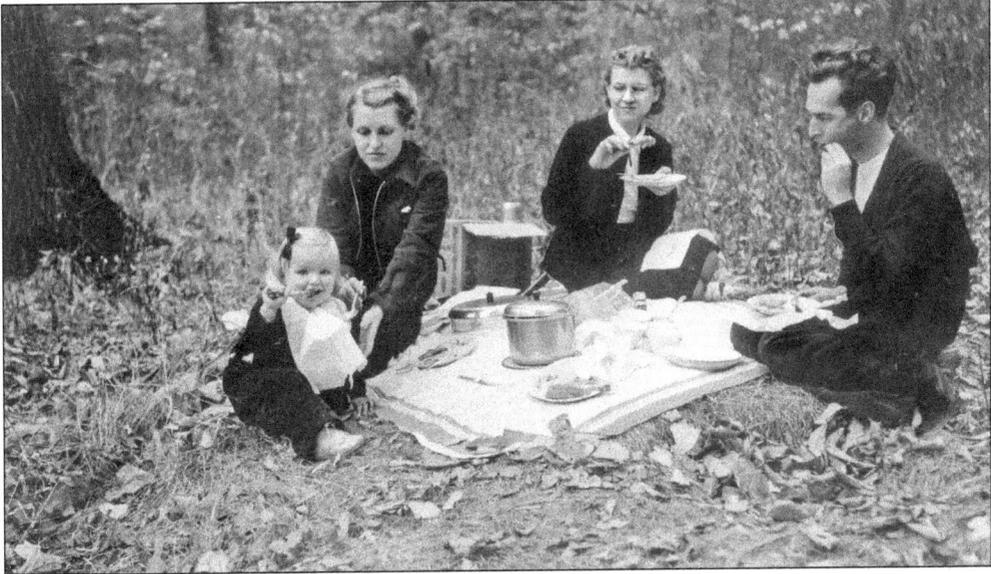

In the 1930s, one thousand members of the Civilian Conservation Corps created seven lagoons, five dams, and two drainage ditches out of what had been a swamp between Winnetka and Northfield. Some workers lived in homes along Northfield's eastern boundaries, with some landlords advertising alcohol and dancing on their upper floors. With the swamp cleared, people were able to enjoy the outdoors in new ways. This photograph shows a family picnicking at what some Northfield residents called "Snook Brook" in 1939. (Courtesy Carolyn Collins.)

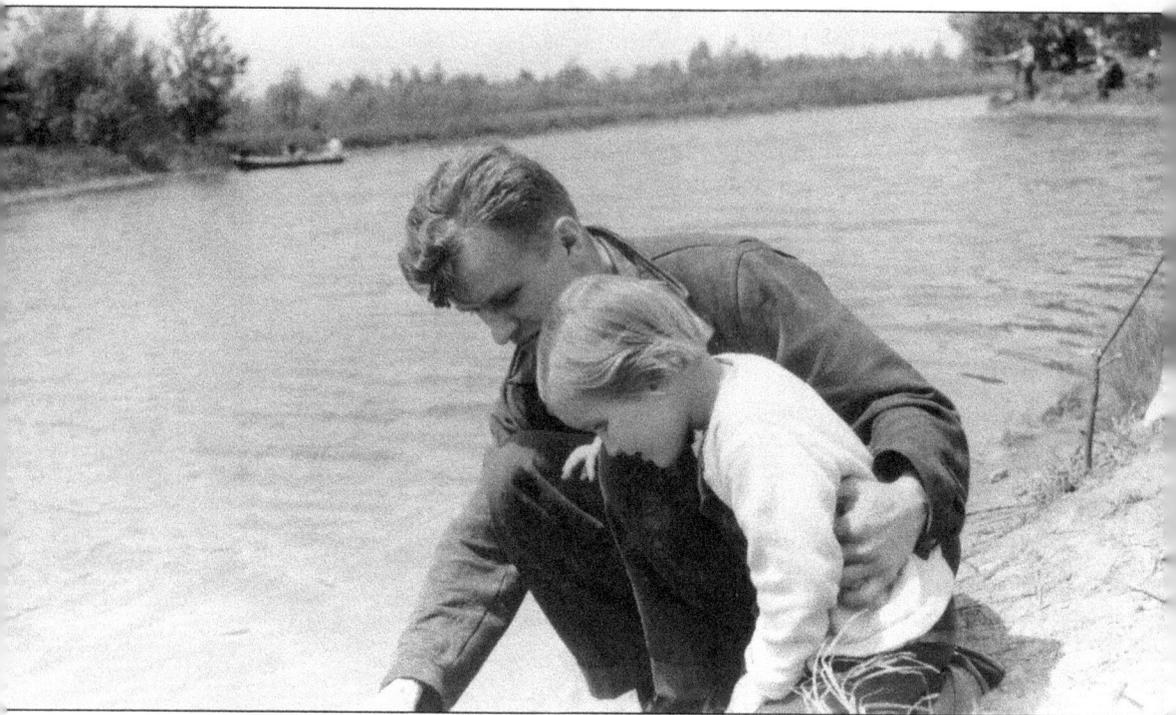

The Skokie Lagoons became a place for fishing, boating, relaxing, and enjoying nature. In the spring of 1941, Karl Krueger shows his daughter Carolyn the water. Karl worked in nearby Evanston as editor of *Rotarian* magazine. The family home was not in the Northfield School District, so Carolyn and her brothers would not go to Sunset Ridge School and instead would attend Avoca School in Wilmette. (Courtesy Carolyn Collins.)

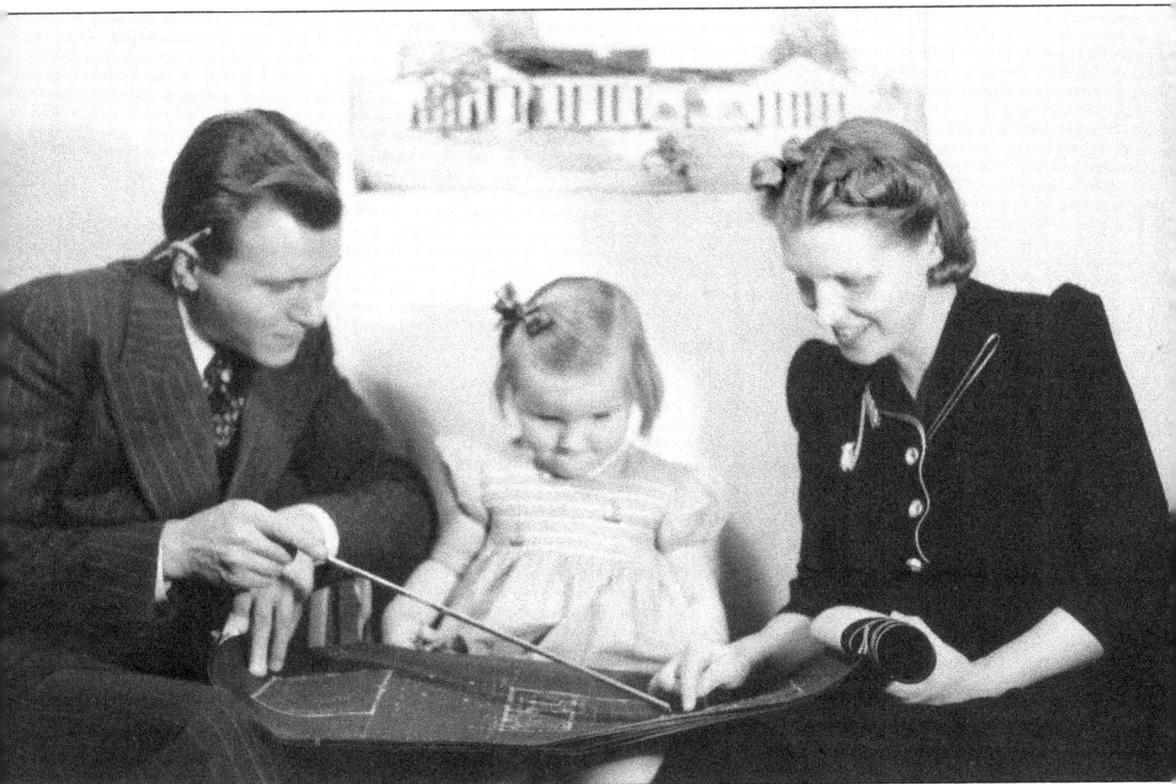

Although Samuel Insull was dead, his dream for Northfield came to fruition. Here Karl and Dorothy Krueger review plans with their young daughter Carolyn for a home to be built on the east side of Northfield at Mount Pleasant and Latrobe Avenues. (Courtesy Carolyn Collins.)

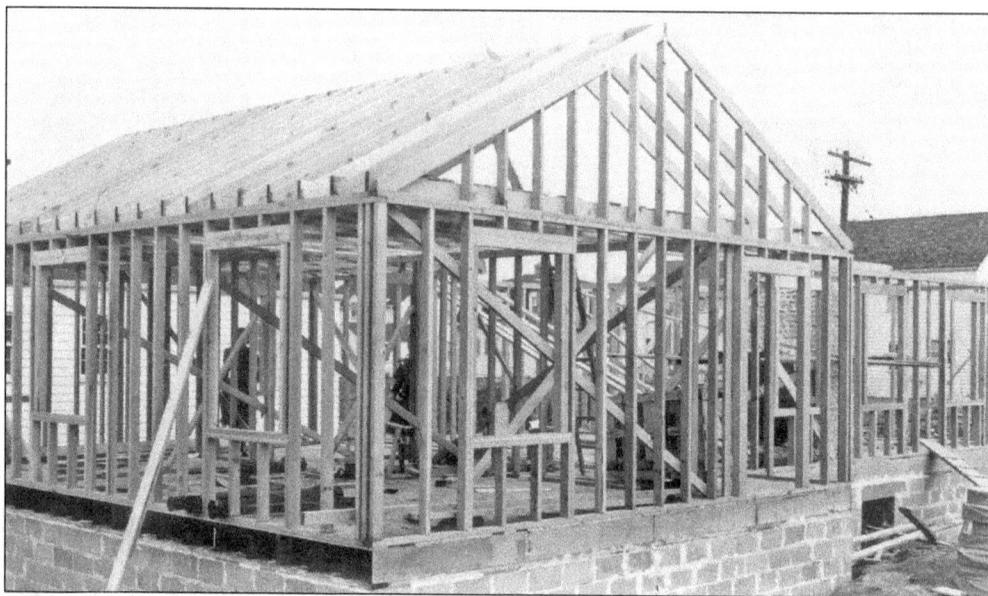

The Krueger home was built in 1941 in an area that would have been unusable before the Skokie Lagoons project. Northfield was developing right up against the border of Winnetka. Although World War II would put a temporary damper on new construction, Northfield was poised for an explosion of new homes, new businesses, and new families. (Courtesy Carolyn Collins.)

The Krueger home was completed, and it was a fulfillment of the American dream for the family. The Kruegers would go on to have two sons to round out their happy family. Note the lack of sidewalks; most streets in town still do not have sidewalks, with the exception being the downtown area around Northfield Village Hall and the corridors leading away from Sunset Ridge and Middlefork Schools. (Courtesy Carolyn Collins.)

36

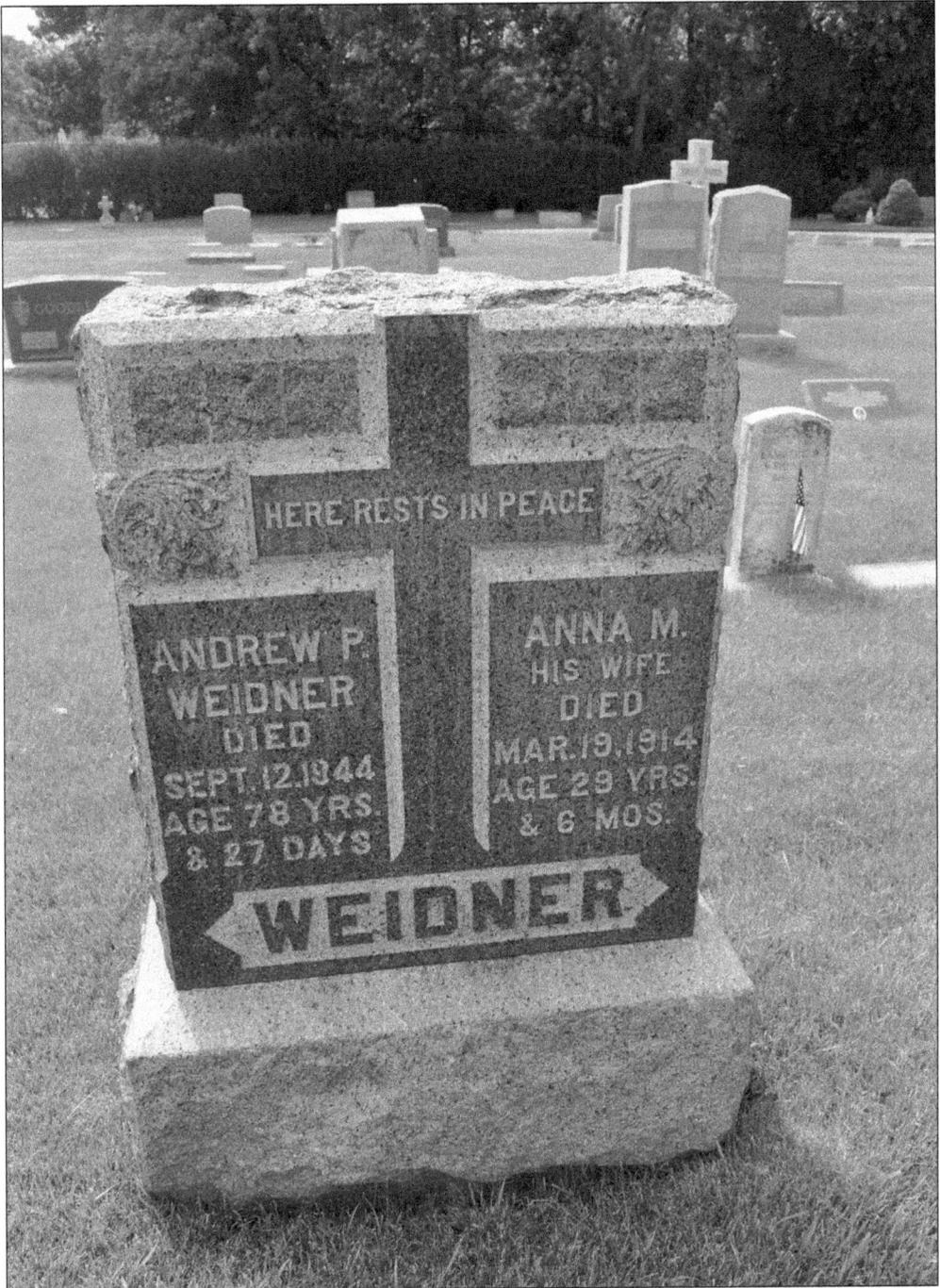

The Techny Cemetery, now on land owned by the Divine Word Missionaries, tells many heartbreaking stories of Northfield. Here is the Weidner grave: wife Anna died at just 29 years, while her husband would live on until he was 78. The grave of their son Lambert can also be seen, decorated with a small American flag commemorating his service in the U.S. Army. He was killed in World War II, and his death broke his father's heart. Lambert was just three years old when Anna died. (Courtesy Charles Seymour.)

While there are tragic stories to be read on the gravestones of Techny Cemetery, there is also a great sense of community. The Leverniers, the Happs, the Seuls, the Selzers, the Straubs—all the early settlers of Northfield—have come together here for their final rest. (Courtesy Charles Seymour.)

Two

SEVERAL LITTLE SCHOOLHOUSES

The story of most every family is the same: a father and mother want what is best for their children; they want to give them a better life than they themselves have had. For most people, the way to do that is to give them an education. Northfield parents are no different from any others—they want good schools. The first settlers in Northfield either paid tuition to the Winnetka Public Schools or paid tuition to St. Norbert's School in Northbrook. There were a few "in-house" schools where rudimentary lessons were given by mothers for a small fee, and there was always the option of sending a child away to a boarding school or to live with a relative who could provide an education.

Northfield is spread out across three public school districts: Glenview School District 34 in Glenview, Avoca School District 37 in Wilmette, and Sunset Ridge School District 29. The latter serves the largest portion of the population.

The Brown School was a one-room building that was just right for a loose-knit farming community but was not quite sufficient for a growing suburb. In 1924, the school had an enrollment of 13 boys and five girls. Residents of the community voted on creating a school board with three members. In addition to the Brown School, parents had the choice to send their children to Winnetka, Northbrook, and parochial schools. The Brown School was torn down in 1930 after the building of Sunset Ridge School. (Courtesy Northfield Historical Society.)

Wealthy matron Dorothy Clark divided her time between three homes around the country and did not need a public school education for her three children. Yet she had a great love for Northfield, and she prodded the community to build a school that would accommodate all Northfield children and set a standard of academic excellence. The school, just down the road from the posh Sunset Ridge Country Club, would be named Sunset Ridge School. (Courtesy Northfield Historical Society.)

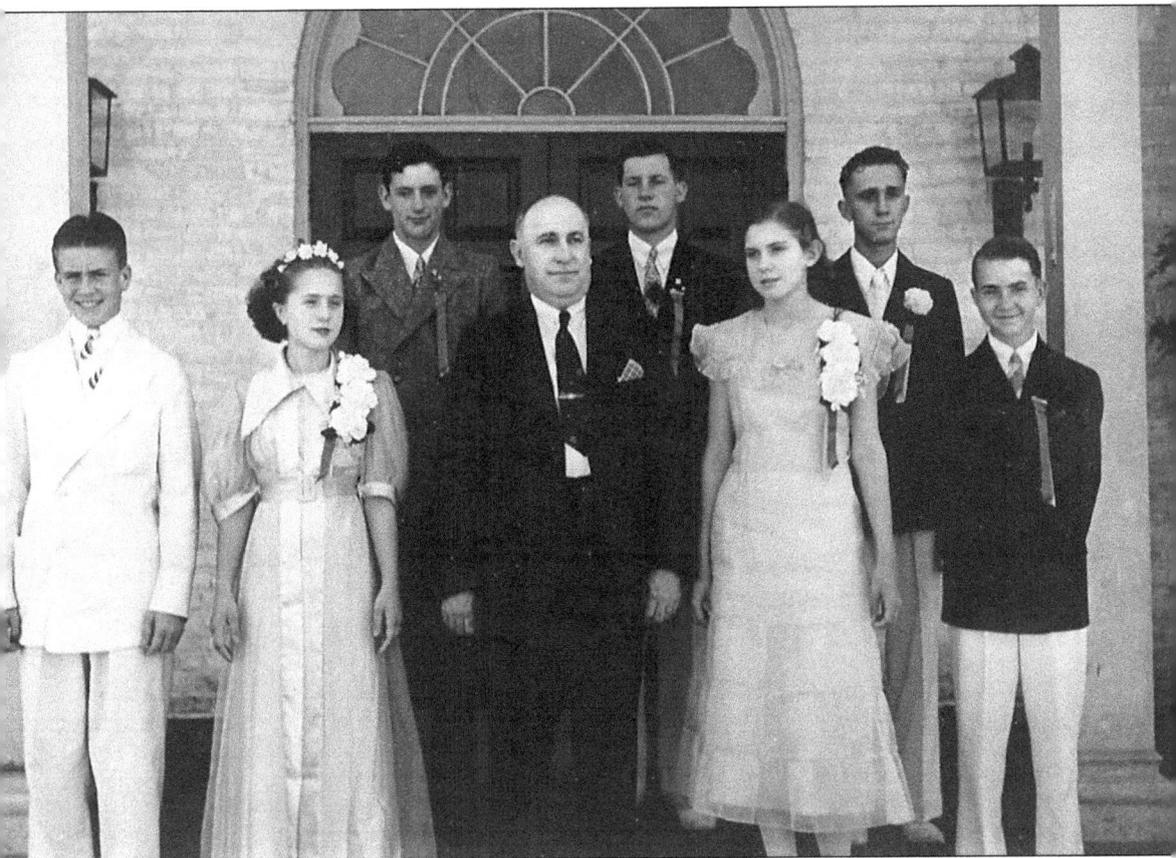

It was difficult to persuade Northfield residents to pay for the building of a new school, especially as the Great Depression loomed, but Dorothy Clark was a persuasive advocate. William Cray, pictured here with his first graduating class at Sunset Ridge in the early 1930s, was persuaded by Clark to abandon his position as principal of Northbrook School. His wife was a housekeeper to the Clark family, and the Cray family was given a home on the Clark family property. (Courtesy Northfield Historical Society.)

District 29's Sunset Ridge School was a simple building just north of where the Brown School had stood. There were two classrooms, two teachers' offices, and a large fireplace that is still in existence today after many additions and modifications to the building. (Courtesy Sunset Ridge School.)

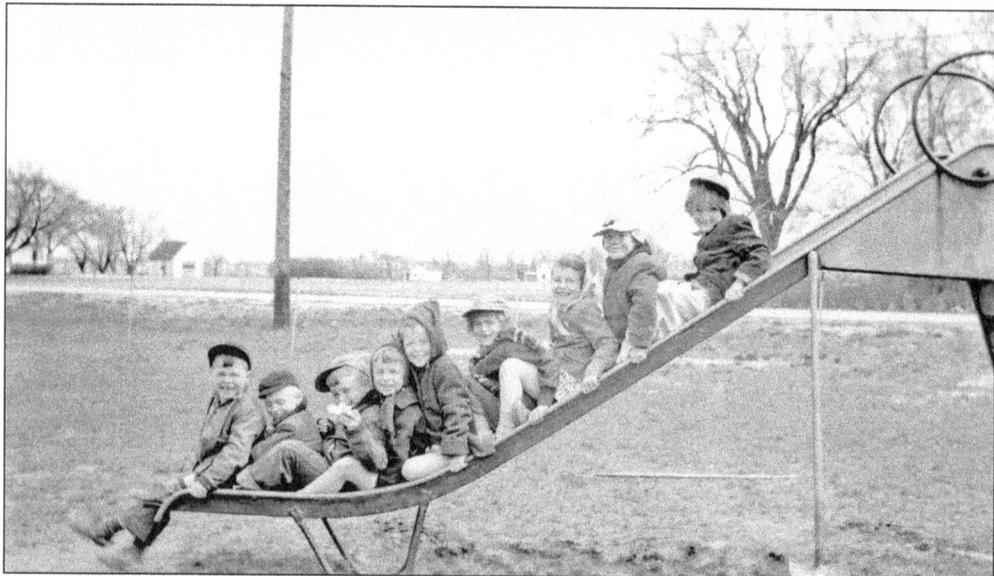

Recess is always a good time to make friends, and the new Sunset Ridge School had a great playground for kids to make friends. These nine children were happy to have their picture taken. While nearby Winnetka prided itself on its progressive educational system, Sunset Ridge maintained a strong focus on fundamentals and on social discipline and courtesy. (Courtesy Sunset Ridge School.)

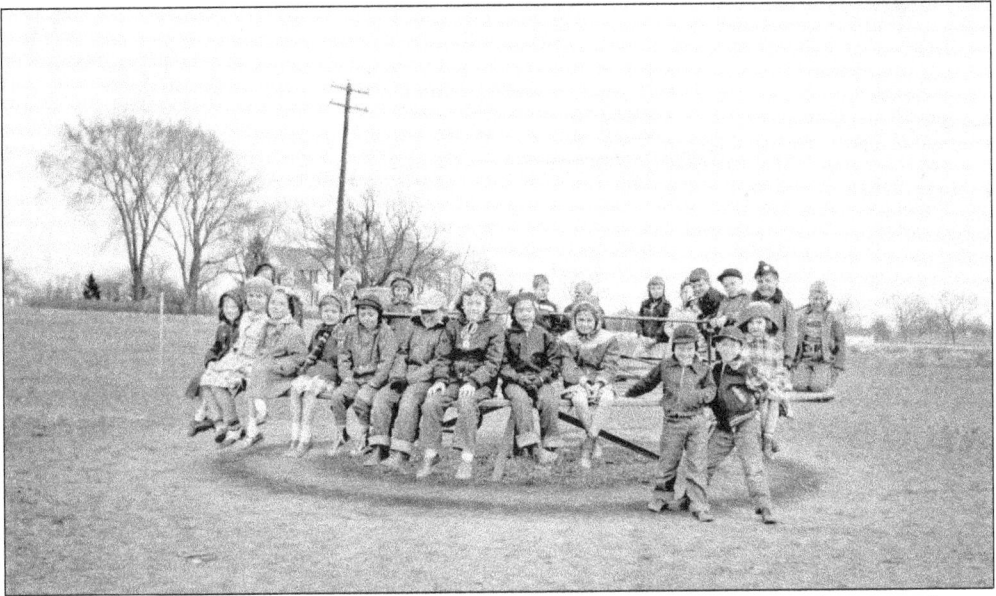

A spindle-hopper (also known as a whirligig) can induce the greatest, most delicious, and most nauseating dizziness, especially when one is surrounded by so much empty land. Northfield was set to explode with new homes, businesses, and families. (Courtesy Sunset Ridge School.)

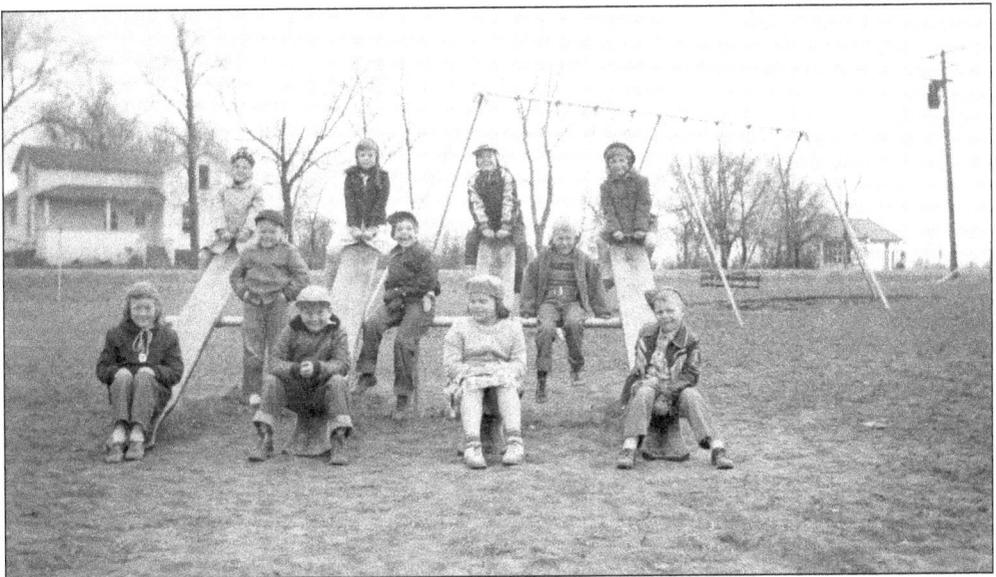

A seesaw is a wonderful thing, and four of them in a row can make for a wonderful recess. The Sunset Ridge School was an incredible improvement on the amenities afforded by the Brown School, and though the children pictured here probably did not realize or acknowledge it, their parents certainly did. (Courtesy Sunset Ridge School.)

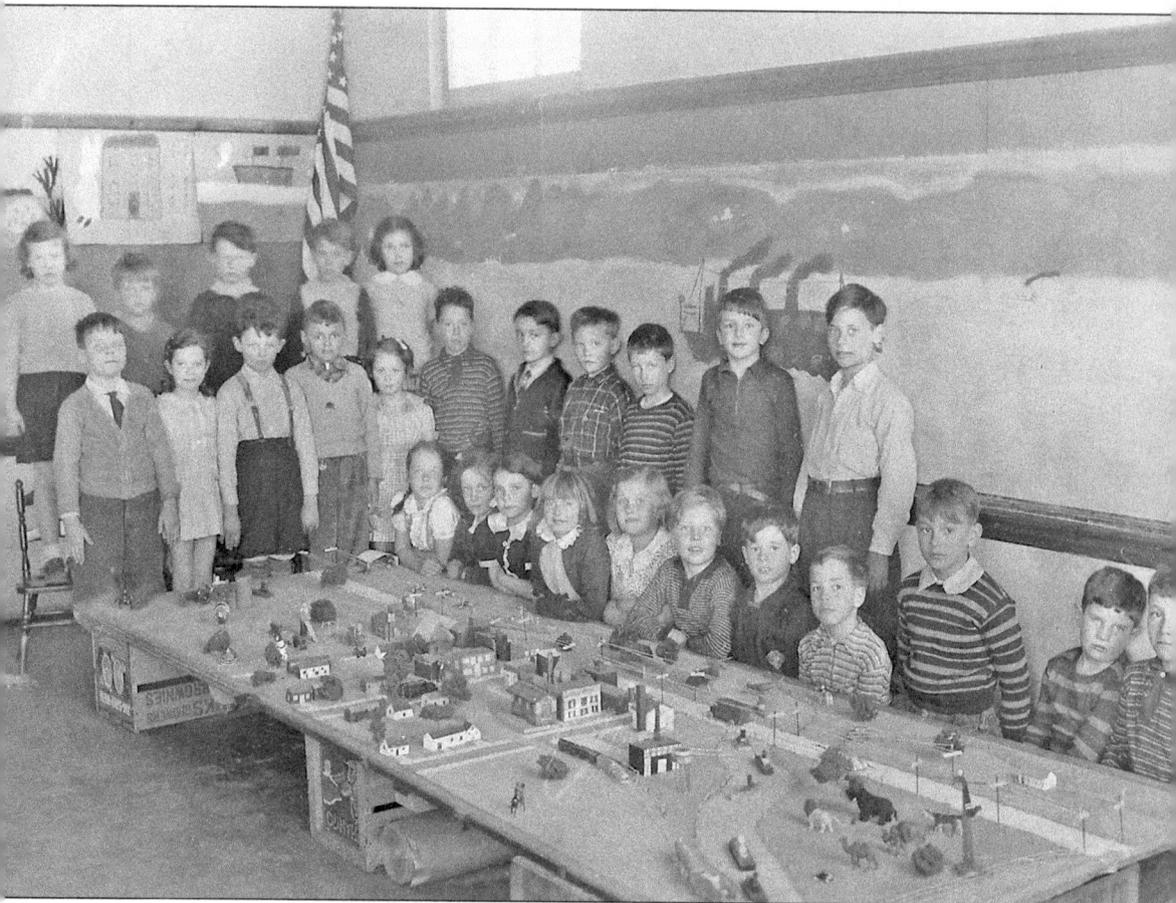

At the newly opened Sunset Ridge School, third graders proudly displayed a three-dimensional map of their community. On the blackboard, the ships represented the journeys of their forebears from Ireland, Germany, England, and France among other nations. (Courtesy Sunset Ridge School.)

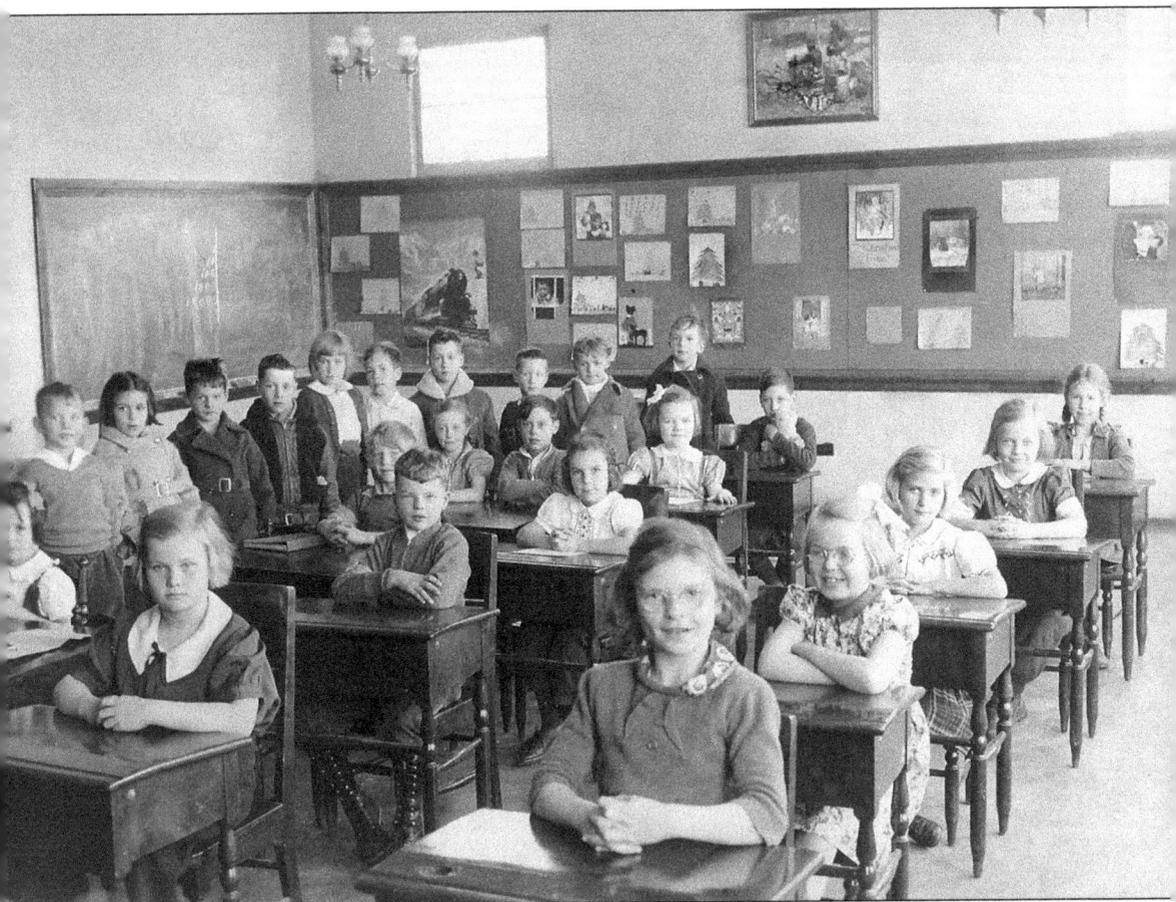

In 1936, the country was suffering in the Great Depression. These third graders little realized their economic deprivation and certainly did not know that just five years later their country would be plunged into war. In 1937, the Northfield School Board made the painful decision to send sixth-, seventh-, and eighth-grade students to Skokie School in Winnetka, using taxes to pay for the transportation and tuition costs. Winnetka agreed to the arrangement. Sunset Ridge would serve kindergarten through fifth grade. (Courtesy Sunset Ridge School.)

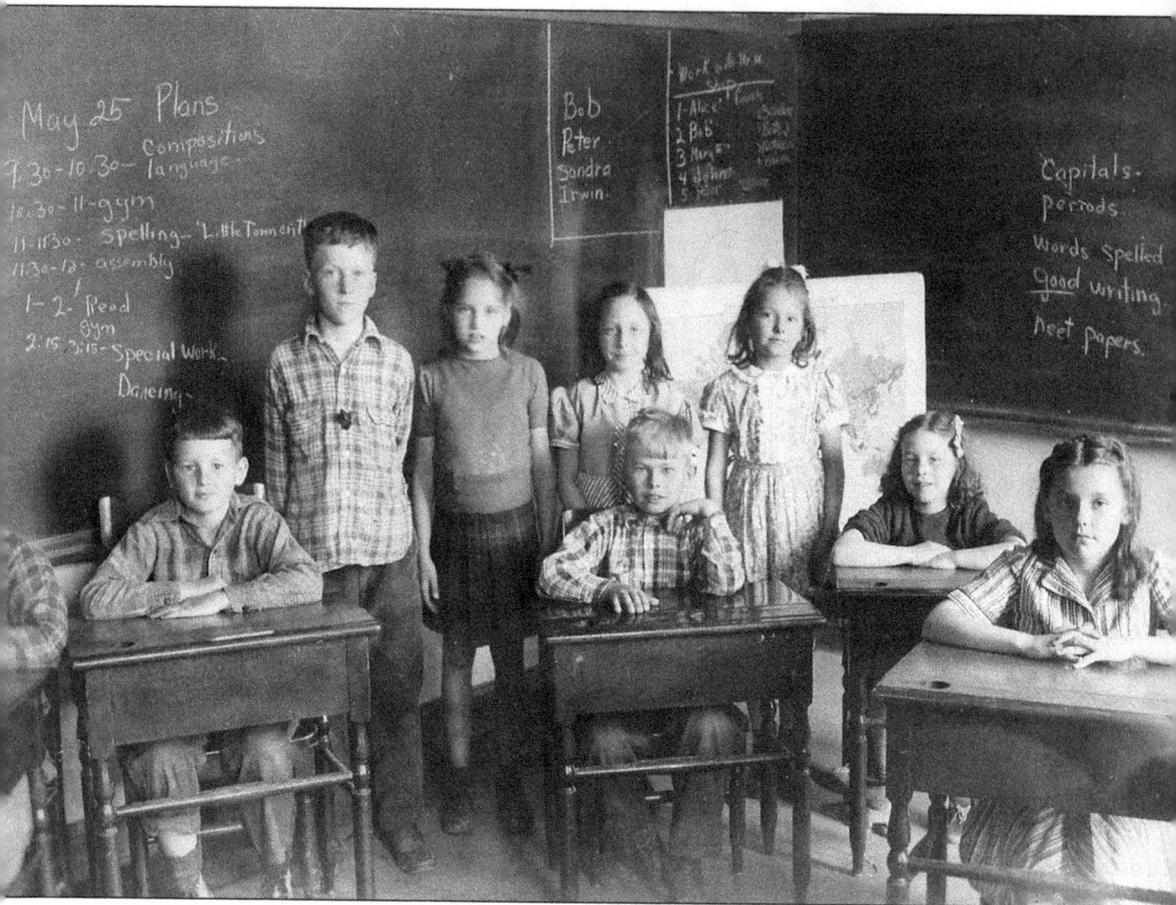

In 1942, this third-grade class posed for a portrait, but what is this? Directly beneath the exhortation to have all words "spelled right" and to create "good writing," these students have also asked themselves to turn in "neet papers." (Courtesy Sunset Ridge School.)

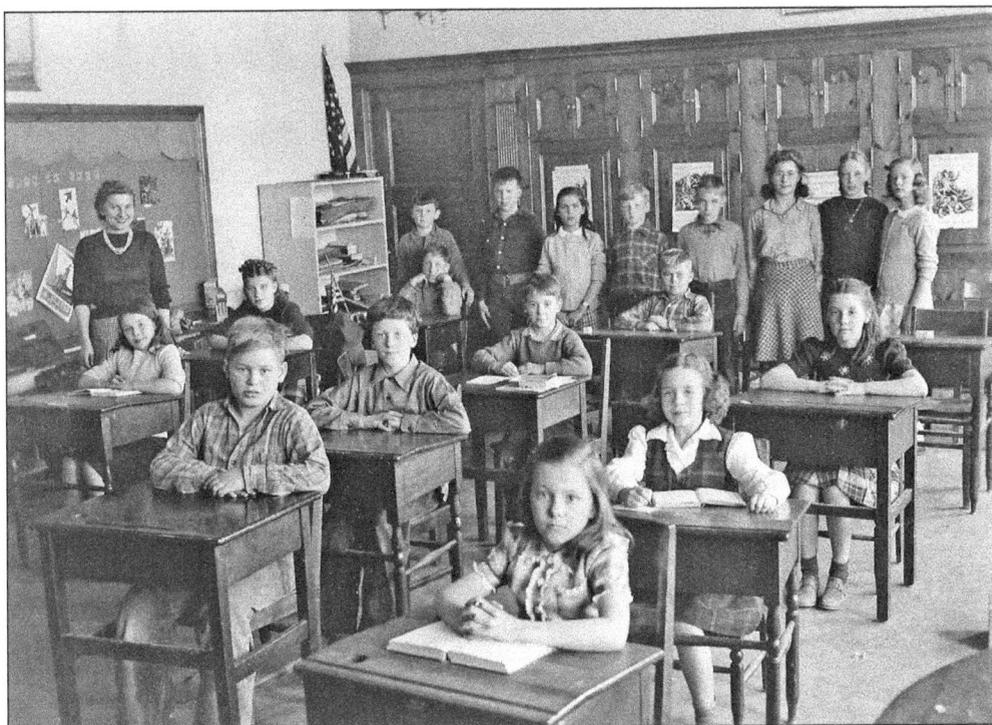

Here is a solemn fourth-grade class of 1943–1944. The community is suffering with the entire country, and while the teacher here bravely smiles, there is little stomach for celebration. Many of these children had fathers fighting overseas. (Courtesy Theresa Anne Happ Selzer.)

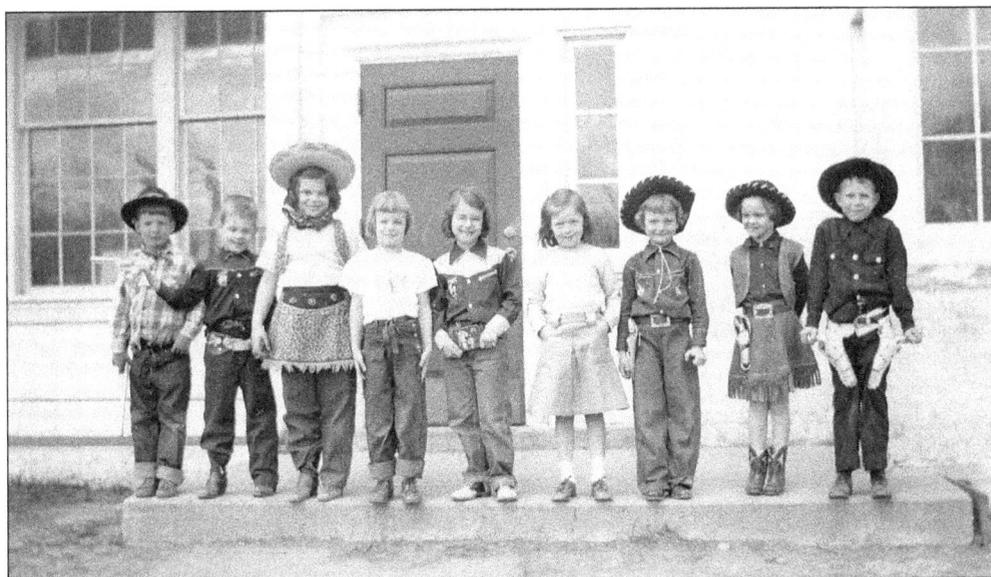

Sunset Ridge emphasized many traditions. A 1946 dress-up party for a spirited game of Cowboys and Indians teaches students about the Westward Expansion. Sunset Ridge adopted some of the Winnetka experiential teaching methods. (Courtesy Sunset Ridge School.)

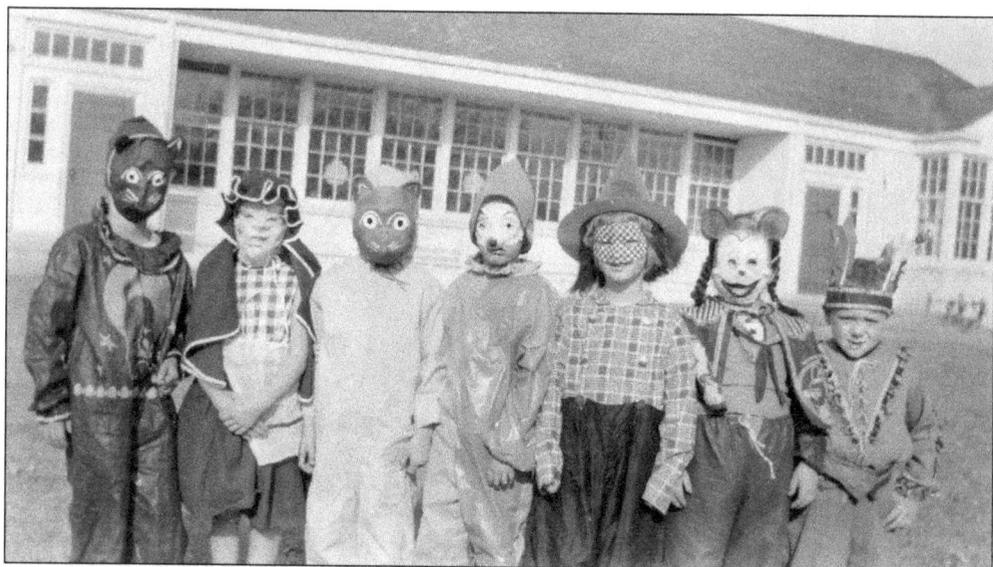

Sunset Ridge encouraged Halloween celebrations during school hours, particularly when trick or treating and nighttime pranks could spell trouble. Here some first graders show off their finery during the 1946 celebrations. (Courtesy Sunset Ridge School.)

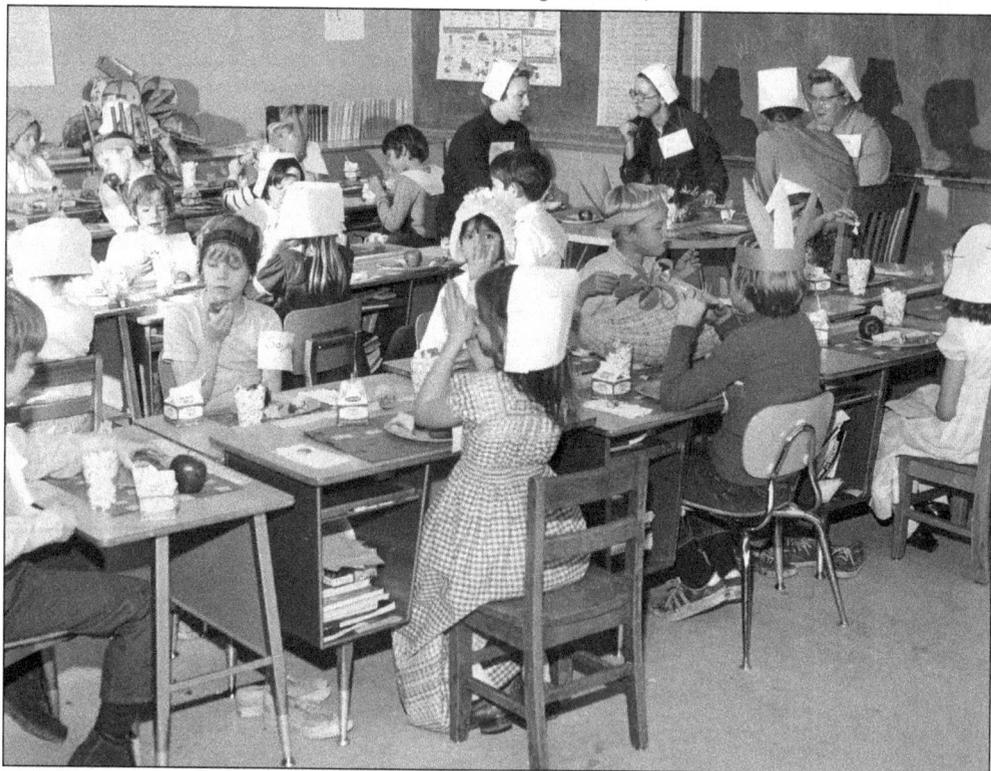

Even while Sunset Ridge School encouraged discipline and rigor in education in preparation for their transition to New Trier High School, students enjoyed fun traditions, including this Thanksgiving feast in which girls were pilgrims and boys were Native Americans. (Courtesy Sunset Ridge School.)

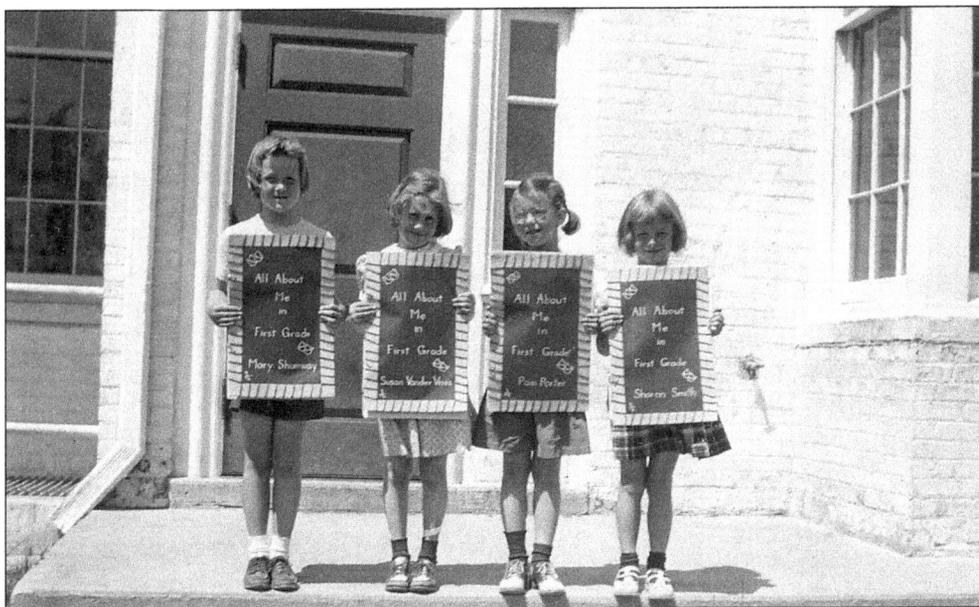

Mary Osborne signed on as a first-grade teacher in 1948 when she was 24 years old, and she created the tradition of "All About Me" days in which children would create and present books that celebrated their individual stories. Osborne sewed the book covers but acknowledged that principal Harry Collins (who signed on after the retirement of the first principal, William Cray) would help sew the books on evenings when the Collins's would invite Mary to dinner. The four girls pictured here with their books are, from left to right, Mary Shumway, Susan Vander Vries, Pam Porter, and Sharon Smith. (Courtesy Sunset Ridge School.)

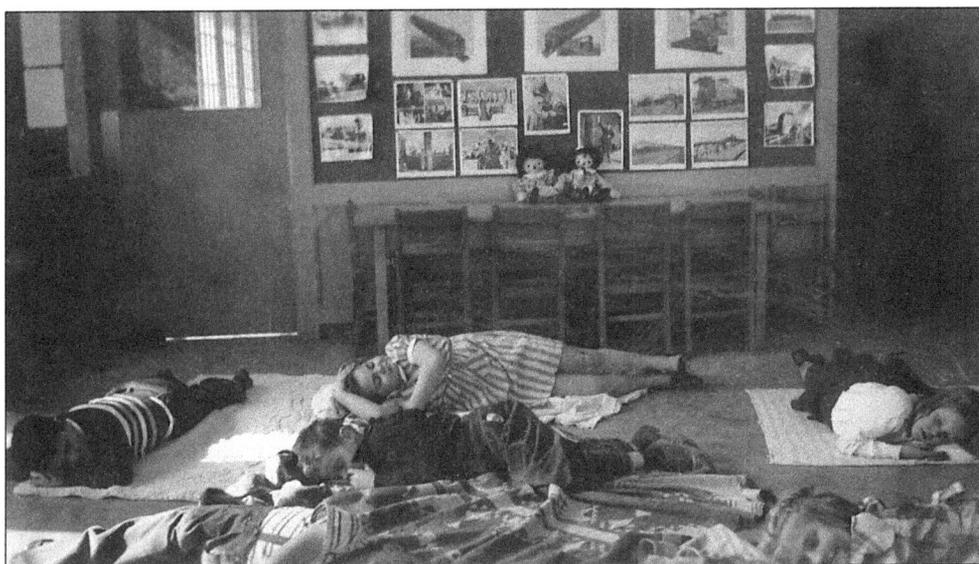

A very important part of any school day is nap time. One of the reasons the school was able to offer so much to their students in a varied day is because of volunteers who would monitor a nap time so that a teacher could engage in curricular preparation. Many adults wish nap time was part of their daily "curriculum" as well. (Courtesy Sunset Ridge School.)

Sunset Ridge School takes as its mission "to cultivate a learning community that engages the hearts and minds of students, one child at a time." Fourth and fifth graders are taught in a traditional elementary classroom. Sixth graders are transitioned into a moving-between-periods system within a supportive environment. Seventh and eighth graders are introduced to the high school model of education and are fully prepared to enter New Trier High School or any other high school of their choice. (Courtesy Charles Seymour.)

After the war, property values soared, and Sunset Ridge hired its first physical education teacher, Jim Clarkson. His first year, he was asked to teach fifth grade and art in addition to physical education. Pictured here in 1975, when the school had four full-time physical education teachers, are (left to right) Sharon Storm, Tom Turner, Doris Pfenning, and Jim Clarkson. (Courtesy Sunset Ridge School.)

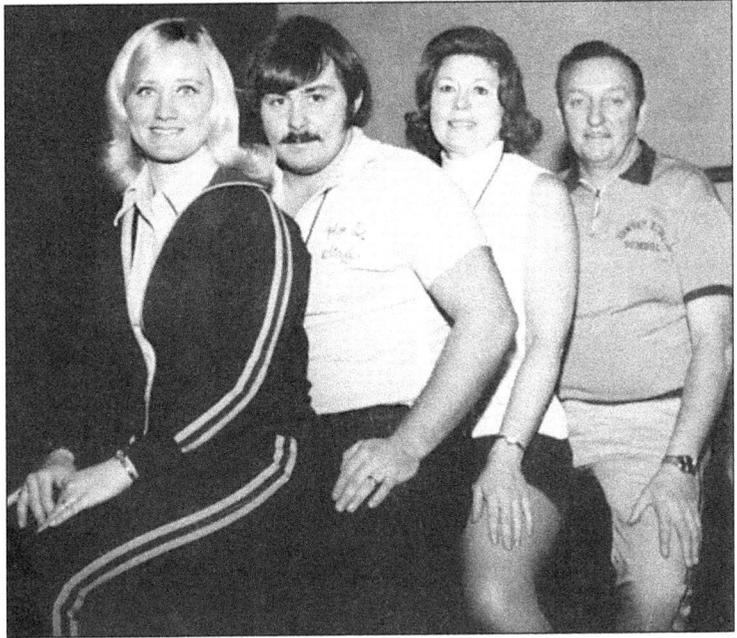

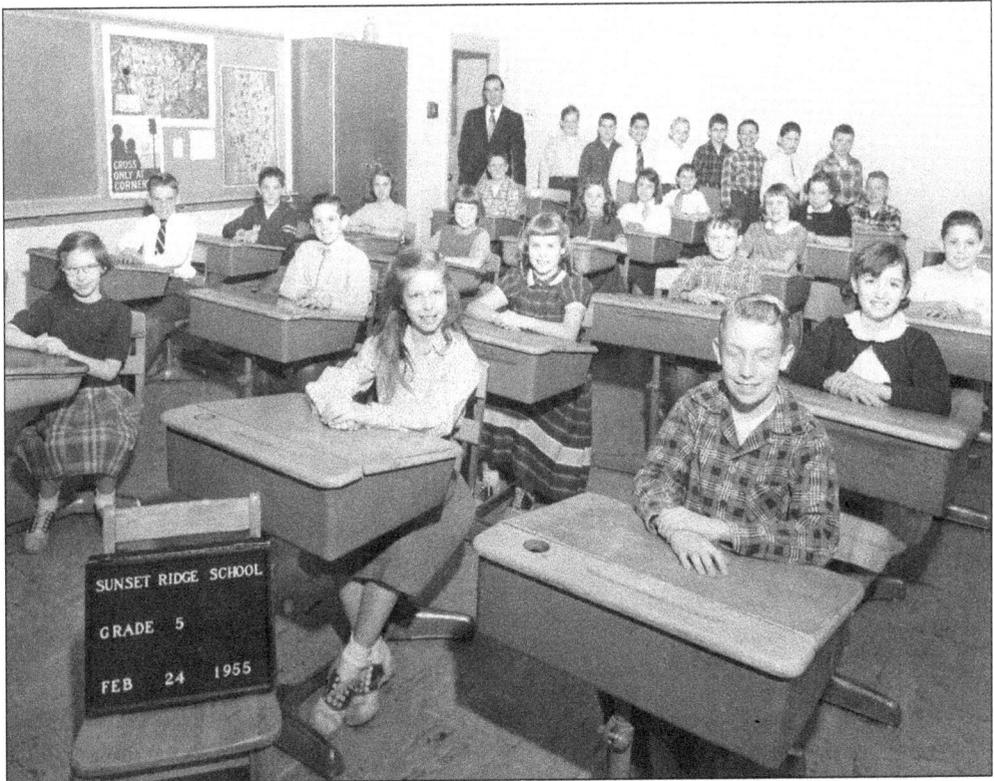

In 1949, Sunset Ridge "took back" its sixth graders, and by 1954, Northfield public school children went to Sunset Ridge until eighth grade. Here the 1955 fifth-grade class, taught by Jim Clarkson, Carol Donnelly, and Nancy Stein, poses for a picture. (Courtesy Northfield Historical Society.)

In the late 1950s, with Sunset Ridge bursting at the seams, Northfield formed a park district and purchased a tract of land that had once belonged to Mrs. Mary Bracktendorf. The land was spliced by the Middle Fork north branch of the Chicago River. The park district would name the land Willow Park. The school district bought 5 acres of the land to build Middlefork School and opened its doors in 1959 to kindergartners, first graders, and second graders. (Courtesy Northfield Historical Society.)

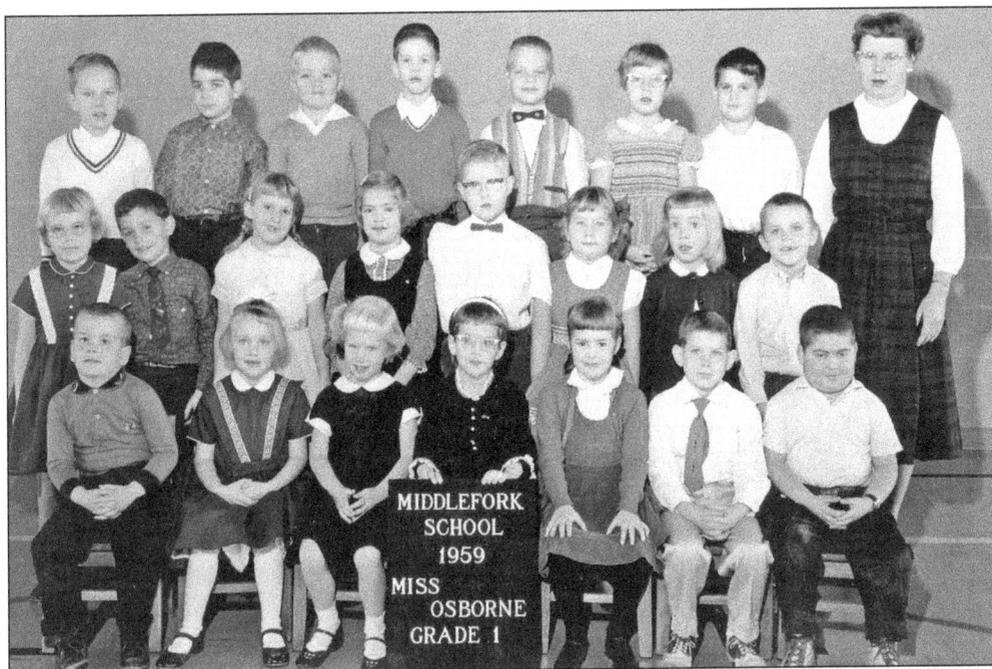

Mary Osborne was named principal of Middlefork, but she continued to teach first grade. Middlefork was a "progressive" school; there were no letter grades given to students, believing the theory that a poor grade would demoralize and discourage a child from trying his or her best to improve. (Courtesy Sunset Ridge School.)

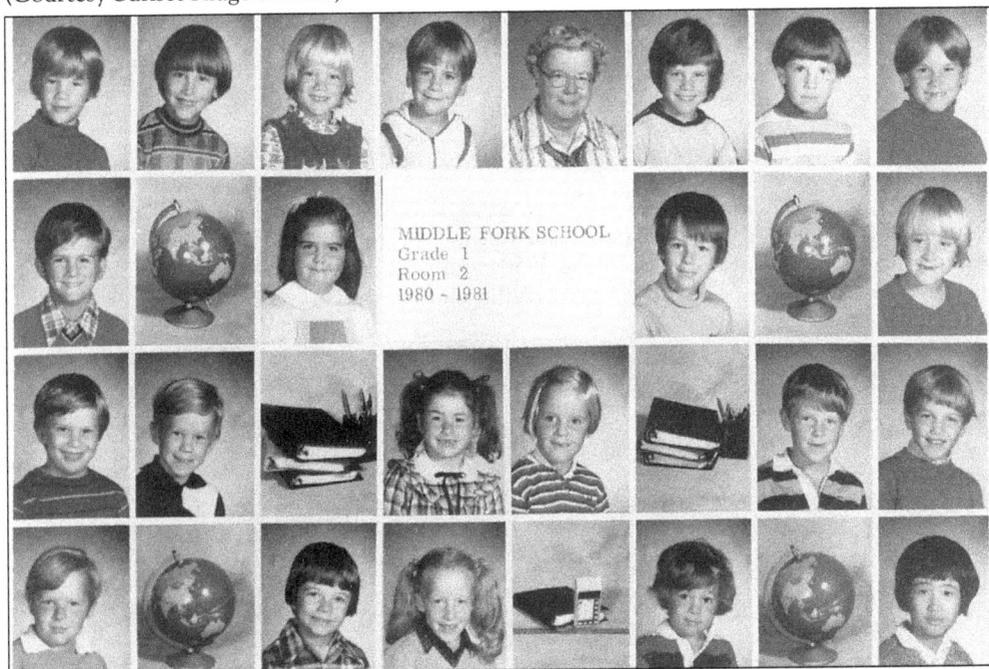

Mary Osborne worked for 40 years in the Northfield Public Schools system. Here is her first-grade class of 1981. In 1984, declining enrollment nearly shuttered the school, but Northfield stayed the course, and today both schools are thriving. (Courtesy Sunset Ridge School.)

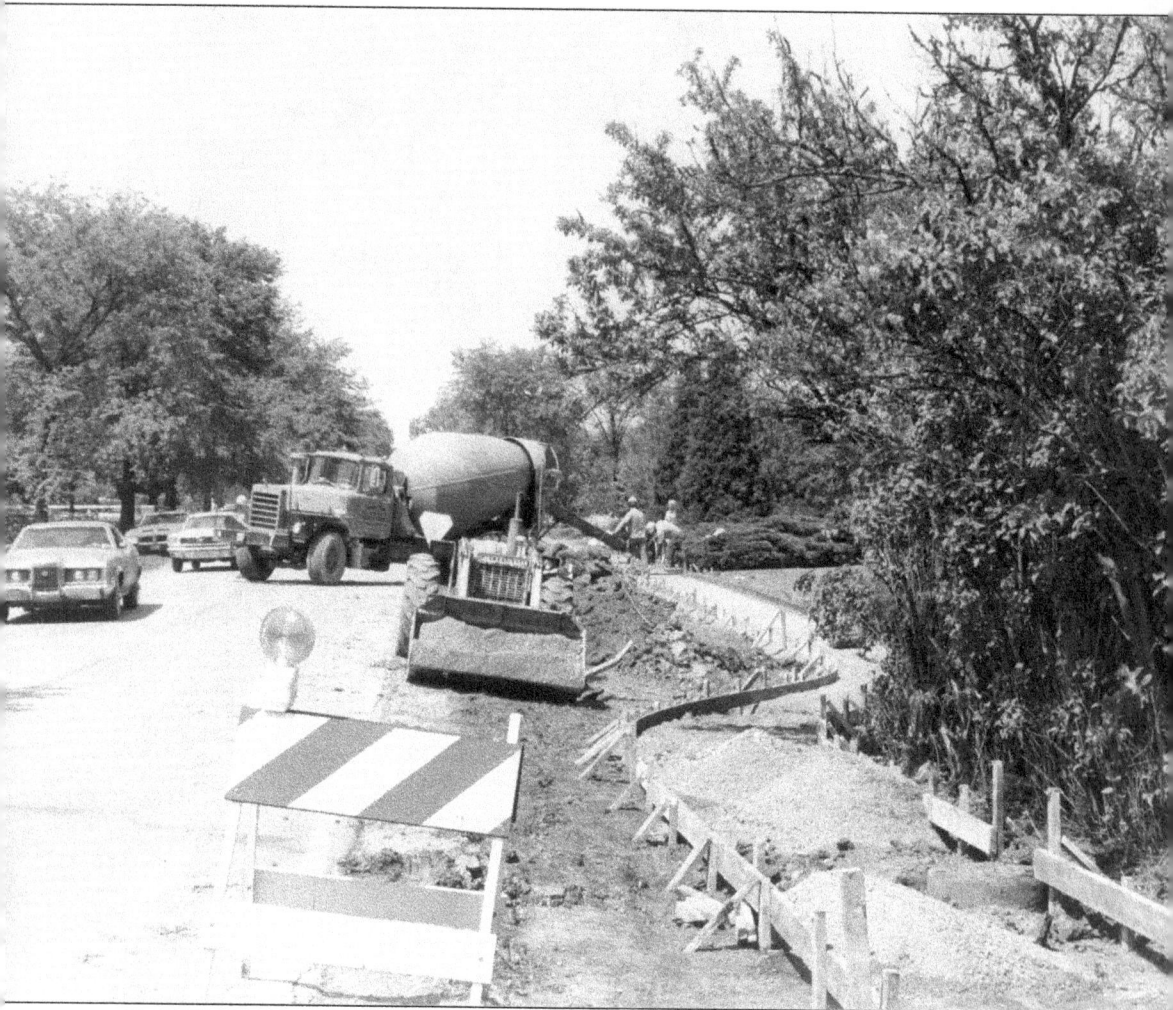

Northfield generally does not have paved sidewalks, but parents were concerned about children walking across busy Willow Road. In the 1950s and early 1960s, the village paved a series of sidewalks around the two schools. (Courtesy Village of Northfield.)

Students on the easternmost side of Northfield are part of the Avoca School District 37, which serves some parts of Wilmette, Glenview, Northfield, and Winnetka. The name Avoca means "a watering spout of knowledge." An even smaller sliver of Northfield is in the Glenview School District 34. Here students from Northfield in 1950 get on the bus to go to Avoca School in nearby Wilmette. (Courtesy Carolyn Collins.)

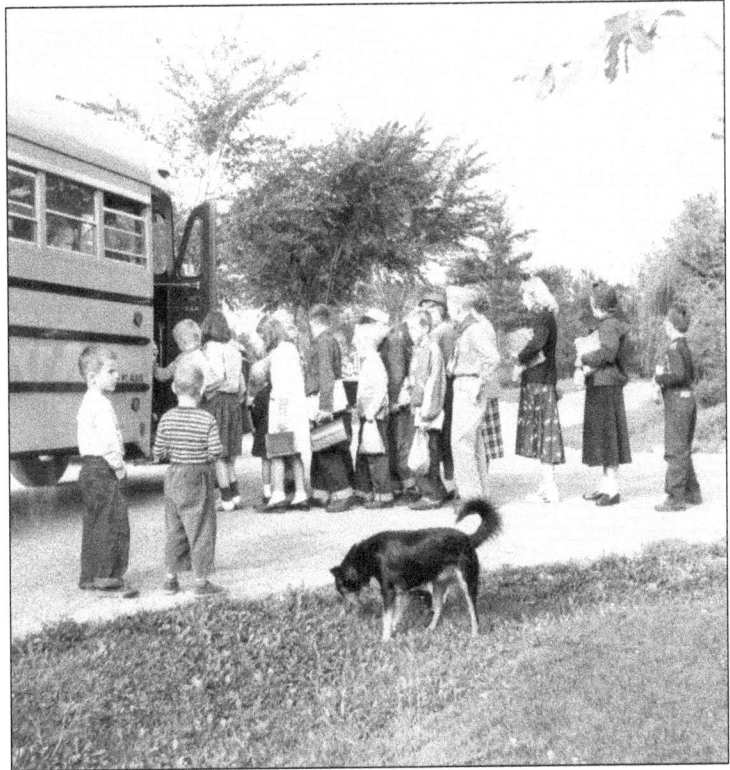

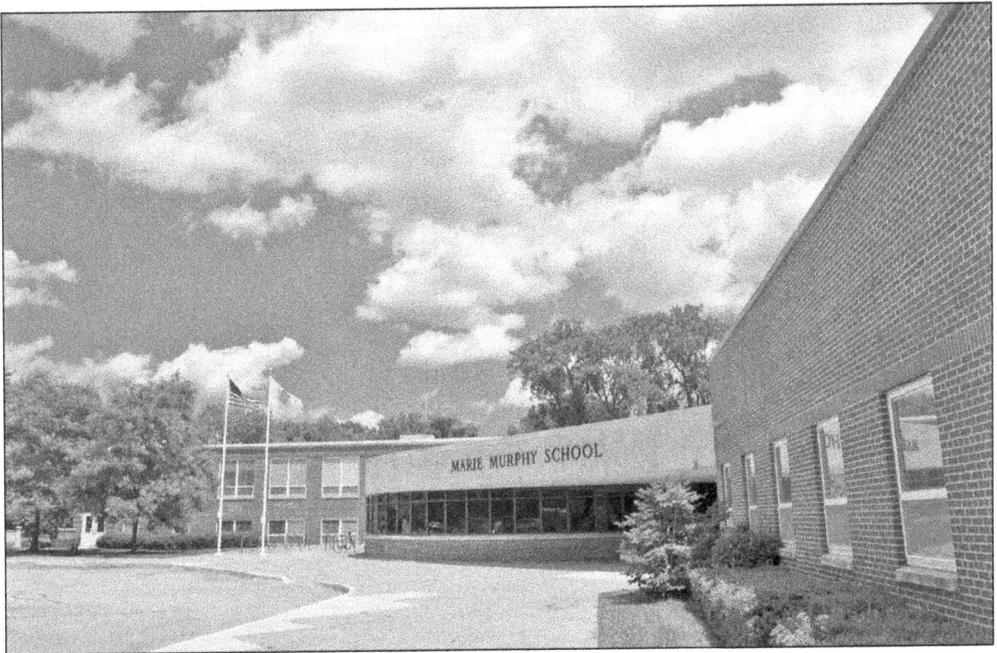

Marie Murphy began her teaching career at the Avoca School District 37 in 1932, retiring as superintendent in 1968. This school was named for her and serves as a middle school. The Avoca West School serves kindergarten through fifth grade. The school district's mission is to "provide an education that maximizes the unique potential of each child." (Courtesy Charles Seymour.)

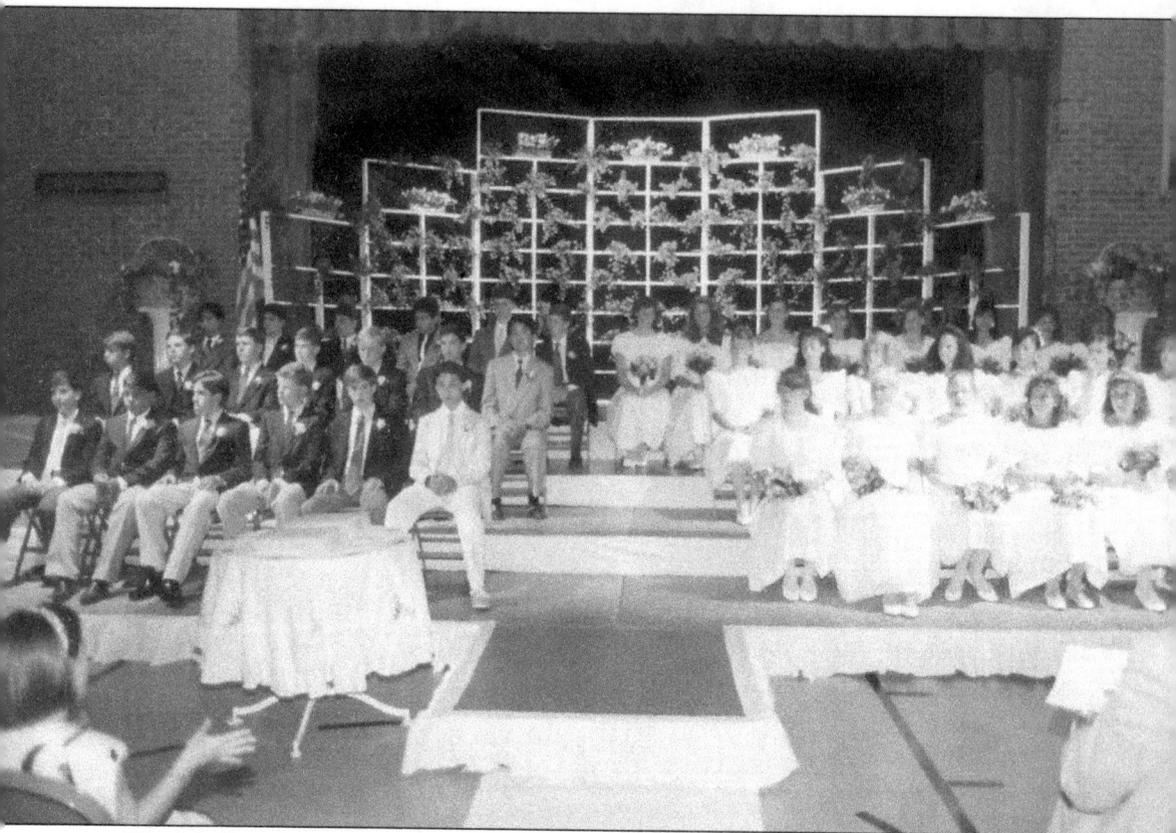

Northfield graduates from the Sunset Ridge School and Avoca go on to New Trier High School. The very small number of Northfield students who live in the Glenview district go to Glenbrook South High School. This photograph shows the 1989 eighth-grade graduation of Sunset Ridge. Most schools on the North Shore of Chicago traditionally ask their students to wear white dresses and formal suits to commencement. (Courtesy Sunset Ridge School.)

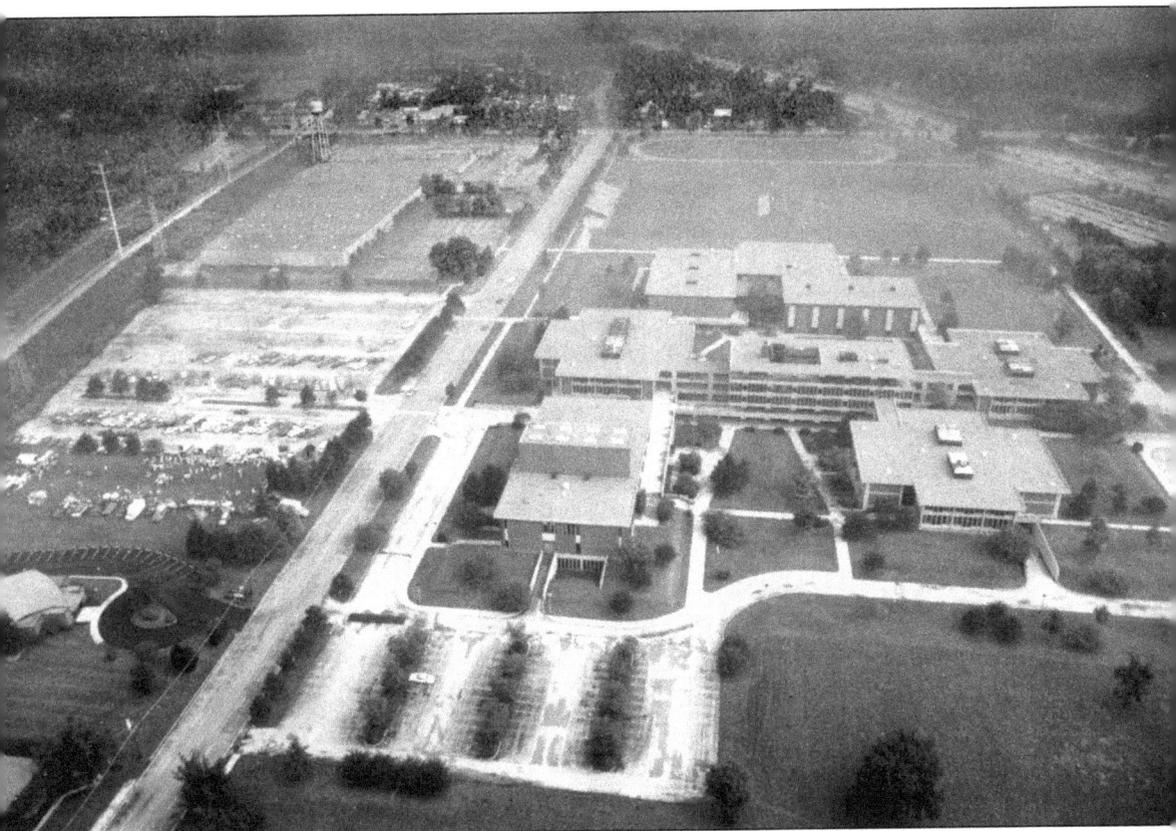

Although New Trier High School originally opened its doors at a campus in Winnetka in 1901, the school district opened a second high school in Northfield in 1965 for freshmen and sophomores. In 1967, New Trier West was designated as a separate four-year high school. The geographic boundaries dividing the district meant that Northfield students attended a school in their own town. The school is seen here from above. On the left are (from top to bottom) the Mystik Tape Company, a parking lot, the Northfield Farmer's Market, and the Am Yisrael Conservative Congregation of the North Shore. Mystik Tape Company would later leave Northfield. (Courtesy Village of Northfield.)

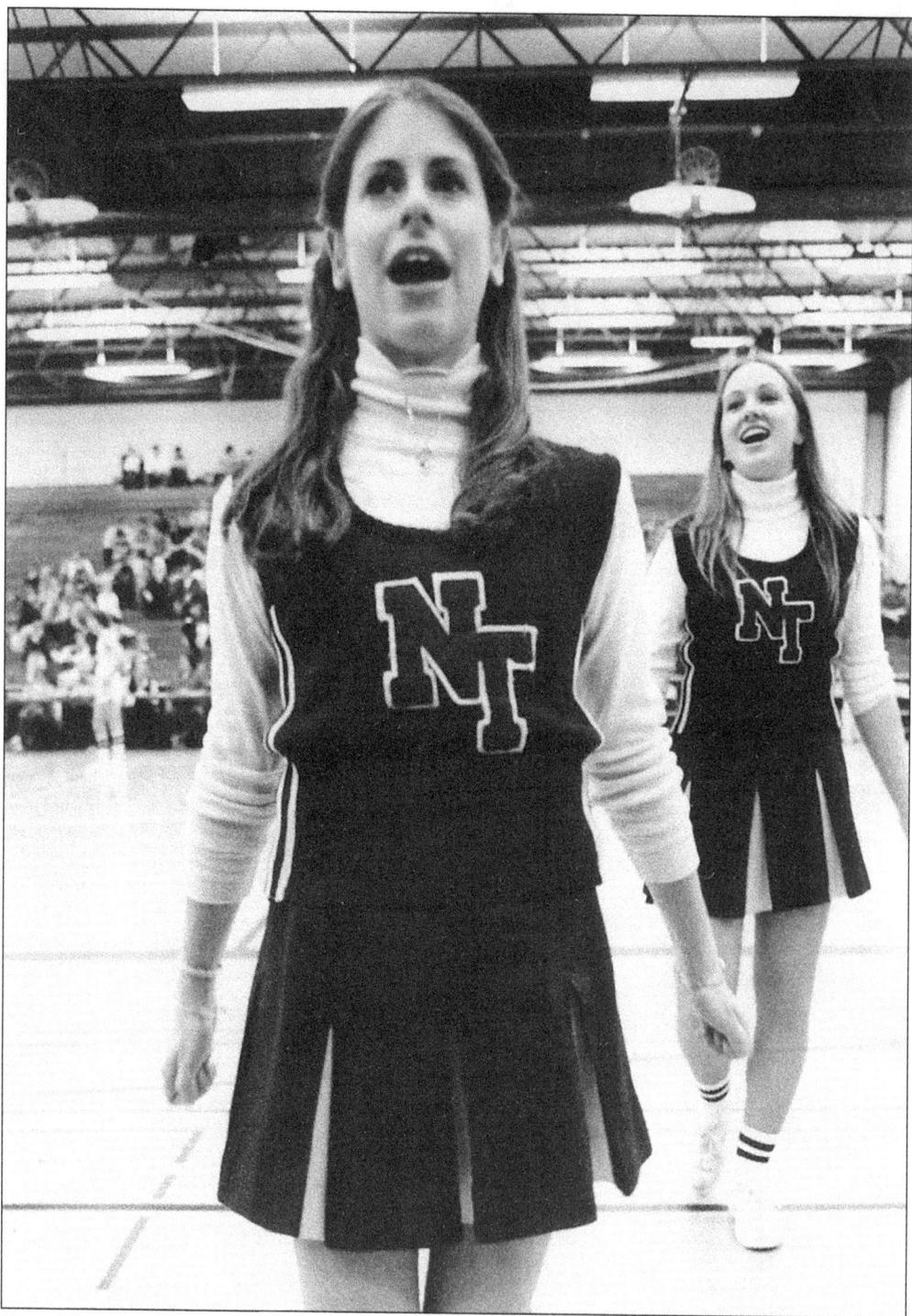

These New Trier West cheerleaders show their school spirit here in 1979. Two years later, enrollment would drop, and the New Trier School Board would decide to use the Northfield campus as a freshman-only campus. In 1985, New Trier West was closed altogether. It was reopened again as a freshman-only campus. (Courtesy Sunset Ridge School.)

New Trier West was created to be like a college campus with interlocking buildings and open courtyards. The campus was perfect for multiple uses, and in the late 1980s parts of New Trier West were rented out for use as a senior center, corporate dormitories, a public swimming pool, and an alternative high school. The campus was also used by director John Hughes for such films as *Ferris Buehler's Day Off* and *The Breakfast Club*. (Courtesy Charles Seymour.)

With enrollment increases, New Trier West opened its doors again to students in 2001 as a freshman-only campus. The New Trier School Board proposed that the two campuses be full four-year campuses with geographical boundaries determining where an individual student would attend. Community opposition was so high that the plan was abandoned, and New Trier West became a freshman-only campus, with all students attending the New Trier East campus for sophomore, junior, and senior years. (Courtesy Charles Seymour.)

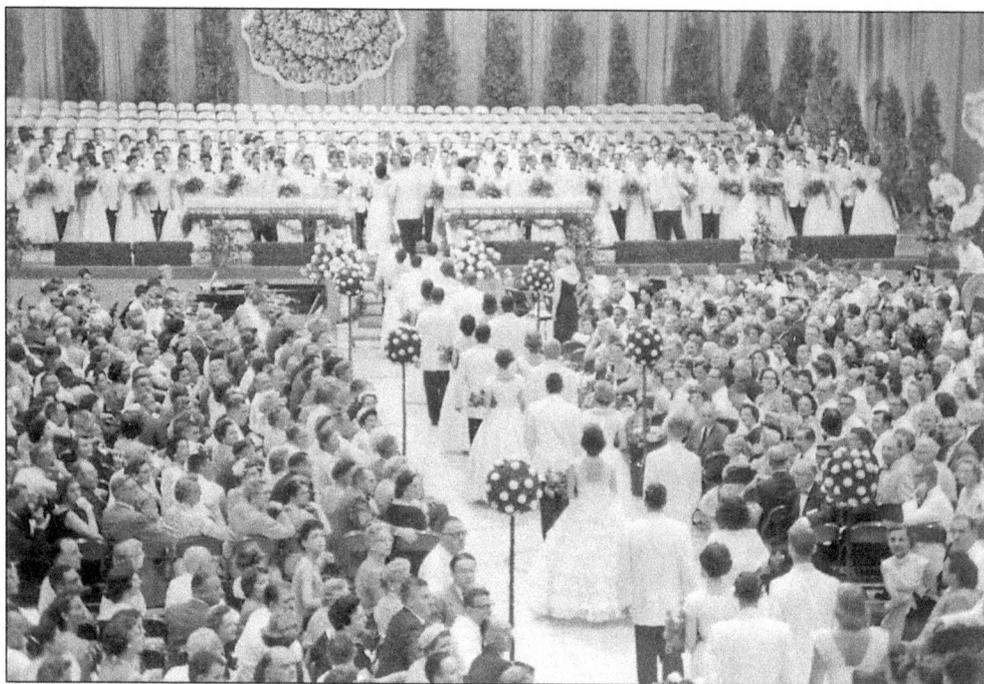

In 1956, students from Wilmette, Winnetka, Glencoe, Kenilworth, and Northfield graduate in a ceremony replete with tradition: young women wear white gowns and carry flowers, while young men wear white tuxedos and sport boutonnieres. The traditional dress continues today. (Courtesy Carolyn Collins.)

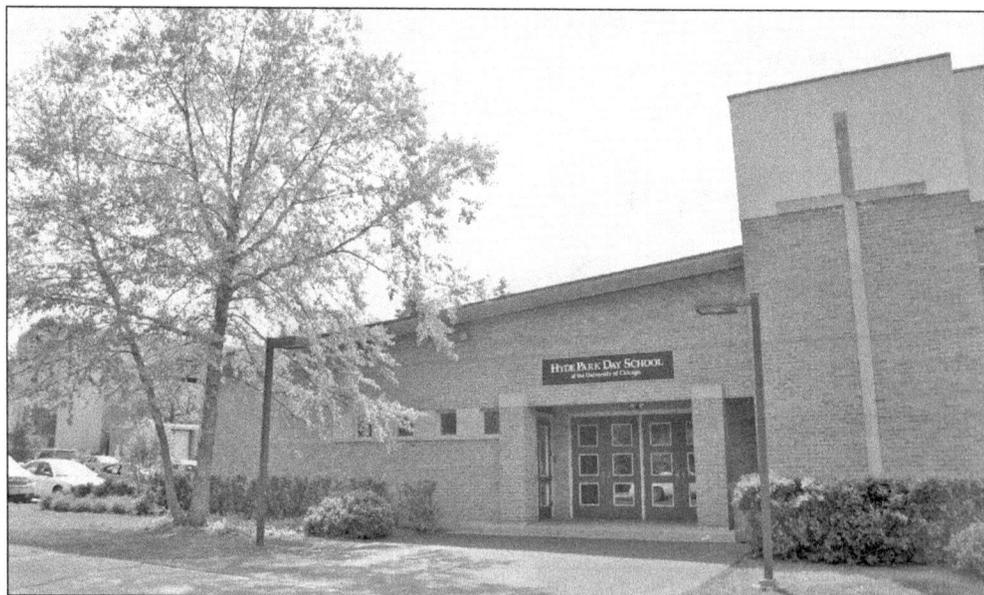

The Hyde Park Day School on Old Willow Road serves students with learning disabilities who are otherwise of average or superior intellectual ability. It is run by the Leslie Shankman School Corporation in association with the University of Chicago. The school building is rented from the St. Philip the Apostle Parish and was the location of St. Philip the Apostle Catholic School, which closed in 2004. (Courtesy Charles Seymour.)

The Glenview Montessori School opened in Northfield in 1991 in what was then the St. Louise de Marillac High School and served children ages three to six. Later Marillac High School merged with Loyola Academy in Wilmette, and the Christian Heritage Academy purchased the building. As Christian Heritage Academy expanded, the Glenview Montessori School moved to a renovated ranch house on the campus, which had been home to the Order of Charity of St. Vincent DePaul, the members of which had taught at Marillac. (Courtesy Carolyn Kambich.)

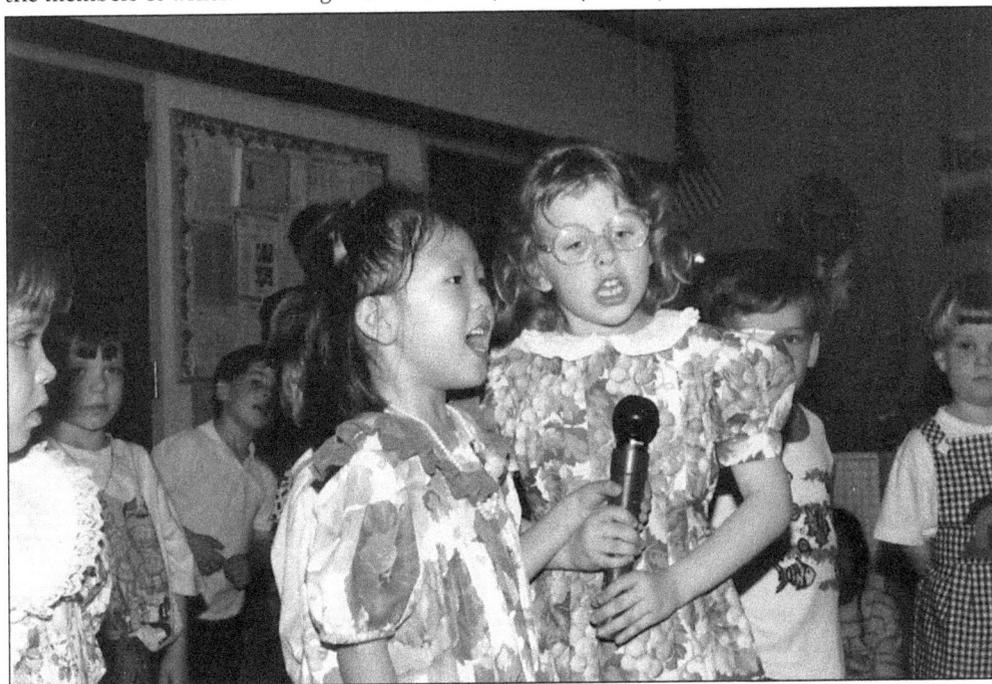

Montessori education emphasizes education for life in an environment with multi-age groupings. Children are encouraged to make decisions for themselves, pursue their own interests, and take responsibility for their activities. Here children present a musical program. (Courtesy Carolyn Kambich.)

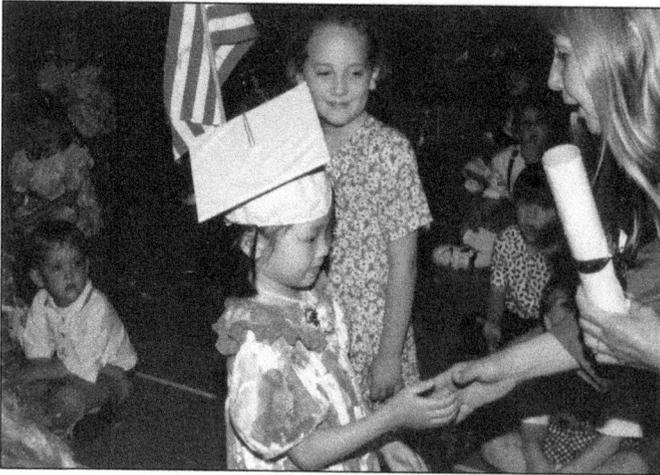

Tony and Carolyn Kambich were early pioneers of the Montessori movement in the Chicago area. Here Carolyn presents a Glenview Montessori graduate with congratulations and a diploma. The Montessori movement in education is an international one, and the Kambichs have been instrumental in the founding of the Victoria Montessori School in Entebbe, Uganda. (Courtesy Carolyn Kambich.)

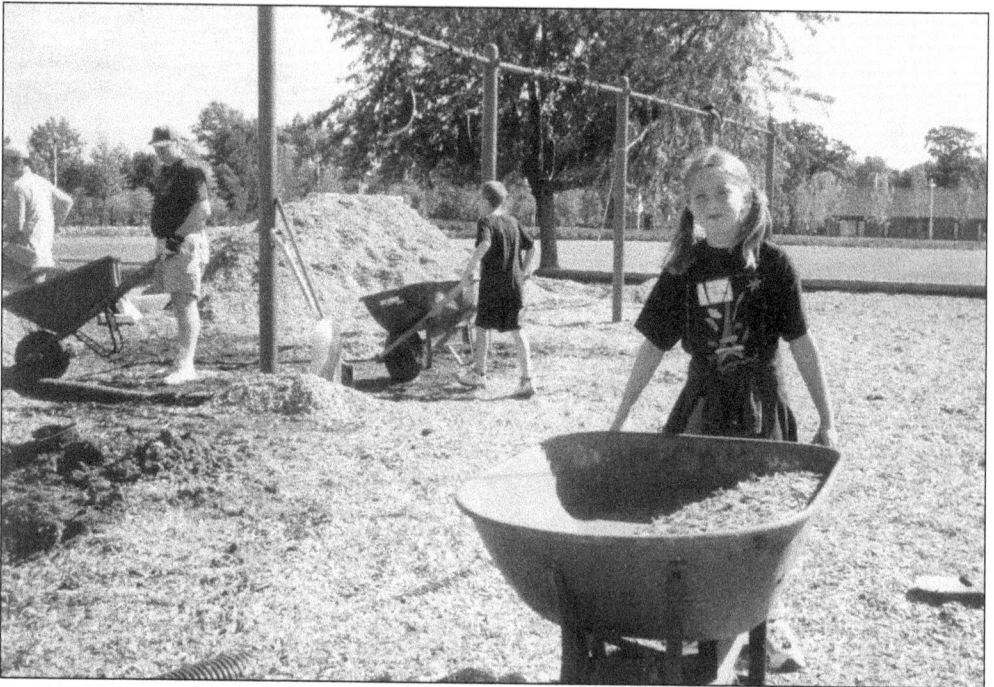

In 1982, five couples came together to pray over the need for a Christian-based education for children in the northern suburbs. In 1984, with 61 students and five faculty members, the Christian Heritage Academy opened in the former Oaklane School in Northbrook. In 1994, with enrollment vastly outpacing the available space, the school moved into what had been the Marillac High School for Catholic girls in Northfield. Here student Anna Guidone helps with the building of the playground. (Courtesy Christian Heritage Academy.)

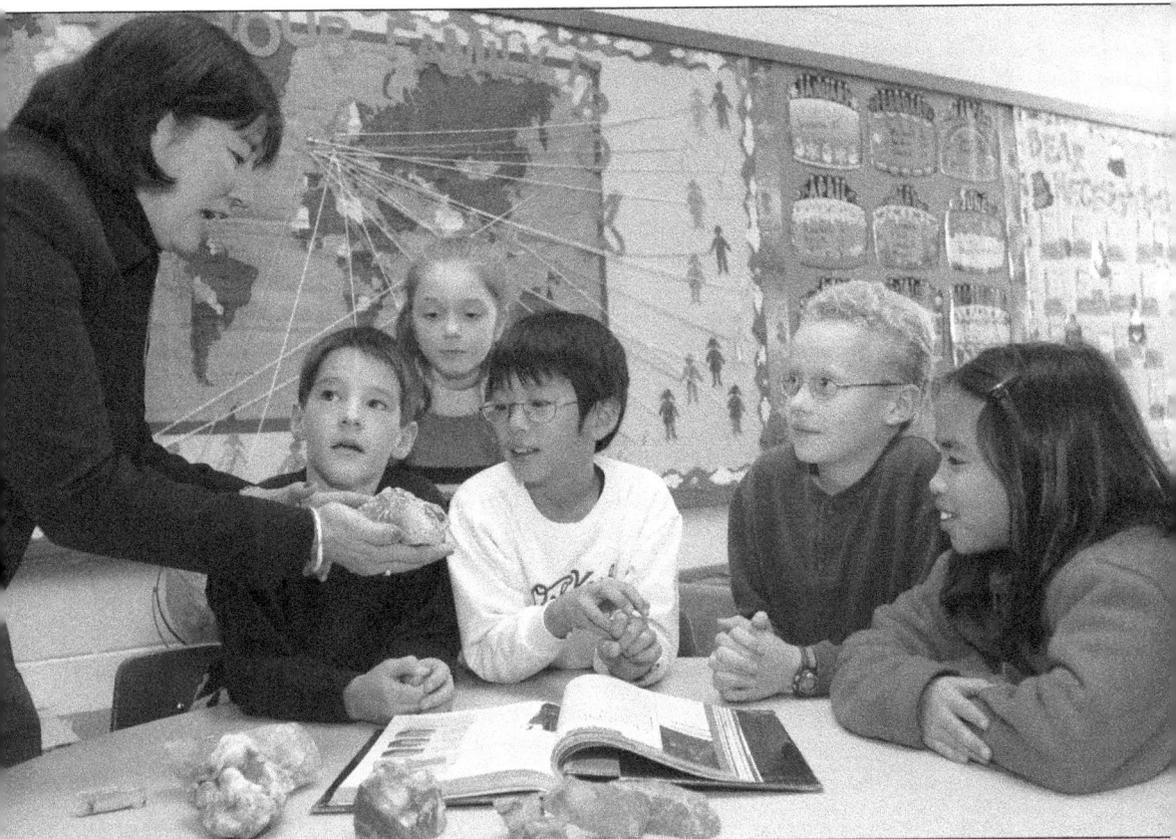

In 2009, Christian Heritage Academy opened an upper school to serve its students, and in 2010, a Chicago campus was opened. The need for a Christian-based education is clear—and the Christian Heritage Academy has provided it. Most of its students at the Northfield campus are from Northfield. Here fourth-grade teacher Joan Okamoto teaches about gems to, from left to right, Michael Barth, Kendall Yoksoulian, Moses Lin, Christopher Vanderkleed, and Faith Doan. (Courtesy Christian Heritage Academy.)

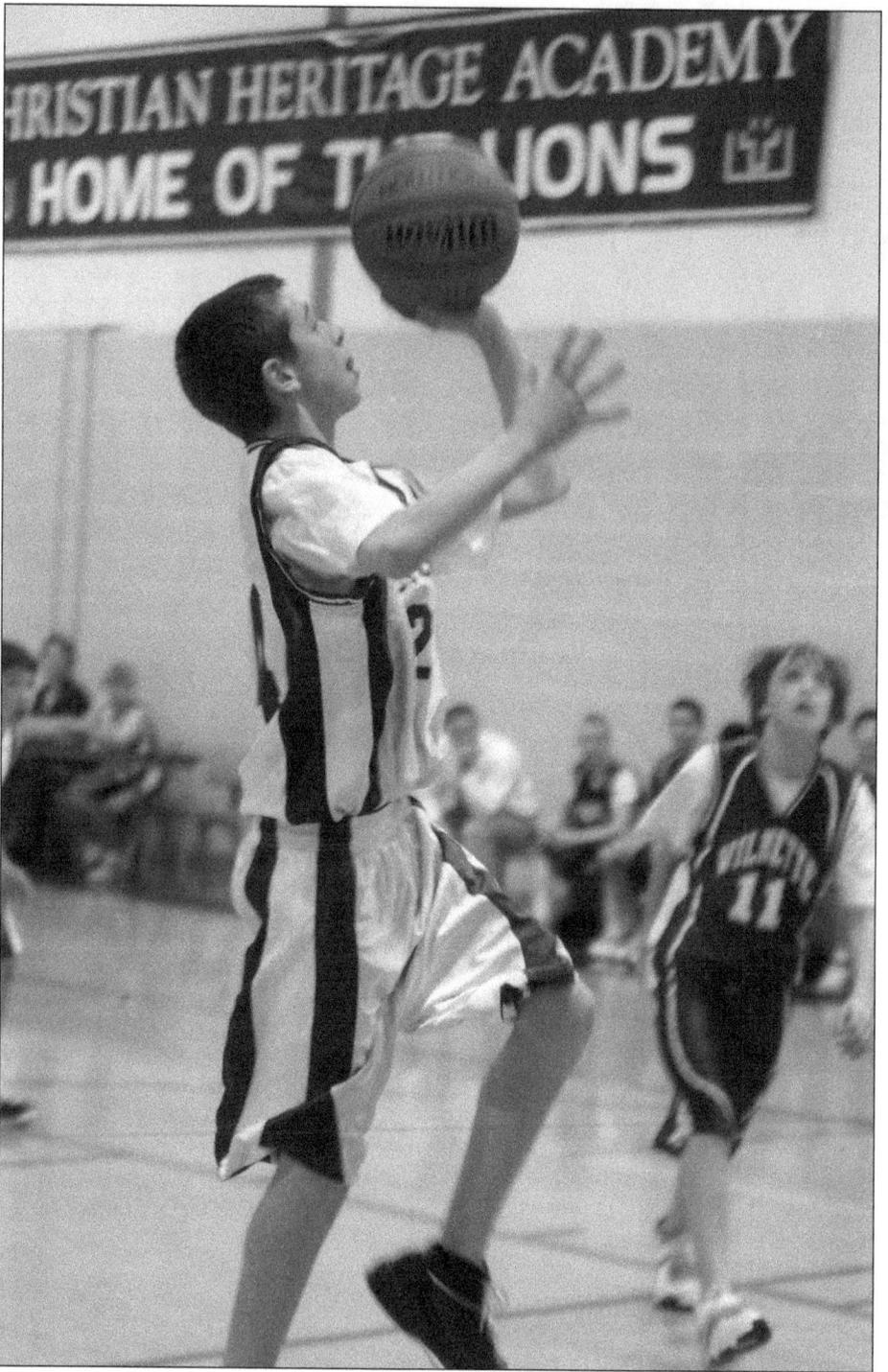

As part of its mission statement, Christian Heritage Academy "offers an exemplary education based on biblical values to children of Christian families, equipping them to be lifetime followers of Jesus Christ." Here eighth grader Paul Jones drives to the hoop in a basketball game against Wilmette. (Courtesy Christian Heritage Academy.)

Three

A Highway
Runs Through It

Northfield was connected to Chicago through a railroad, but after World War II, the economy was so good that most folks owned a car, and taking a car to work was more convenient and liberating than catching a train.

 In response to America's desire to drive, the Edens Expressway opened on December 20, 1951. It was Chicago's first expressway, ultimately three lanes in each direction. Named after William G. Edens, a banker and early advocate of paved roads, the Expressway cut the village into east and west—it changed everything about Northfield.

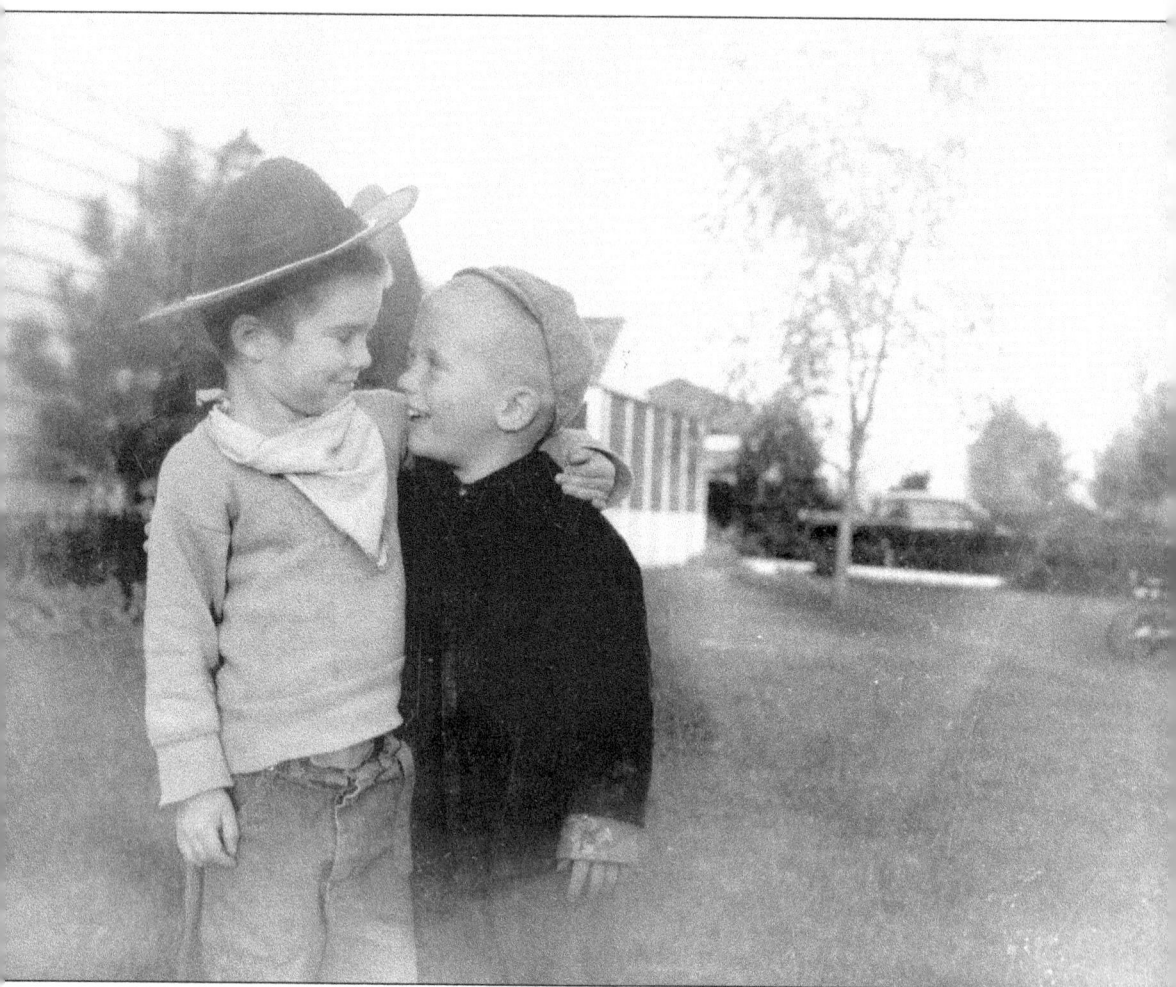

Chris Krueger (left) and Gilbert "Gibby" Watson share a special moment in front of the Krueger home in 1948. Gibby's family would move back East when the boys were in their early teens, but for the moment, it is friends forever. This was a good time to live in Northfield; World War II was over and fathers were returning home, the economy was roaring to life, and the community was at ease. But with the good times there was a challenge facing Northfield. (Courtesy Carolyn Collins.)

Henry Happ holds Rosalie in his arms while Therese Anne stands by. In the window, a message for the iceman: each customer had a card with the numbers 25 and 50 on one side, and 75 and 100 on the other. The customer placed the card on the window so that the iceman could see it from the street and would know how much ice to take out of his truck in order to fill up the family icebox. In this picture, the Happs signal that they need 50 pounds of ice because the "50" is right side up, facing the street. (Courtesy Therese Anne Happ Selzer.)

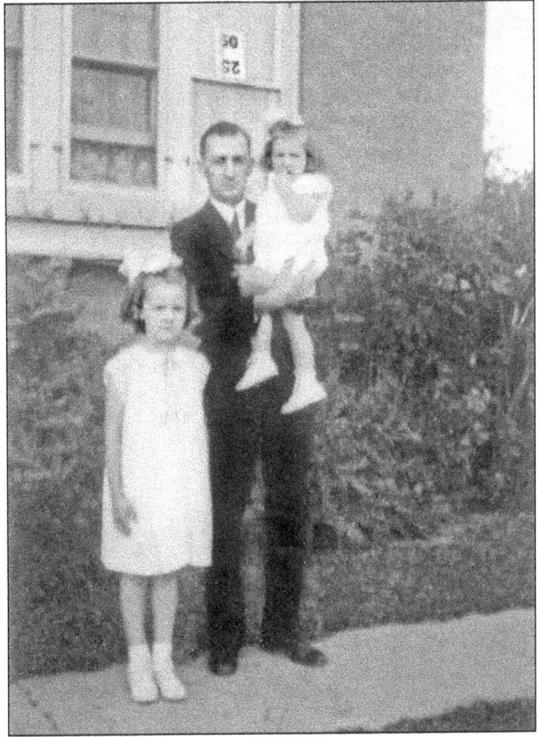

Caroline Krueger and her brothers Chris and Ken are out sledding near Snook Brook in the winter of 1948. Parents in Northfield had no worries about sending their children out to play without supervision. Soon there would be changes in Northfield that would alter parents' attitudes. (Courtesy Carolyn Collins.)

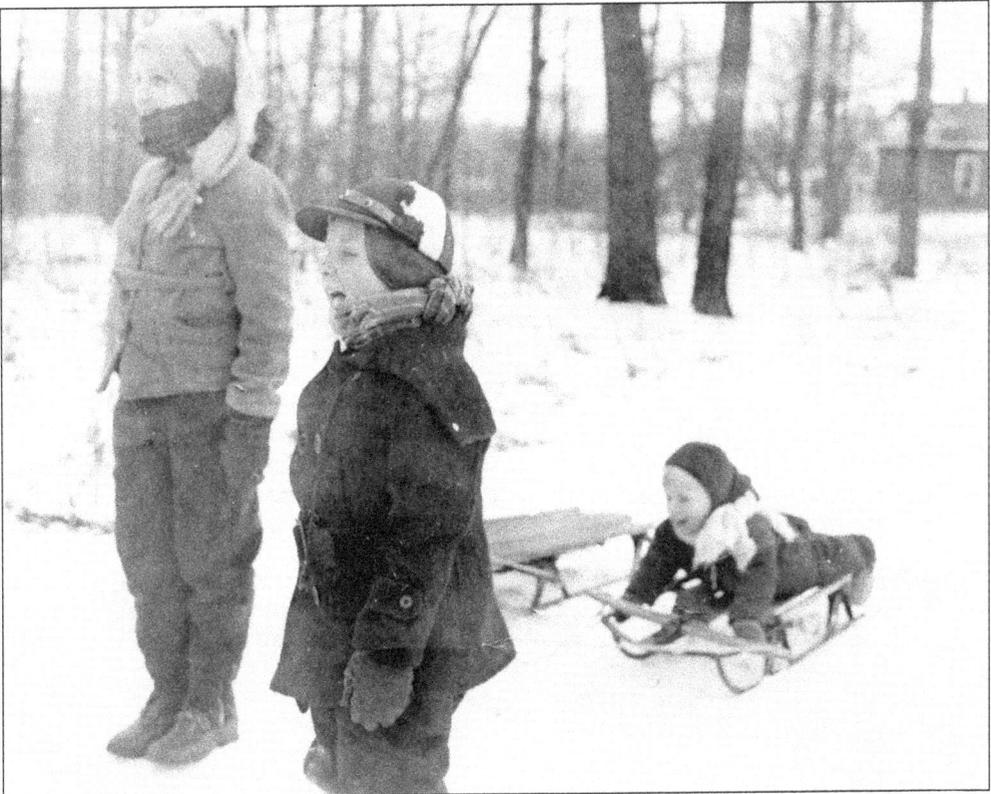

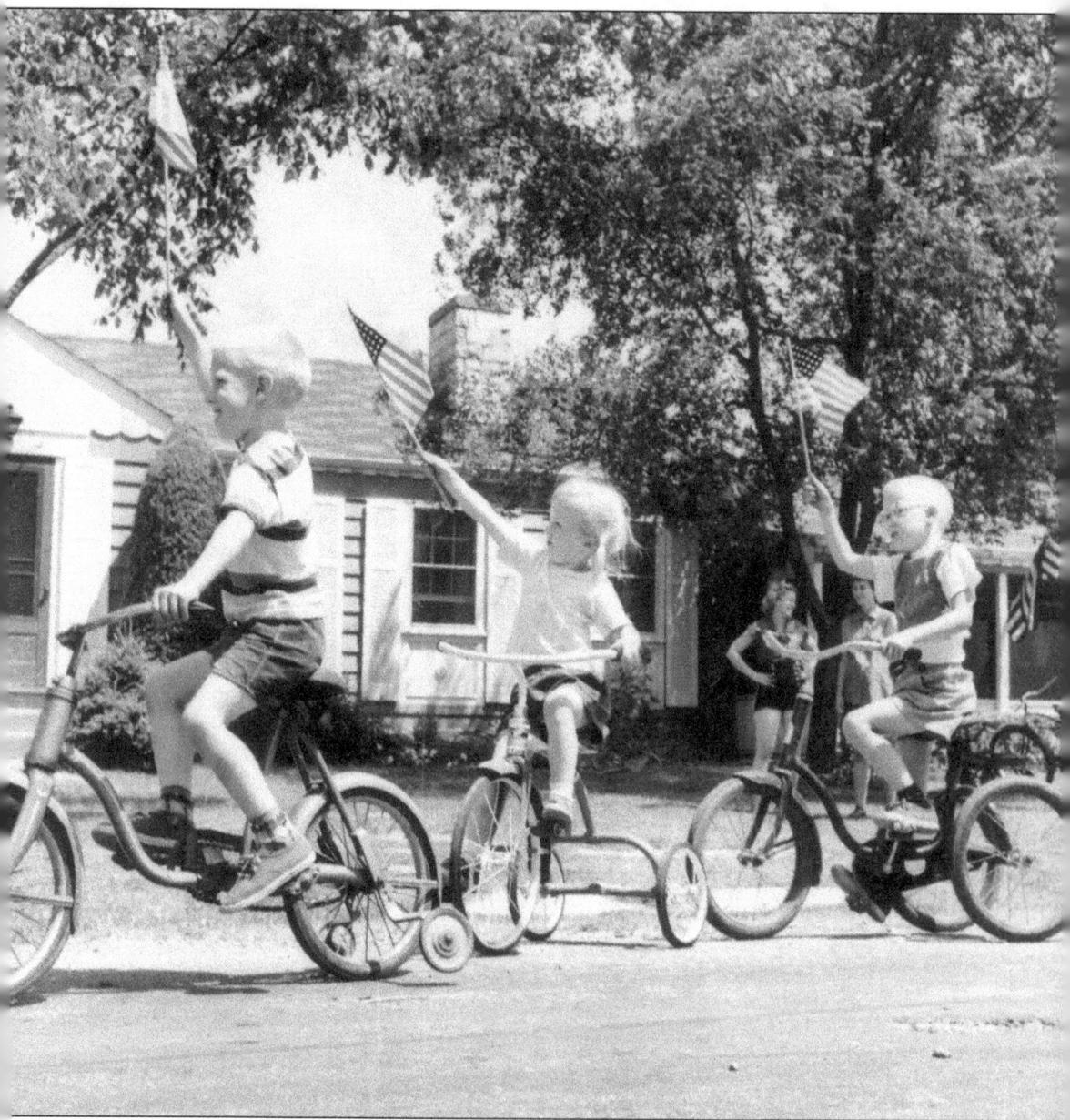

As far back as anybody can remember, the Village of Northfield has sponsored a children's bicycle parade on the Fourth of July, which is followed by a picnic in what is now Centennial Park. Here some children are on their way to the parade lineup. Note the first boy has training wheels, the girl has a traditional tricycle, and the boy behind her has a very large tricycle. (Courtesy Carolyn Collins.)

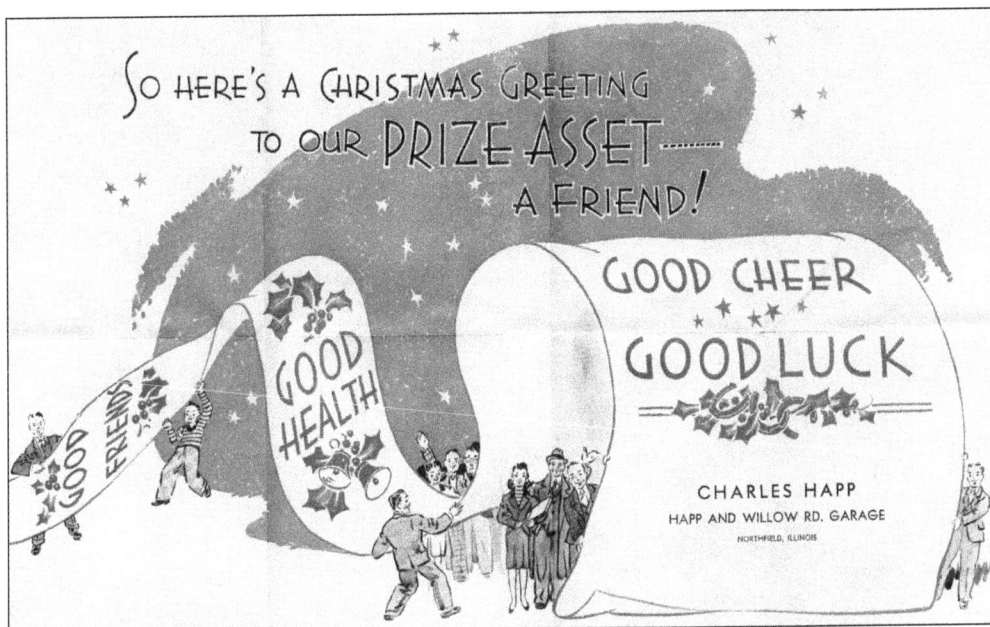

Charles Happ, owner of Happ's garage and gas station, sent out a Christmas card to all his customers in 1948. While the card states Happ's garage was at the corner of Willow and Happ Roads, it actually was on the corner of what is now Old Willow Road and Earl Road, just east of Happ Road. Plans are taking shape for the Edens Expressway, which would become the first expressway in Chicago, and the "new" Willow Road has been built, splitting the town into four quadrants. (Courtesy Village of Northfield.)

Charles Happ sold the station to Rex Kinsey that very year. The Edens Expressway would open in 1951 and have exit and entrance ramps on Willow Road. The population of Northfield exploded. In 1930, the population of Northfield was just 320, but by 1960, that number had risen to 4,005. Kinsey would have been hard-pressed to be able to send out Christmas cards to all of his customers. (Courtesy Northfield Historical Society.)

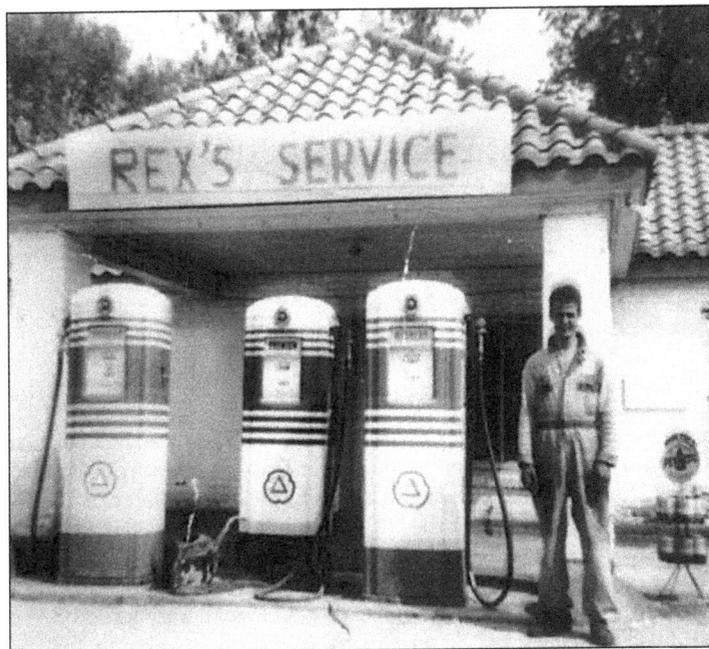

Clarence Seul owned a tavern on Tower Road that was the center of town life. It was moved as it was directly in the path of the Edens Expressway. Clarence and Bee Seul married on the very day—June 22, 1949—that the "new" Seul's tavern opened next to what would become the Edens Expressway at 1735 Orchard Lane. Here the happy couple arrives at the tavern for their wedding reception and grand opening. The Seuls had five children—Linda, Mary, Patrick, Charlie, and Mike—all of whom worked at the tavern. Clarence was mentored in the business by Al Levernier, who had purchased the Selzer Tavern. (Courtesy Seul family.)

Clarence and Bee Seul were part of the St. Philip's Parish, and Clarence was a member of the Lions Club. He sponsored the Veterans of Foreign Wars chapter in the basement of his tavern. Bee was a formidable and wonderful mother to her children. Every one of the Seuls' children worked at the tavern at one time or another. (Courtesy Therese Anne Happ Selzer.)

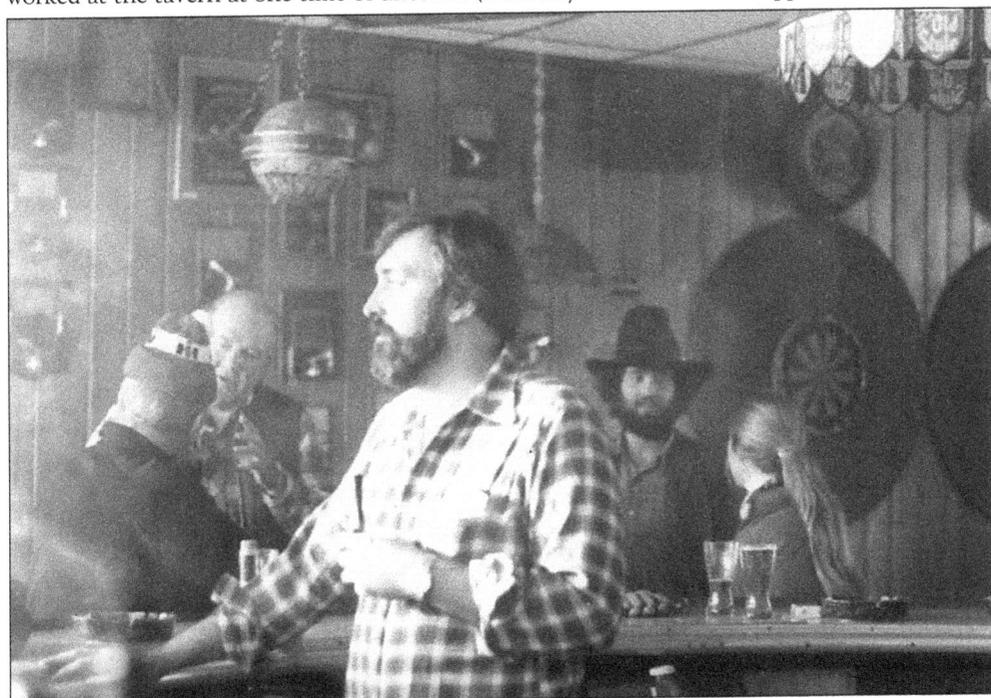

Many Northfield residents remember when Henry "Heinie" Happ worked as a bartender at Seul's as his last career. Here Dan Spence, Clarence Seul's sister's son, tends bar during the mid-1970s. Clarence died in 1994, and the Seul children sold the business to the Monckton family who has honored the family by keeping the name of the tavern. Bee Seul died in August 2008. (Courtesy Therese Anne Happ Selzer.)

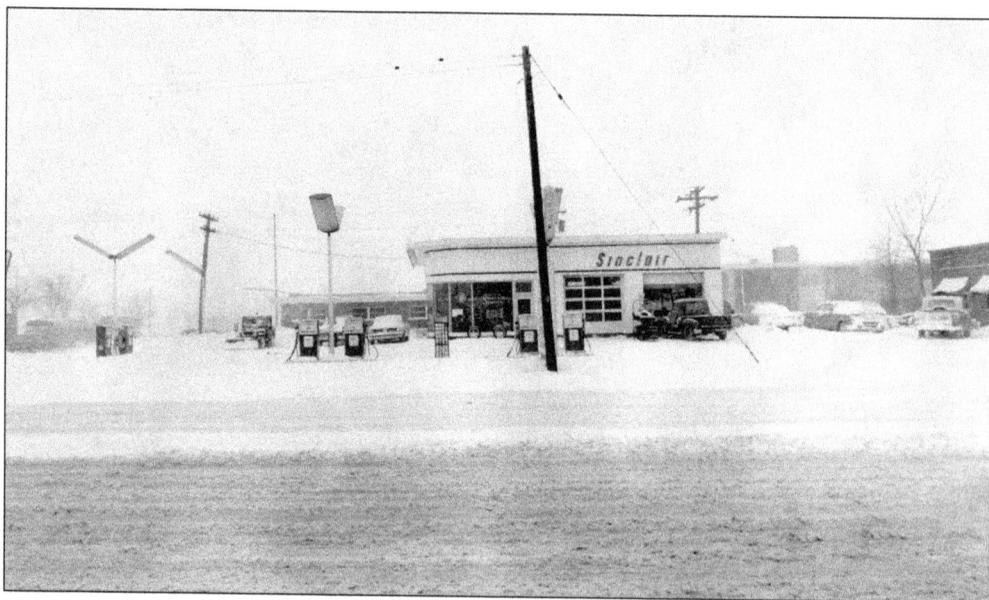

The Sinclair station opened up in order to service the many customers from Willow Road and from the Edens Expressway. Northfield residents were wary but generally regarded the Edens Expressway as a good thing, making commuting to the city easier. (Courtesy Village of Northfield.)

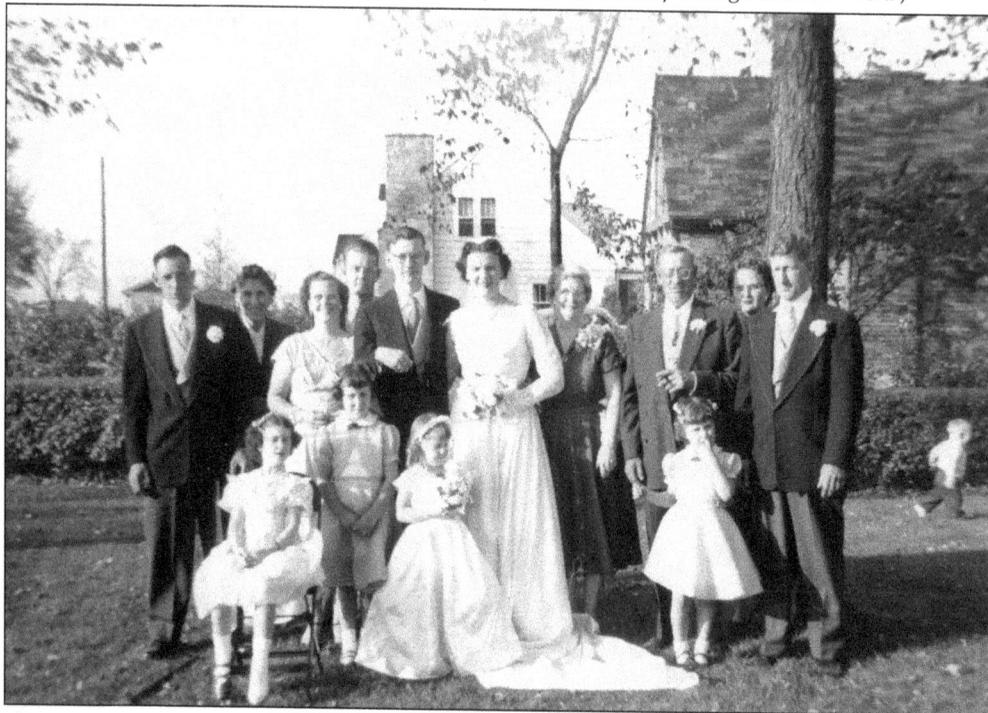

And yet, even with the changes brought about by the Edens and the influx of traffic, Northfield residents tried to keep their small-town values and attitudes. Here Therese Anne Happ poses on her and accountant Frank Selzer's wedding day in 1953. They are surrounded by Happs and Selzers for this formal portrait, although one young wedding guest has made his escape. (Courtesy Therese Anne Happ Selzer.)

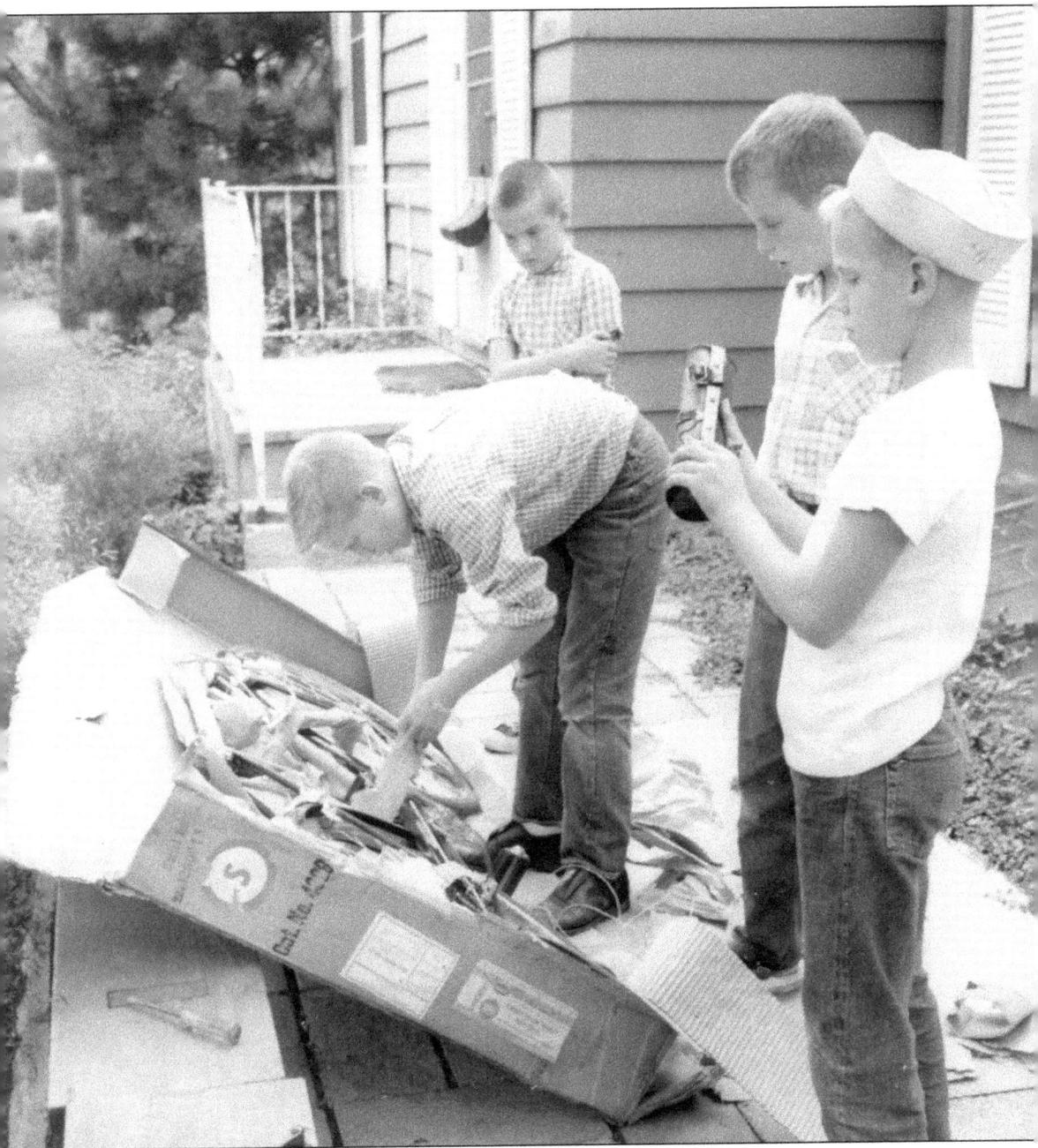

School is out, and that means it is time for bike riding. In this 1956 photograph, Chris Krueger has opened the delivery box, and his buddies are ready to help him assemble a new bicycle. They will be ready for the Fourth of July parade, but they will have to cross Edens Expressway at either the Willow Road or Winnetka Avenue overpass in order to participate. (Courtesy Carolyn Collins.)

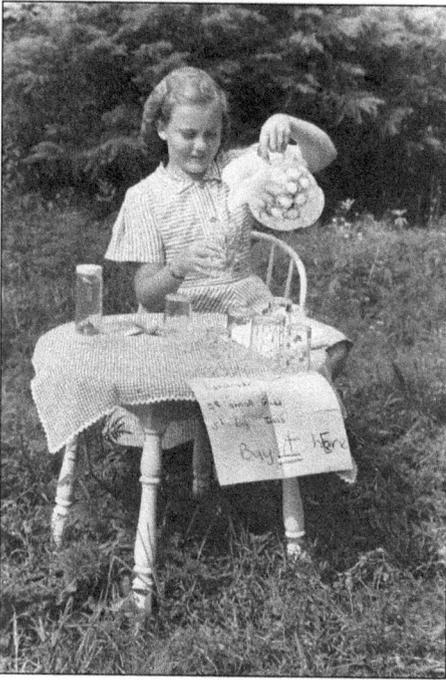

Northfield prices for lemonade remained stable during the 1950s. Here a young entrepreneur offers small glasses for 2¢ and large for just 5¢. She exhorts potential customers with "Buy it here!" (Courtesy Northfield Historical Society.)

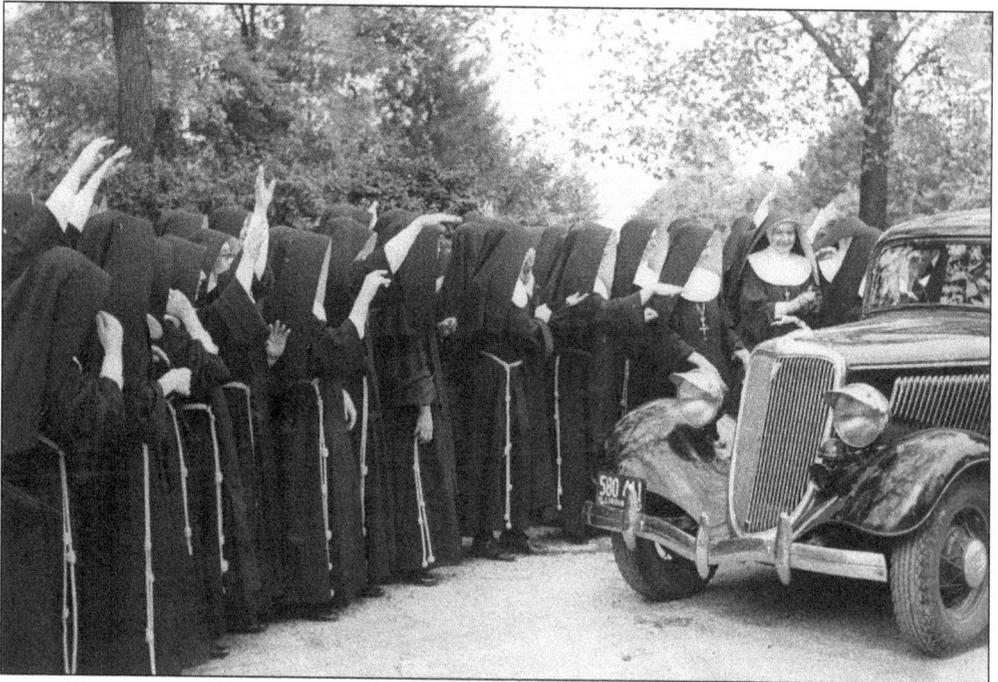

Unlike lemonade, real estate prices rise rapidly, and the Holy Spirit Missionary Sisters had the resources to send sisters to far-flung parts of the globe. They would work as teachers and nurses, sharing the good news of Christ's love. A particular focus of their work was in the South, setting up schools for African Americans in an atmosphere that predated the civil rights movement. Here sisters gather to say goodbye to a sister leaving on a mission. (Courtesy Holy Spirit Missionary Sisters.)

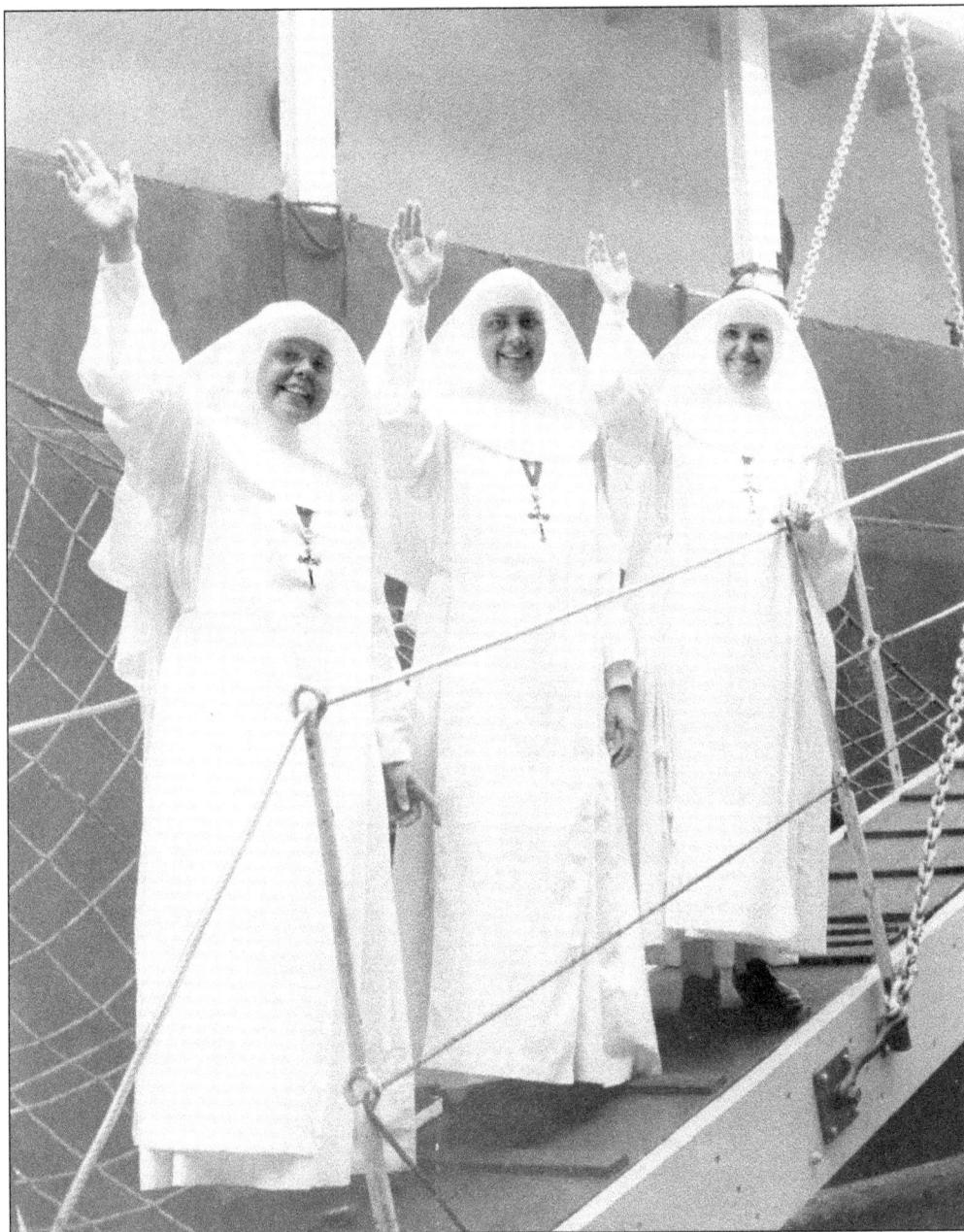

In 1960, Sr. DePassi, Sr. Mary Joseph, and Sr. Mary Catherine leave for their mission to Africa. The sisters wore white habits in the summer or when on a mission in a tropical climate. The exception, of course, is that white habits were never worn on missions to China or Japan, where white is considered the color of mourning. (Courtesy Holy Spirit Missionary Sisters.)

The Happ family picnic of 1960 brought together Happ, Straub, Reinwald, Selzer, and Enright family members. The 1960s would prove to be a time of great change for the little town of Northfield. To the west and north, new suburbs were burgeoning, and the fastest way to get home from the Chicago was the Edens, getting off at the Willow Road exit. Traffic was choking Northfield. (Courtesy Therese Anne Happ Selzer.)

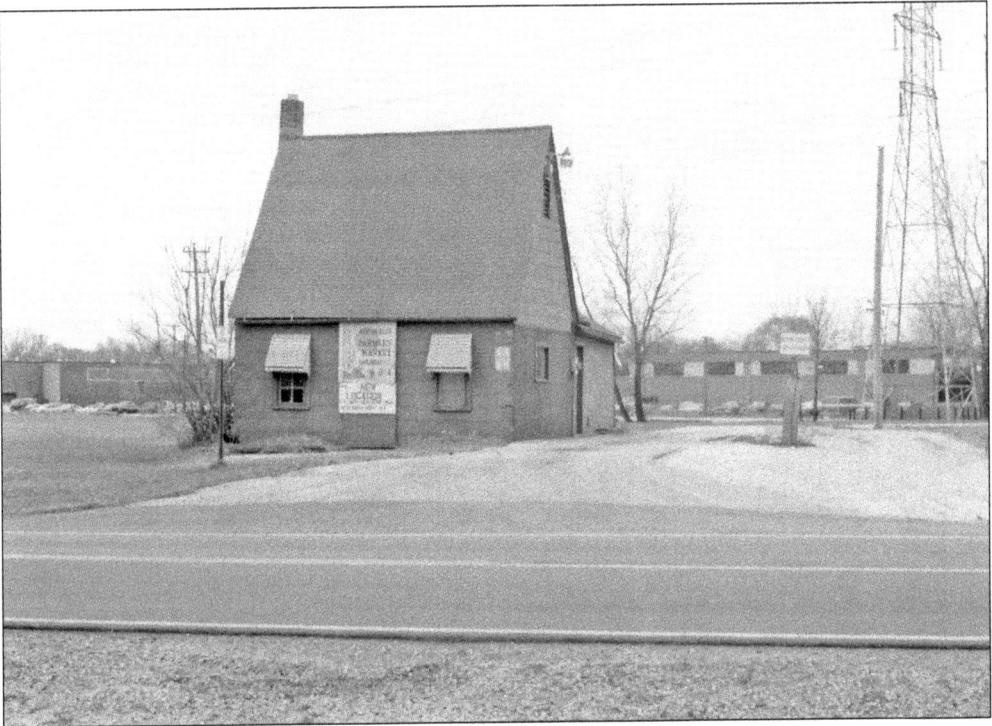

The commuter rail service was discontinued in 1963. However, freight rail traffic continued through the 1970s, even as trucks became a cheaper way to bring goods to market. The Northfield Police Department used the Northfield Scale House to weigh the many trucks that used the Edens Expressway. Pictured here in 1974, the Scale House was located on Happ Road just south of Willow Road. It was torn down to make room for a strip mall in the early 1980s. (Courtesy Village of Northfield.)

Stations along the tracks have been converted to other uses or torn down. In some communities, the tracks have been removed, but Northfield still has remnants of the Insull dream. The tracks were used for freight traffic for a number of years. (Courtesy Charles Seymour.)

It is unclear whether commuting by train or by car is more convenient. At morning and evening rush hour, the Edens Expressway slows to a frustrating crawl, and the Willow Road exit is seen as a gateway to the northwest suburbs. Willow Road is a two-lane street through Northfield, and the town and the Illinois Department of Transportation have been at odds over whether to expand Willow Road to four lanes. (Courtesy Charles Seymour.)

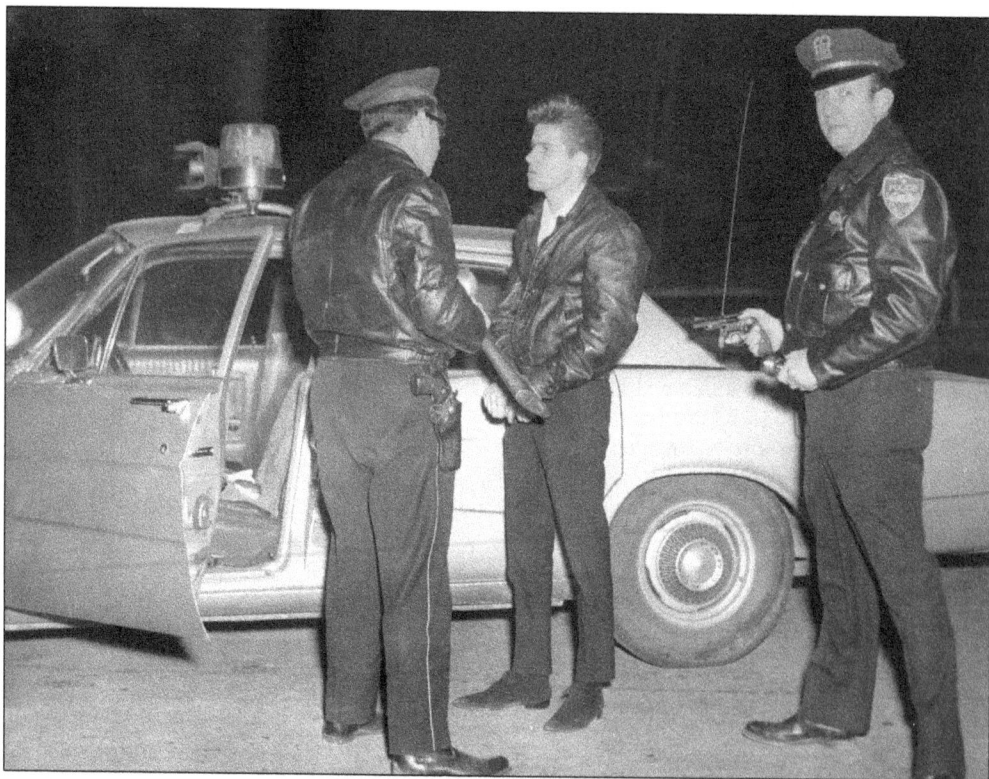

With easy getaway possibilities onto the Edens Expressway and exploding population growth, crime started to rise. On Christmas Eve in 1965, Northfield police noticed that someone other than Santa Claus was on the prowl. Des Plaines resident Richard Wood, age 21, broke into the Northfield Foods store on Willow Road. Pictured here from left to right are patrolman Donald Lantz (later deputy chief), suspect Richard Wood, and officer Richard D. Klatzco (later chief). (Courtesy Northfield Police Department.)

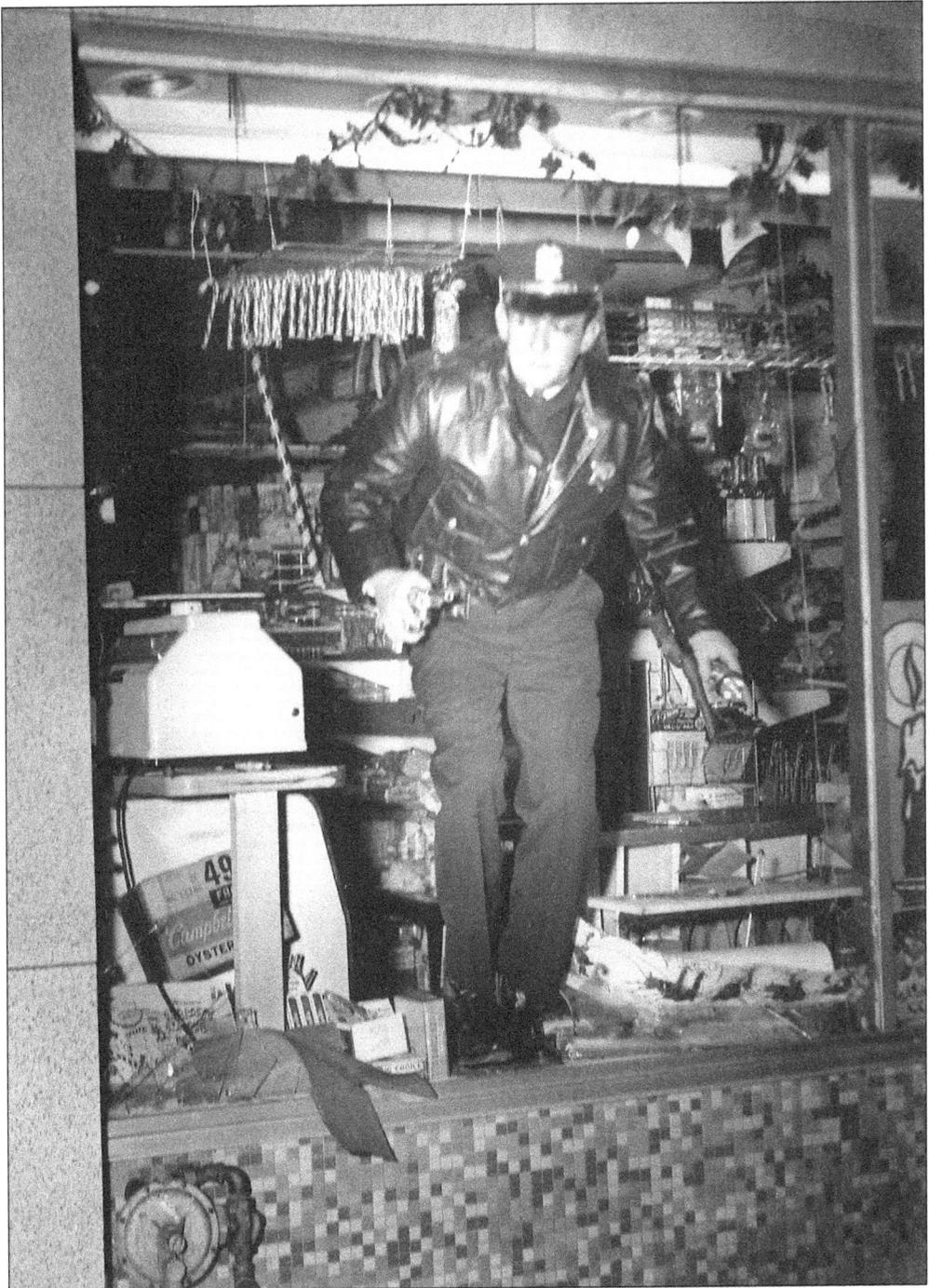

Officer Richard D. Klatzco climbs out of the window of Northfield Foods after apprehending the "Santa Claus Burglar" on Christmas Evein 1965. The store later became Reagan Meats and was located just east of the Edens. (Courtesy Northfield Police Department.)

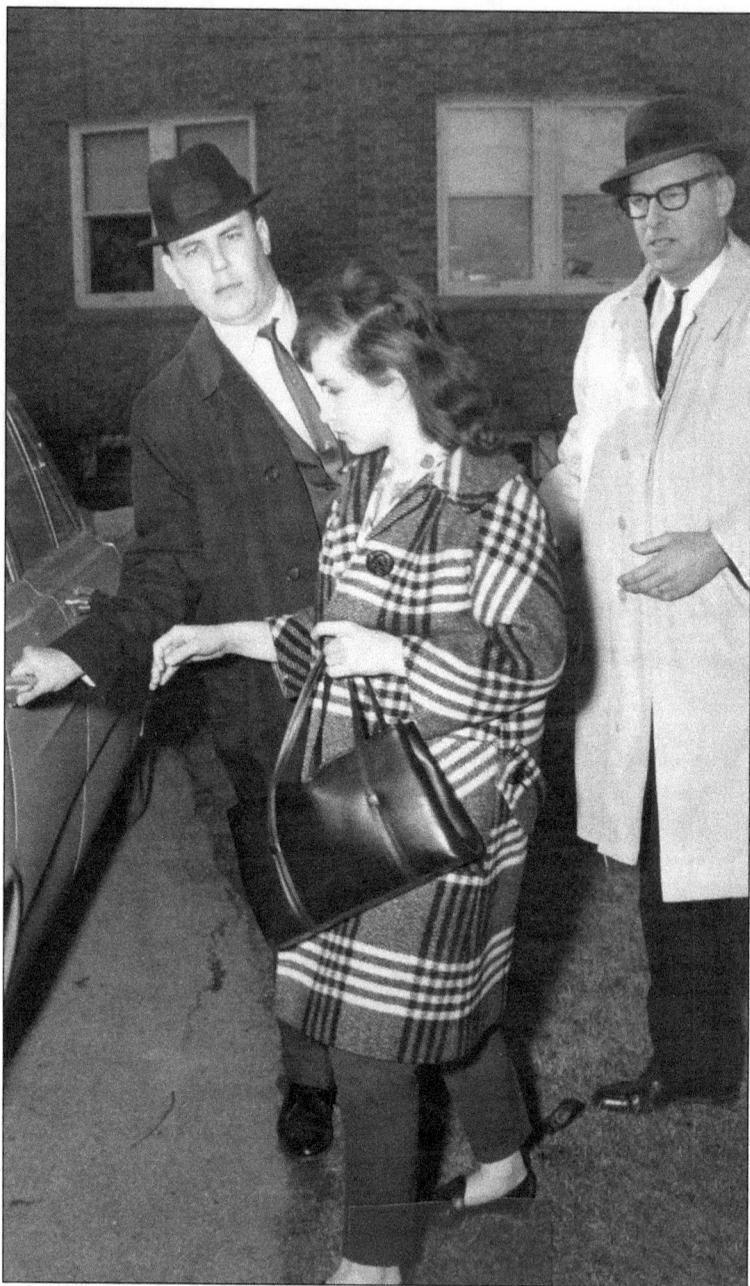

In January 1966, a three-month burglary spree was brought to an end by the cooperation of Northfield, Northbrook, and Wilmette police. Eva Zubris, a 19-year-old mother of two infant daughters, was arrested by Northfield police along with James Smith, age 22, after police found furs, cash, jewelry, bonds, and silverware in Zubris's apartment. She had recently lost her job as a solderer, and she said she wanted money to purchase Christmas presents. Zubris, Smith, and a third conspirator, 20-year-old Robert McLeod, cruised the northern suburbs looking for homes to burglarize. They were able to get into and out of towns along the Edens, including several in Northfield, with great ease. Shown here leaving Zubris's apartment building are, from left to right, Sgt. Edward Dedmond, Eva Zubris, and Chief John L. Aman. (Courtesy Northfield Police Department.)

Zubris's cooperation was brought about in part because the state was taking away her two daughters, and she was told that they could be returned to her after a short sentence. "If that happens," Zubris said, "I'd like to try to be a good mother to my two girls and the baby that is on the way." (Courtesy Northfield Police Department.)

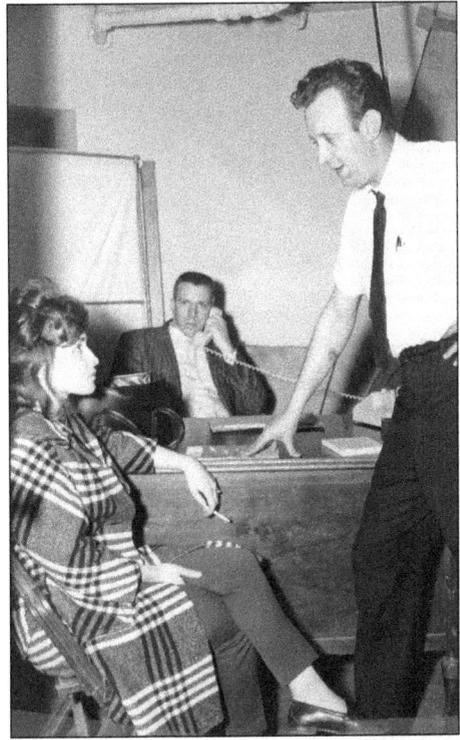

In addition to putting pressure on Northfield's police department, the Edens also required extra vigilance and resources from the fire department in its capacity as a medical emergency response team. This car accident at the Winnetka Avenue viaduct over the Edens in 1963 was such a shock that it attracted hundreds of gawkers; today's drivers would simply continue on their way. (Courtesy Northfield Police Department.)

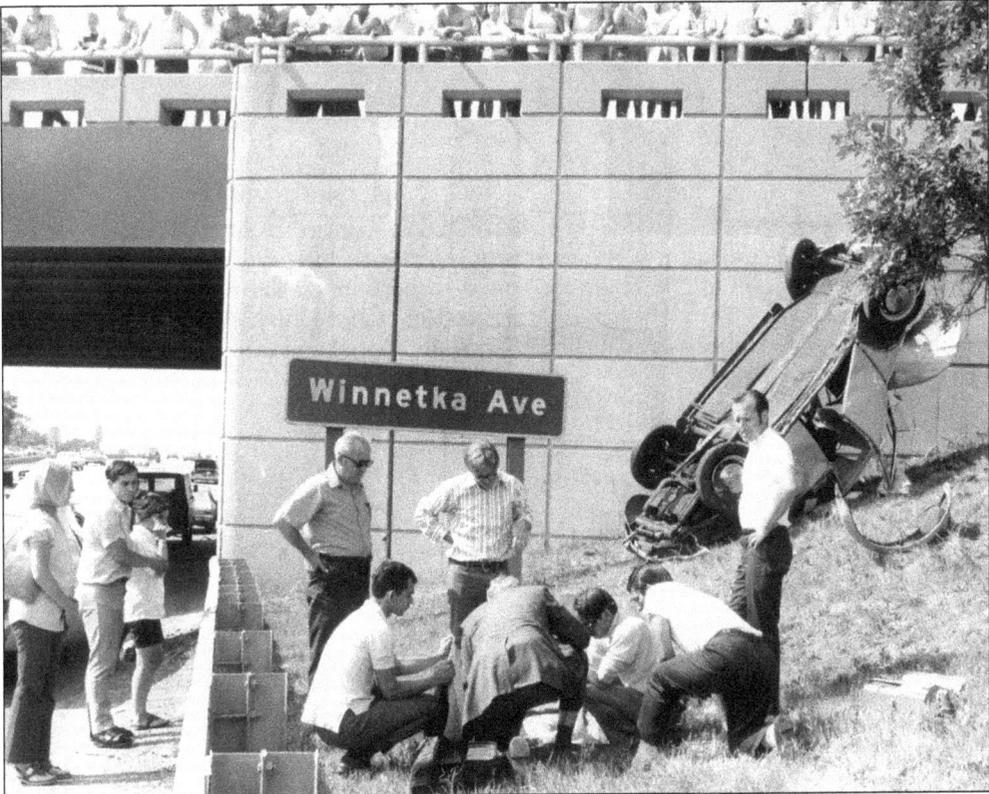

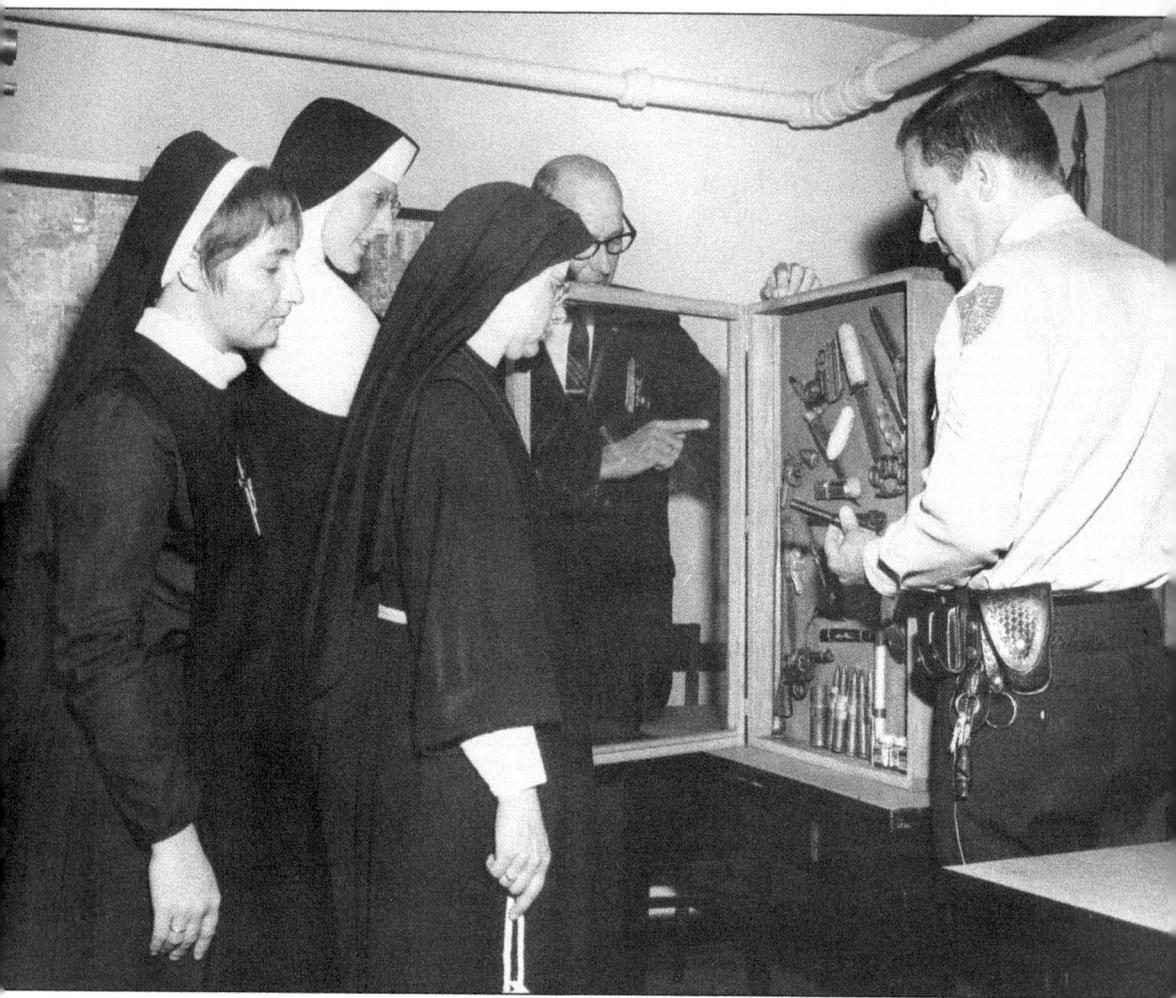

The Northfield Police Department became acutely aware of the necessity of citizen education to fight crime. Here sisters from St. Philip the Apostle School are taught to recognize potentially lethal items that might fall into the hands of their students. Chief John L. Aman and Sgt. Edward Dedmond (who would retire as a commander) open the contraband case. (Courtesy Northfield Police Department.)

Four

A VILLAGE OF
SERVICE AND SACRIFICE

In order to meet the challenges posed by the growth in population and the increased traffic through town, Northfield required a steady hand in government. The first town meetings were held in Al Levernier's tavern.

While that seemed like a good way of managing affairs at the time, it was hardly sufficient for the challenges of the second half of the 20th century and beyond. The village relies on a board of trustees—volunteers who come together to shape policy and ordinances. The village also has a professional staff that manages and administers the daily business, as well as strong and active police and fire departments. Northfield relies on people who are willing to give of themselves for the greater good of the community.

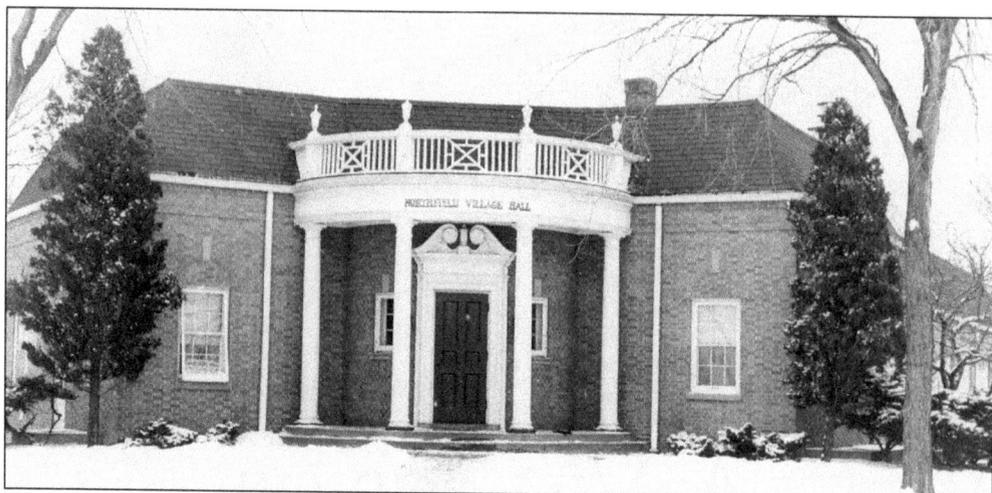

Northfield's "old" village hall was first built in 1936 at the corner of Willow and Happ Roads. Before the construction of the village hall, business was conducted at Al Levernier's store and tavern, where a person could order a drink as well as participate in a village meeting. (Courtesy Village of Northfield.)

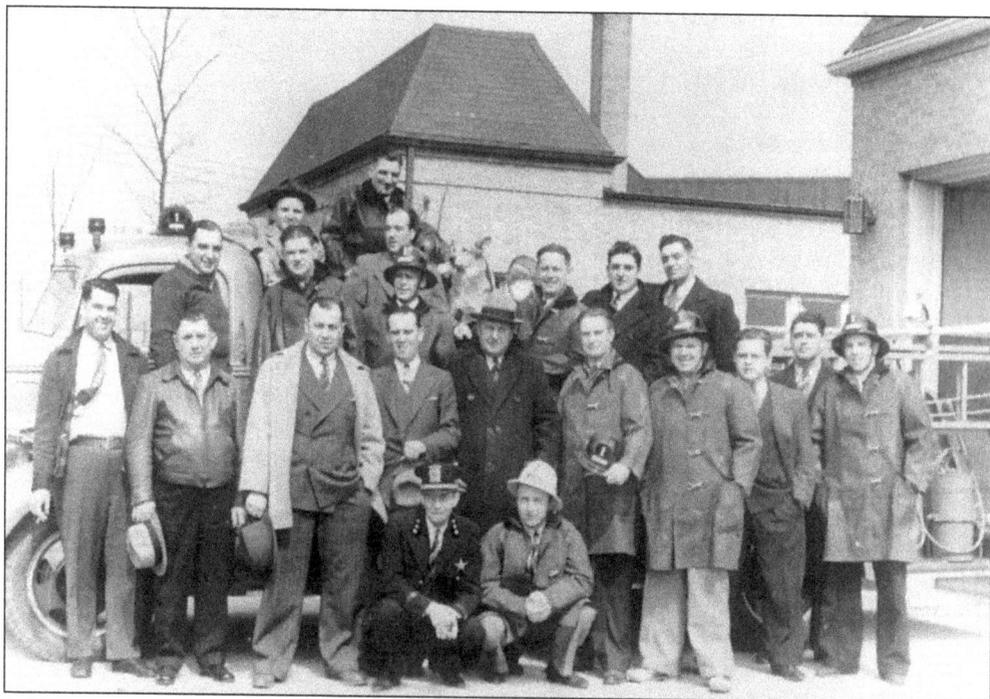

Village services did not require much manpower, and many people worked more than one job for the village. Here, in 1941, the entire staff of the village—police and firemen as well—poses for a picture, and the names are familiar. From left to right the men are (first row) police chief Edward Clapper and fire chief Carlton Affeldt; (second row) John Higgins, Peter Selzer, A. C. Kutz, Robert McClelland, George Selzer, Joseph Kozza, Robert Franden, John Levernier Jr., George Schildgen, and Kenneth Wagner; (third row) Rufus Seul, Joseph Kochlefl, Oscar Strand, "Corky," George Mau, Robert Levernier, and William Schildgen; (fourth row) Robert Klauke and Clarence Braun. To the left of Corky is Roscoe Happ. (Courtesy Village of Northfield.)

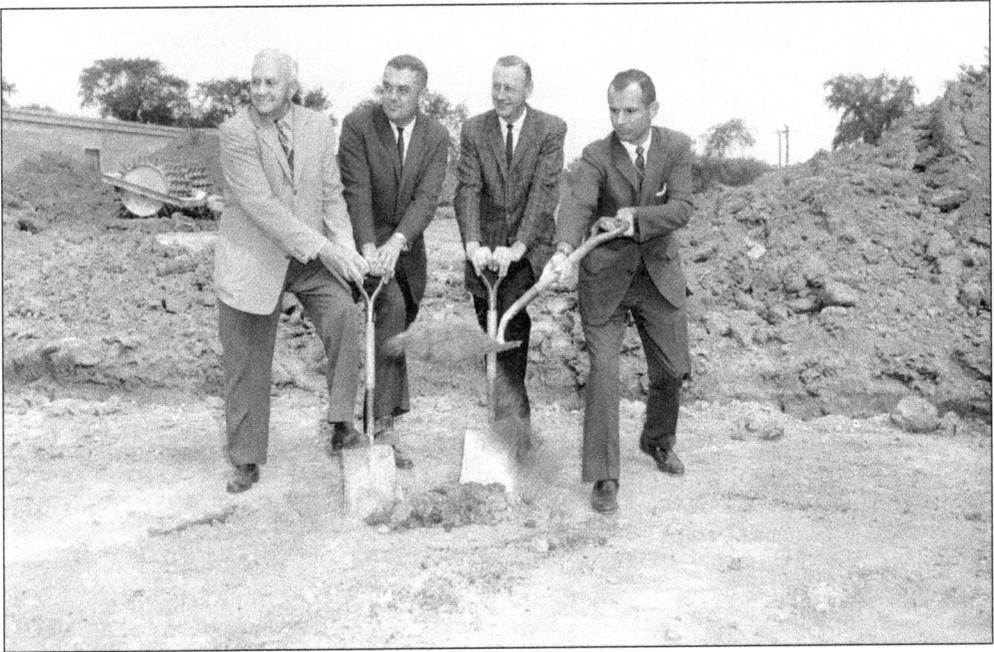

Ground was broken for a new village hall in the mid-1960s. Here, from left to right, are village administrator Stanley Farwell, village president John Boylston, Robert Jorgenson (head of the Northfield Public Works Department), and an unidentified contractor hoisting their shovels. (Courtesy Northfield Police Department.)

Today Northfield Village Hall (refurbished in 1999) is a modern, streamlined building that houses village offices, a council room, several conference rooms, and the police department. Also within the building is the original Waubun sign that graced the train station. (Courtesy Charles Seymour.)

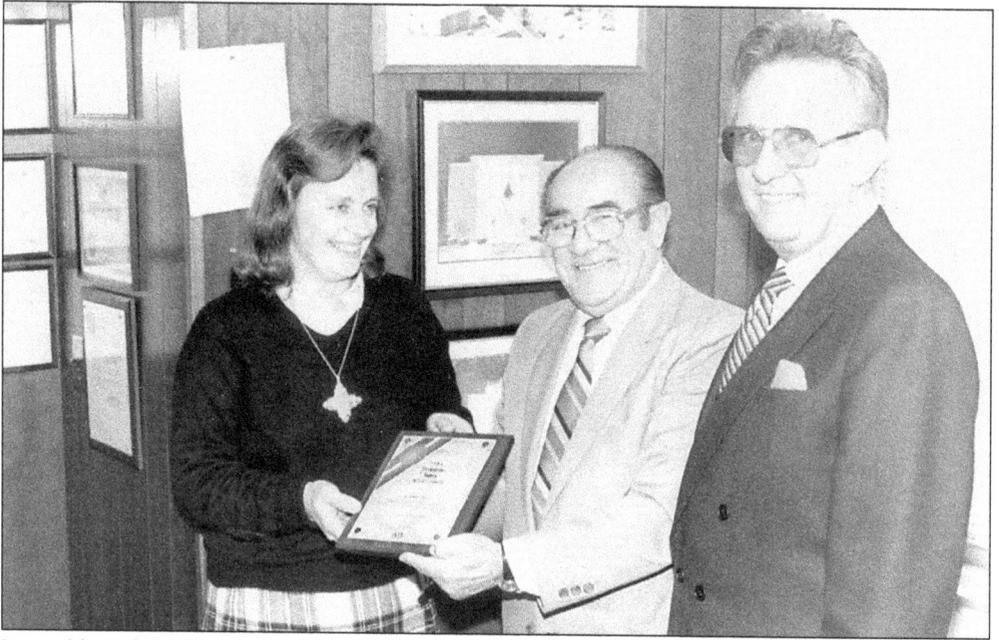

It would not be until the mid-1980s that Northfield would elect its first female village president. Barbara D. Wick served from 1985 to 1989 after sitting as a village trustee and as a member of the zoning board. Here she is pictured with police chief Richard D. Klatzco (right) receiving the AAA Pedestrian Protection Award in 1984. The village received the award for 11 years in a row. After her stint as village president, Wick continued to volunteer her time for both the village and the North Shore Senior Center. (Courtesy Village of Northfield.)

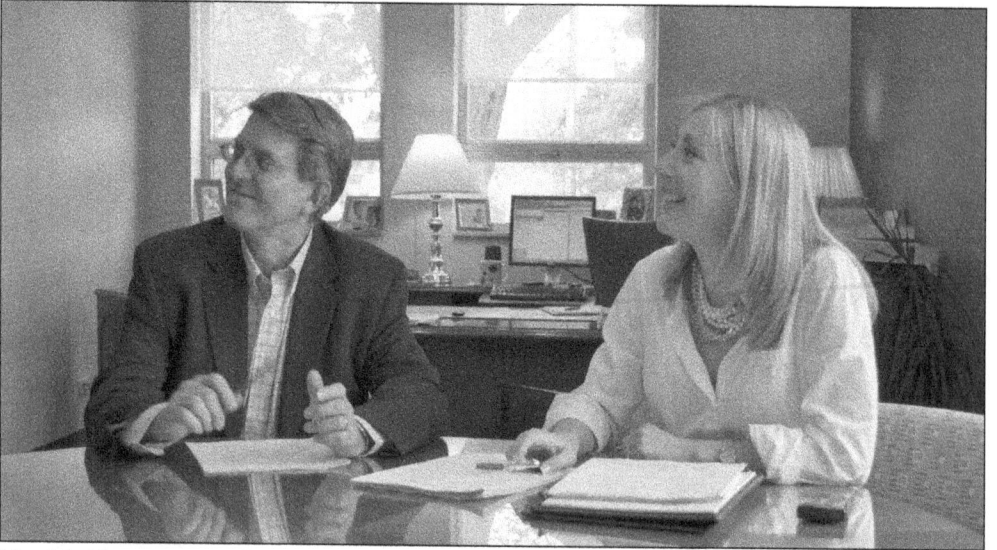

Northfield uses a council-manager form of government. The council consists of a village president and six trustees, who serve in staggered four-year terms. The president and board establish policies, approve expenses, enact ordinances, and appoint members to various village boards and positions. The village manager is appointed for an indefinite time and supervises administrative activities of the village. Here village president Fred Gougler and village manager Stacy Sigman meet to discuss village matters. (Courtesy Charles Seymour.)

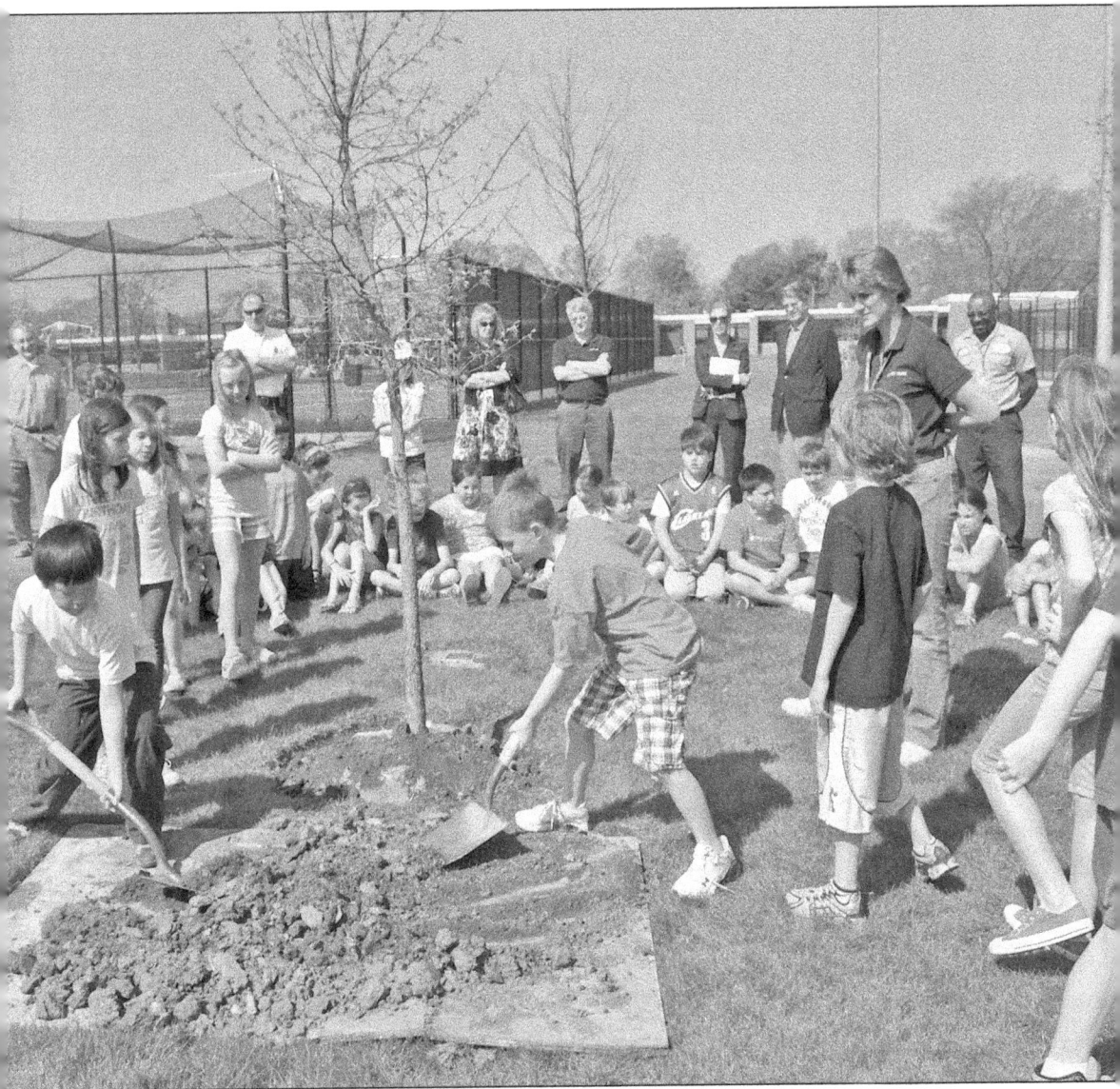

One of the fun duties of village president is officiating at the annual Arbor Day festivities. Northfield has been part of Tree City USA since 1986. The fourth-grade class of Middlefork School traditionally plants a tree on behalf of the village. Here, in Willow Park, a hackberry tree is planted after the reading of the 2010 Arbor Day proclamation by village president Fred Gougler (wearing blazer), who is looking on with other village officials. The ceremony is followed by a poetry reading by fourth graders; the poems' themes are related to trees and their preservation. (Courtesy Charles Seymour.)

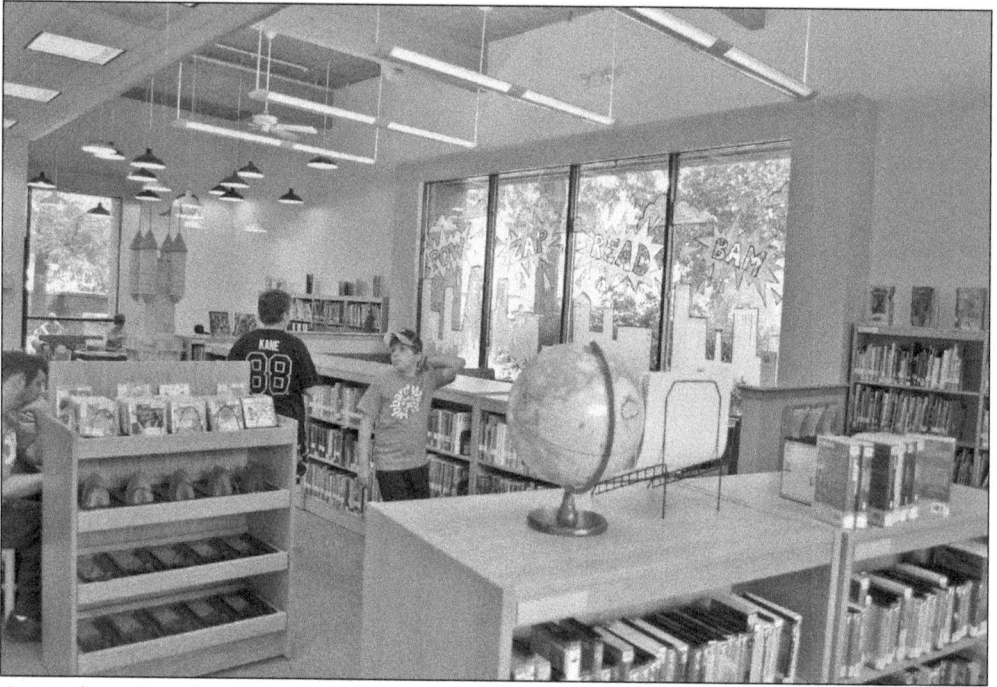

Across from the village hall on Happ Road is the Northfield branch of the Winnetka-Northfield Public Library. In 1974, the Winnetka Public Library converted from a village department to a separate governmental unit so that it could include Northfield residents in its system. The Northfield branch has a children's reading room, a reading room with a cozy fireplace, and the traditional amenities of a library. Programs are offered for both Winnetka and Northfield residents. (Courtesy Charles Seymour.)

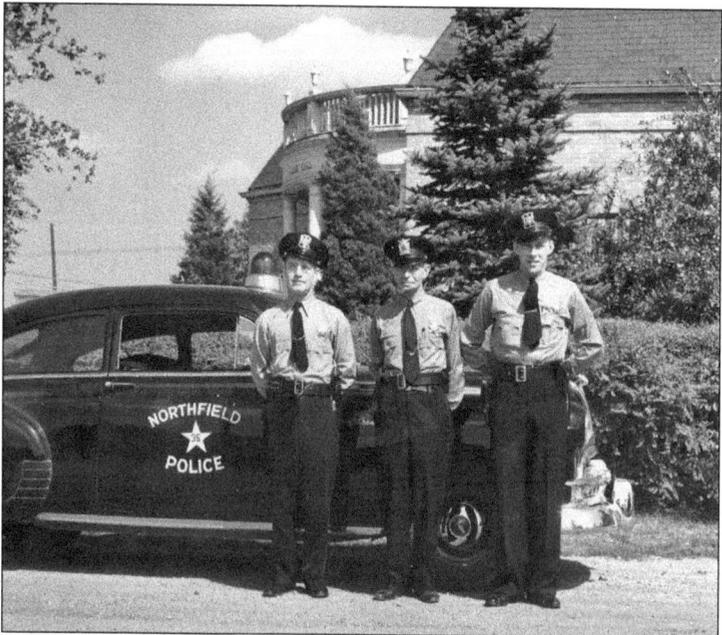

The first duty of government is to protect its citizens. In 1949, Northfield's Ed Clapper (center), future Chief Aman (right), and an unidentified patrolman pose with what was at the time Northfield's only squad car, a Pontiac. Behind them is the "old" village hall where the police department was housed. Today the Northfield Police Department is housed in the new village hall. (Courtesy Northfield Police Department.)

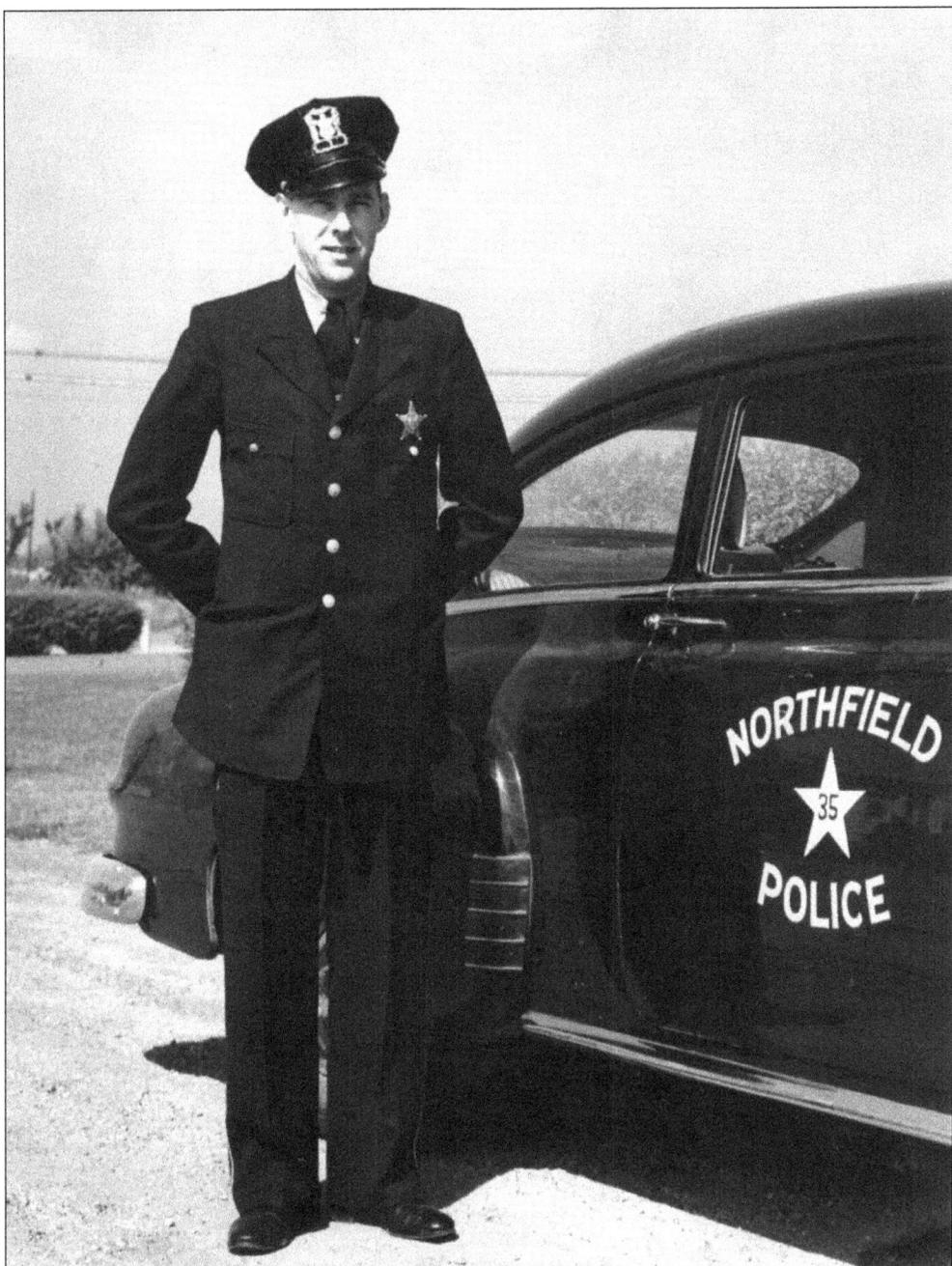

For many years, Northfield had just one squad car and three police officers. When the force finally received a second car, it would traditionally reserve one to ferry the police chief to his home and pick him up the next morning. Here patrolman John L. Aman poses in front of squad car no. 35. (Courtesy Northfield Police Department.)

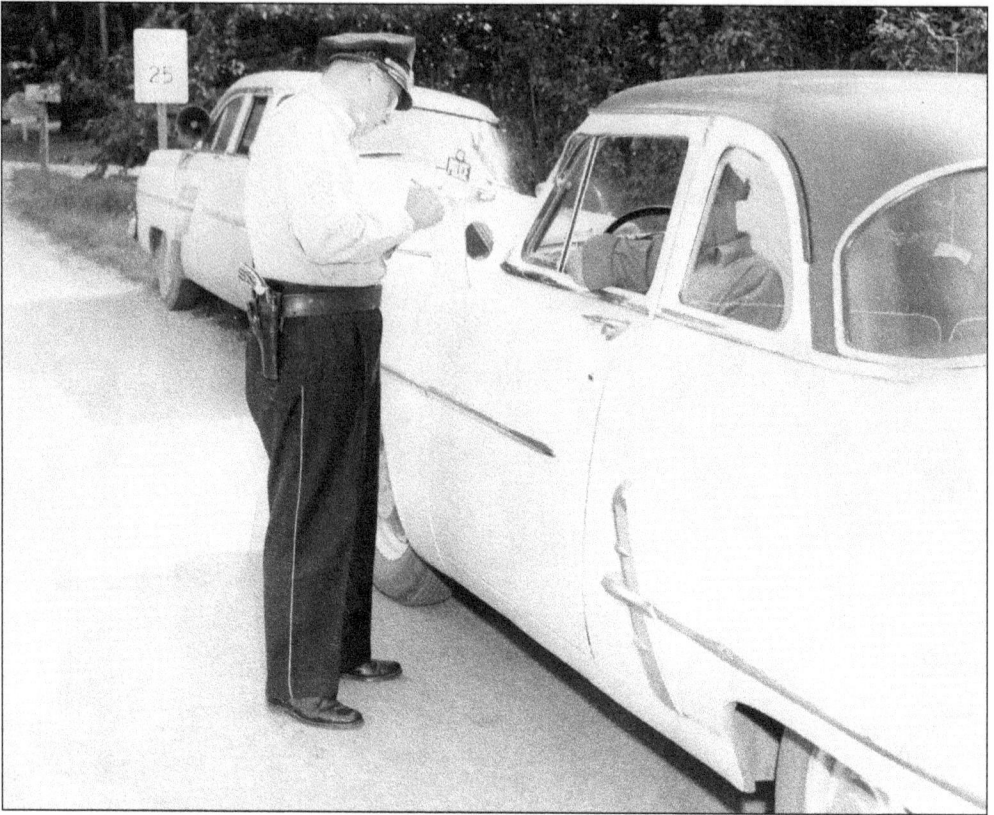

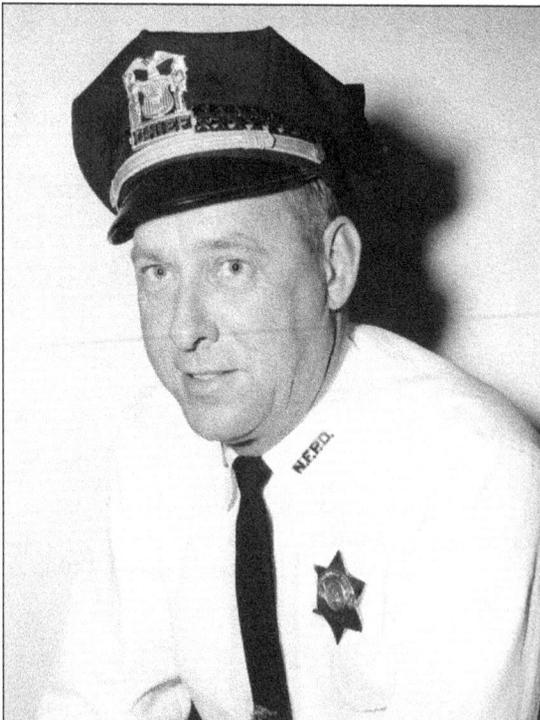

In this photograph, patrolman Al Berendsen issues a ticket to a driver in the late 1950s using squad car no. 160. Northfield had three cars at the time: two marked and one unmarked. The unmarked vehicle generally was considered Chief John L. Aman's car. Berendsen served 20 years in the force and retired as a lieutenant. (Courtesy Northfield Police Department.)

Prior to joining the Northfield Police Department as a patrolman, John L. Aman had been in the U.S. Army. After he retired from the force as a chief, he was hired by Lake County, Illinois, as a deputy coroner. He is pictured here in 1961. (Courtesy Northfield Police Department.)

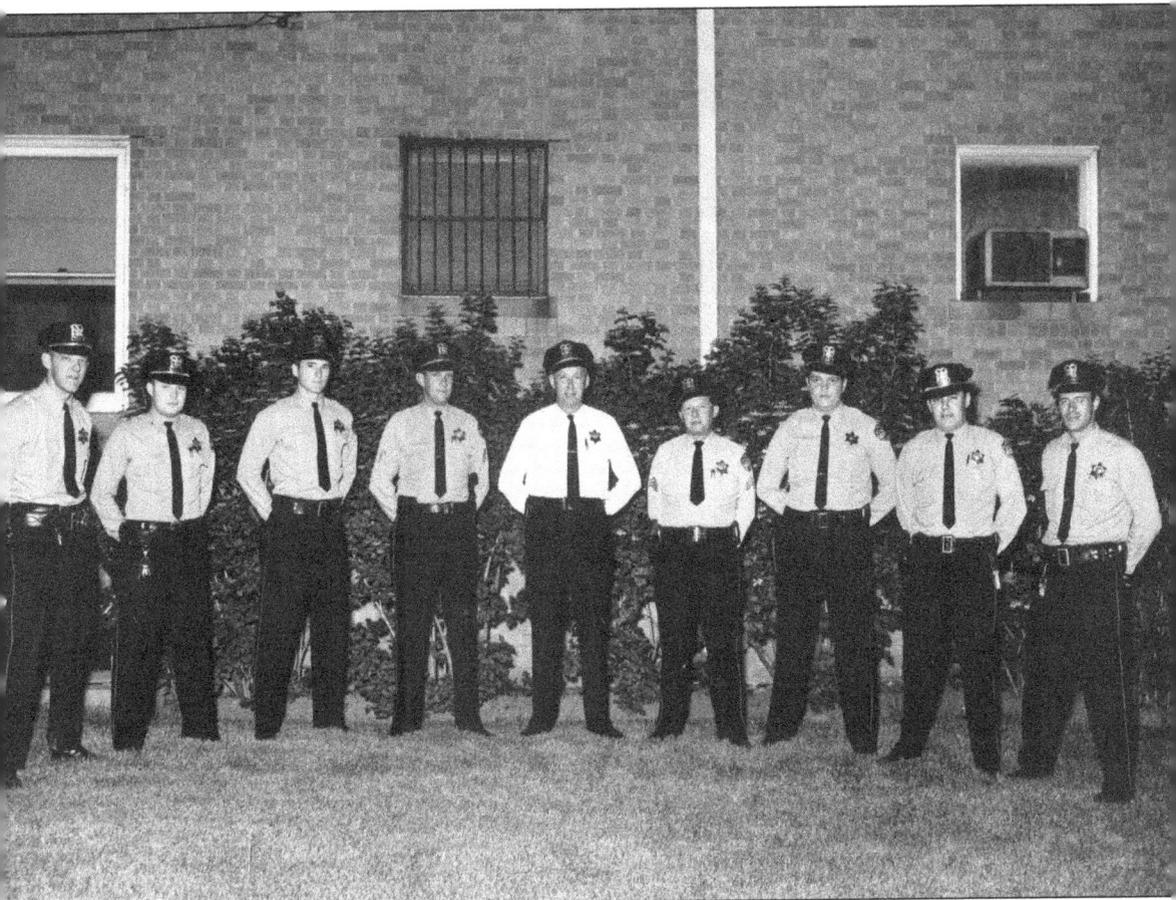

This class picture from the early 1960s shows, from left to right, patrolmen Paul Bartels, Kenneth E. Smith, and Ted Talaber, Sgt. Richard Klatzco, Chief John L. Aman, Sgt. Albert Berendsen, and patrolmen Larry Peiffer, Edward Dedmond, and Todd Sheldon outside of the police station. (Courtesy Tom Actipes.)

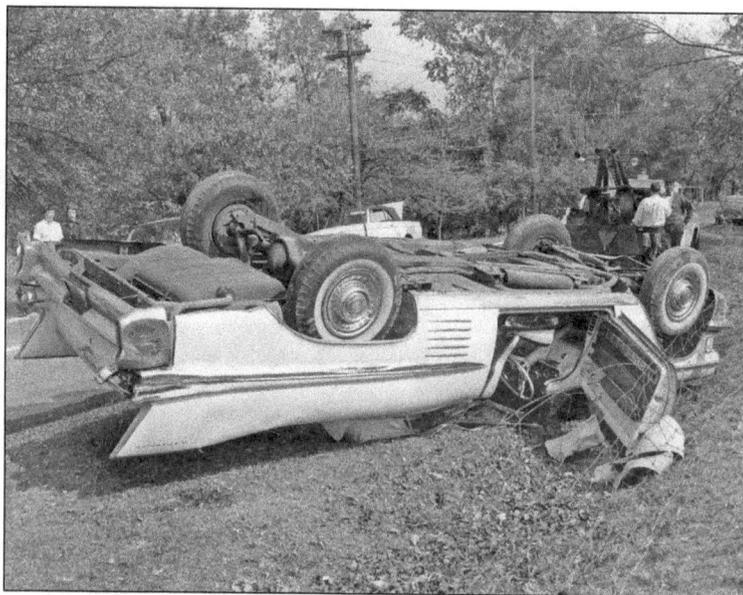

On October 6, 1963, retired police chief Ed Clapper was driving westbound on Willow Road when he lost control of his car, and it rolled over; he was killed instantly. The police department was shaken up by the tragedy. (Courtesy Northfield Police Department.)

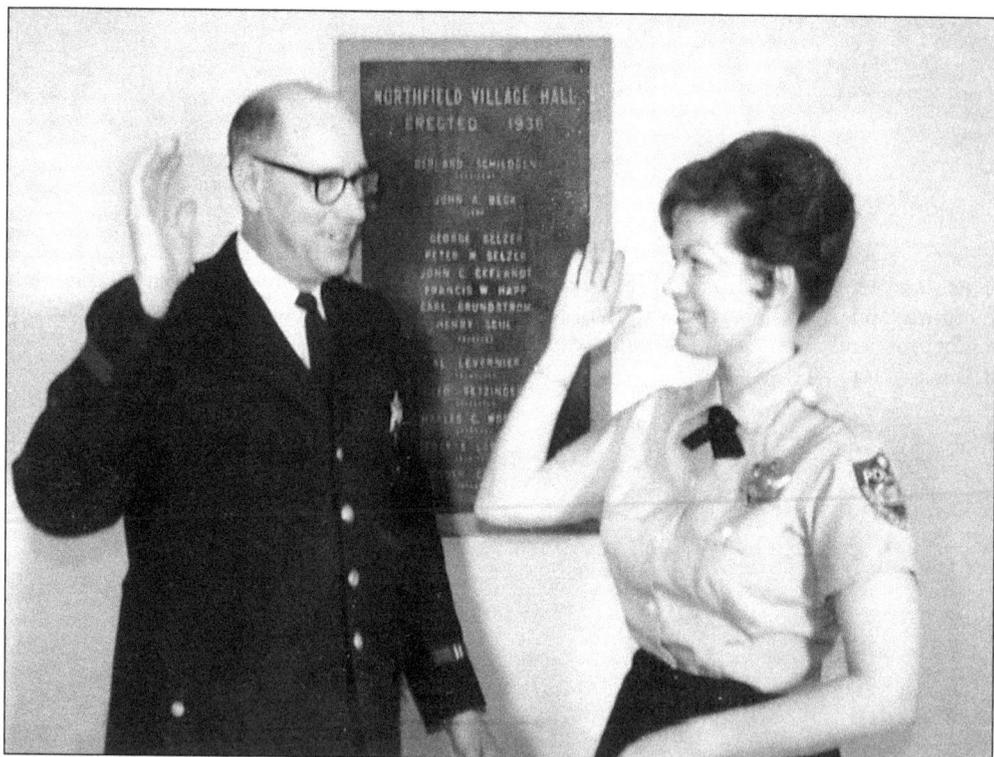

Chief John L. Aman swears in Northfield's first female police officer in 1966. Donna Ellison of Winnetka had worked as a dispatcher, and this was an unprecedented promotion. She served as a file clerk and was used when it was necessary to search female offenders. She graduated from Central State College in Wisconsin and had worked as a parole agent in that state. (Courtesy Northfield Police Department.)

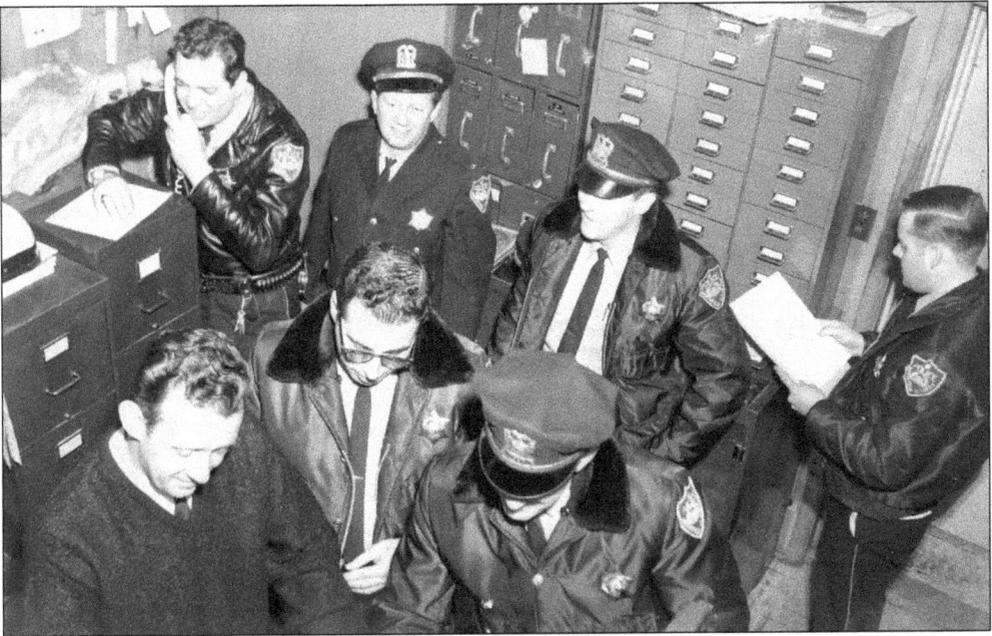

In the early 1960s, the department was bursting at the seams. Squeezing into the main office to do their work are, from left to right, (first row) Lt. Richard D. Klatzco, patrolman Don Lantz, and patrolman Paul Bartels; (second row) patrolman Larry Peiffer, Lt. Al Berendson, patrolman Tom Reynolds, and patrolman Kenneth E. Smith. Within a few years, the new village hall would be built, and the police department would have larger quarters on the same site. (Courtesy Northfield Police Department.)

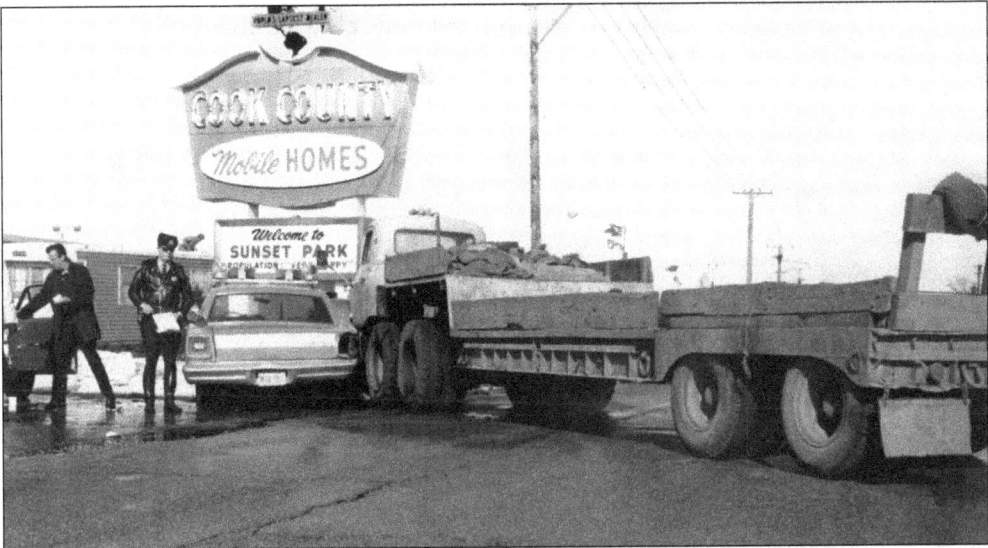

Patrolman Kenneth E. Smith's squad car was hit not once but twice by a landscaper's truck as its driver made a U-turn in front of the squad car on Waukegan Road. The two vehicles came to a stop at the Cook County Mobile Homes (today's Sunset Park) on the western edge of town. Officer Smith was thrown from the driver's seat into the back of the squad car. He suffered back and leg injuries but survived to work at the department until 1990, retiring as a commander. (Courtesy Northfield Police Department.)

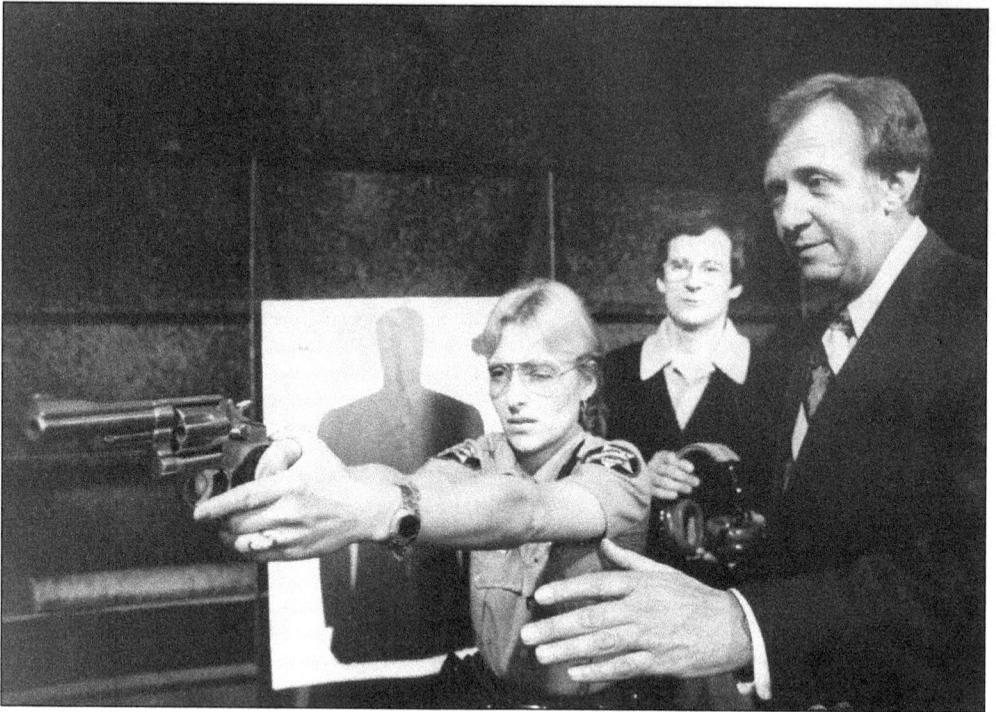

In 1972, Northfield's second female officer was given responsibilities and opportunities that Donna Ellison had not been afforded. Here, in the 1970s, patrolman Barbara Gallowich Alfonso is at the firing range with Chief Richard D. Klatzco. Behind them stands James O'Shea, coordinator of the law enforcement program at Oakton College. Gallowich Alfonso scored third out of 11 applicants for a position on the force. (Courtesy Northfield Police Department.)

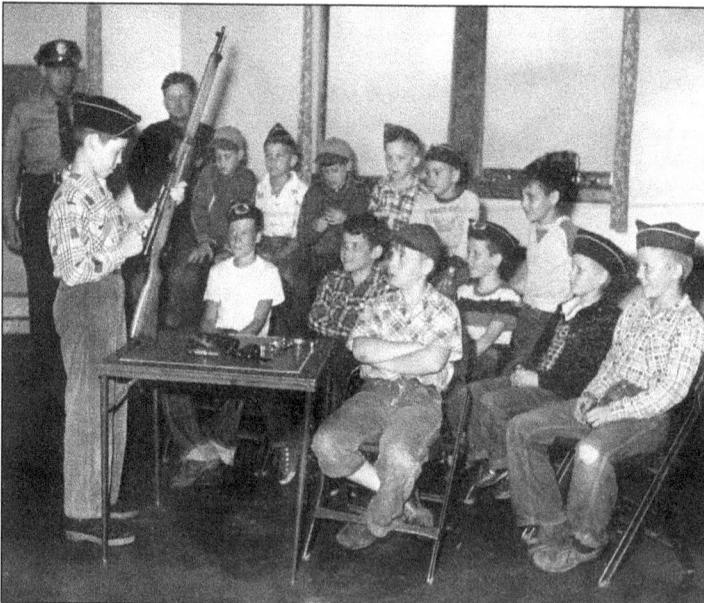

The police department has long been aware that it must do more than fight crime. Here, in 1952, under the guidance of Chief John L. Aman and officer Al Berendsen, members of the Northfield Safety Patrol are being trained in rifle safety. While the boys may have wished the police department had provided them with rifles, this was not part of the plan for the safety patrol. (Courtesy Northfield Police Department.)

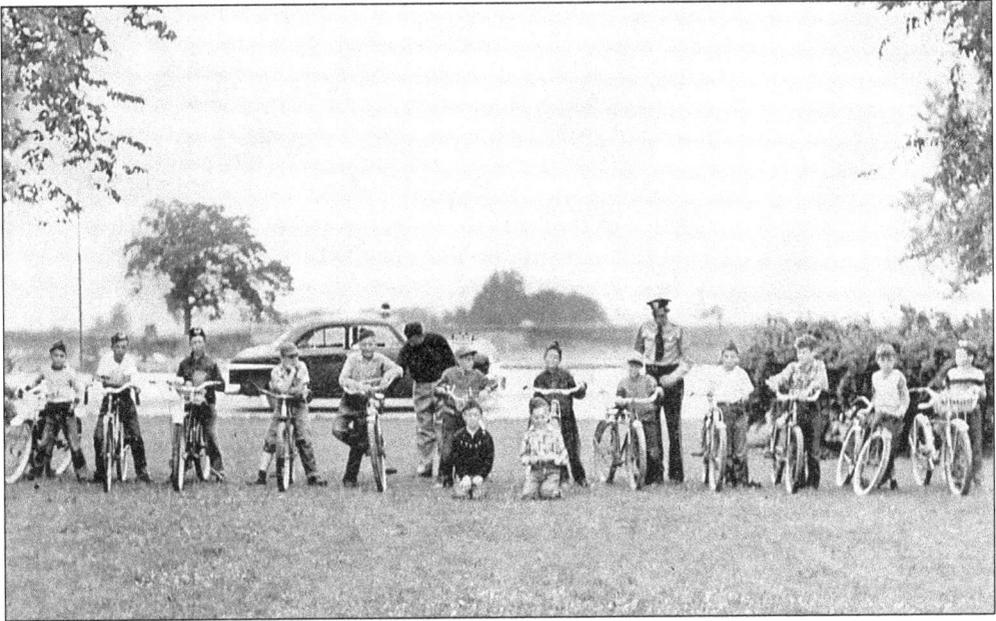

The police also held an annual Bike Rodeo for the safety patrol. Here Chief John L. Aman and officer Al Berendsen supervise the boys. Safety patrol provided the boys with a sense of responsibility, as they were charged with being on the lookout for trouble. Pictured here from left to right are (kneeling) Al Berendsen and Bill Yale; (on bikes) Wayne Pettingill, Spike Stixrood, Bill Byrne, Jack Ricci, Allen Caskey, Donnie Dominick, James Kucera, Bill Dominick, Tony DeFalco, Stephen Thun, James Koller, and Pat Byrne. Safety patrol chief Bill Byrne would have kept the log of attendees. (Courtesy Northfield Police Department.)

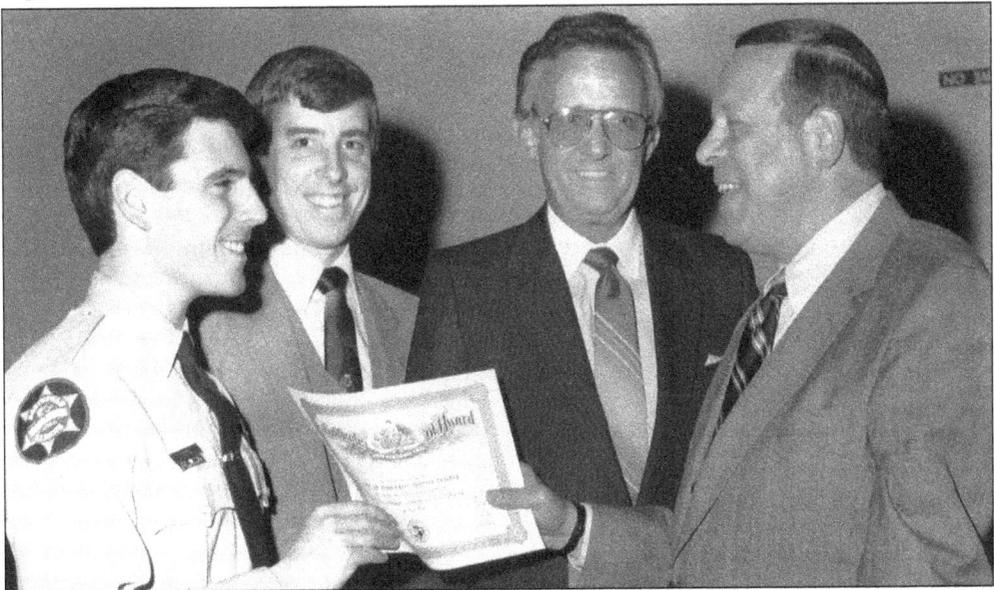

The camaraderie of the department is clear as these three chiefs come together in 1982. From left to right the men are patrolman Bill Lustig (future chief), future chief George Wagner, Chief Richard D. Klatzco, and Cook County sheriff Richard J. Elrod. Lustig is receiving his diploma for graduating from the Cook County Sheriff's Police Academy. (Courtesy Northfield Police Department.)

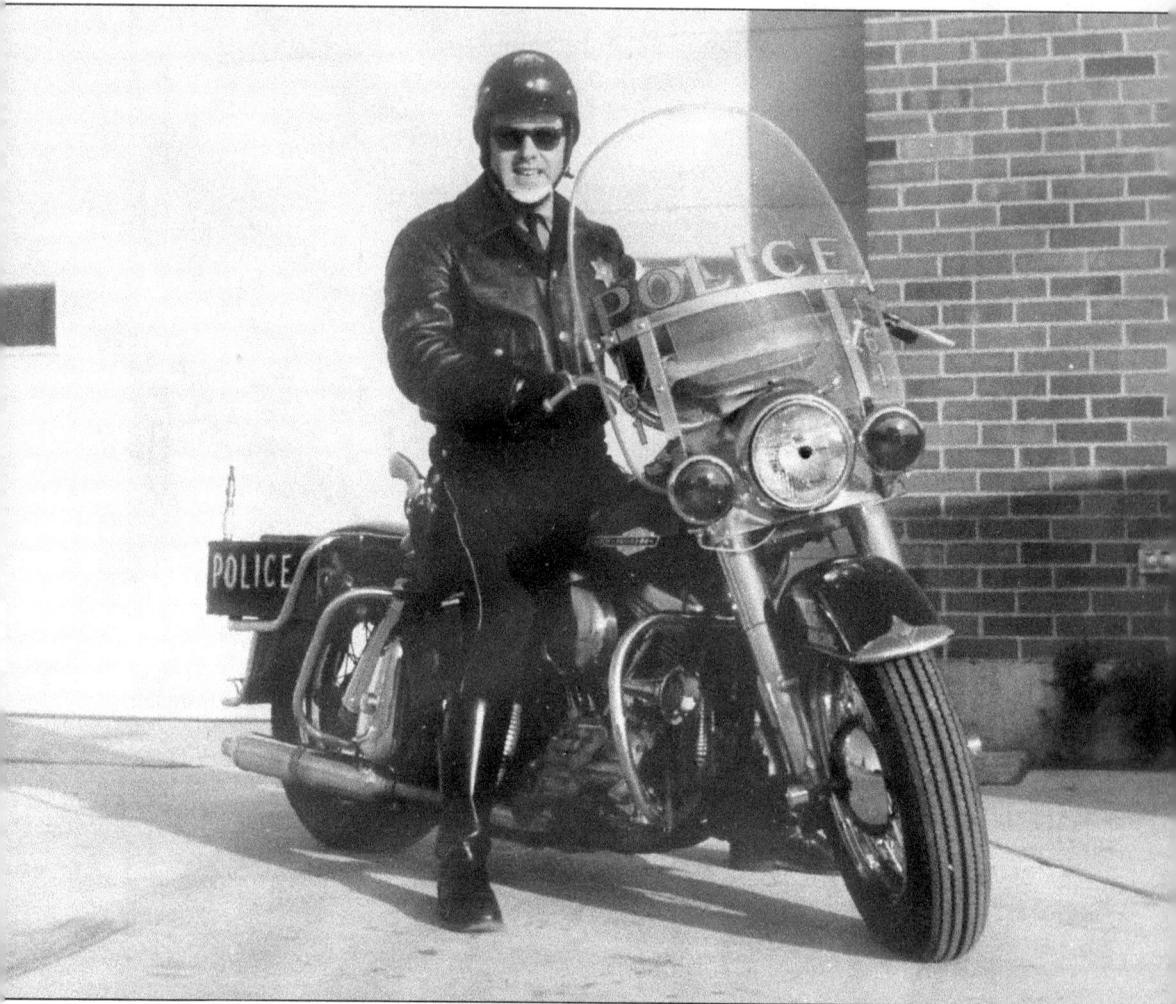

Patrolman Bill Raguse rides the Northfield Police Department motorcycle in 1966. Motorcycles could respond to accidents on the Edens Expressway faster than squad cars when traffic was heavy. Motorcycle patrols were generally used for traffic enforcement and for patrolling New Trier West campus. Raguse retired as a corporal. (Courtesy Northfield Police Department.)

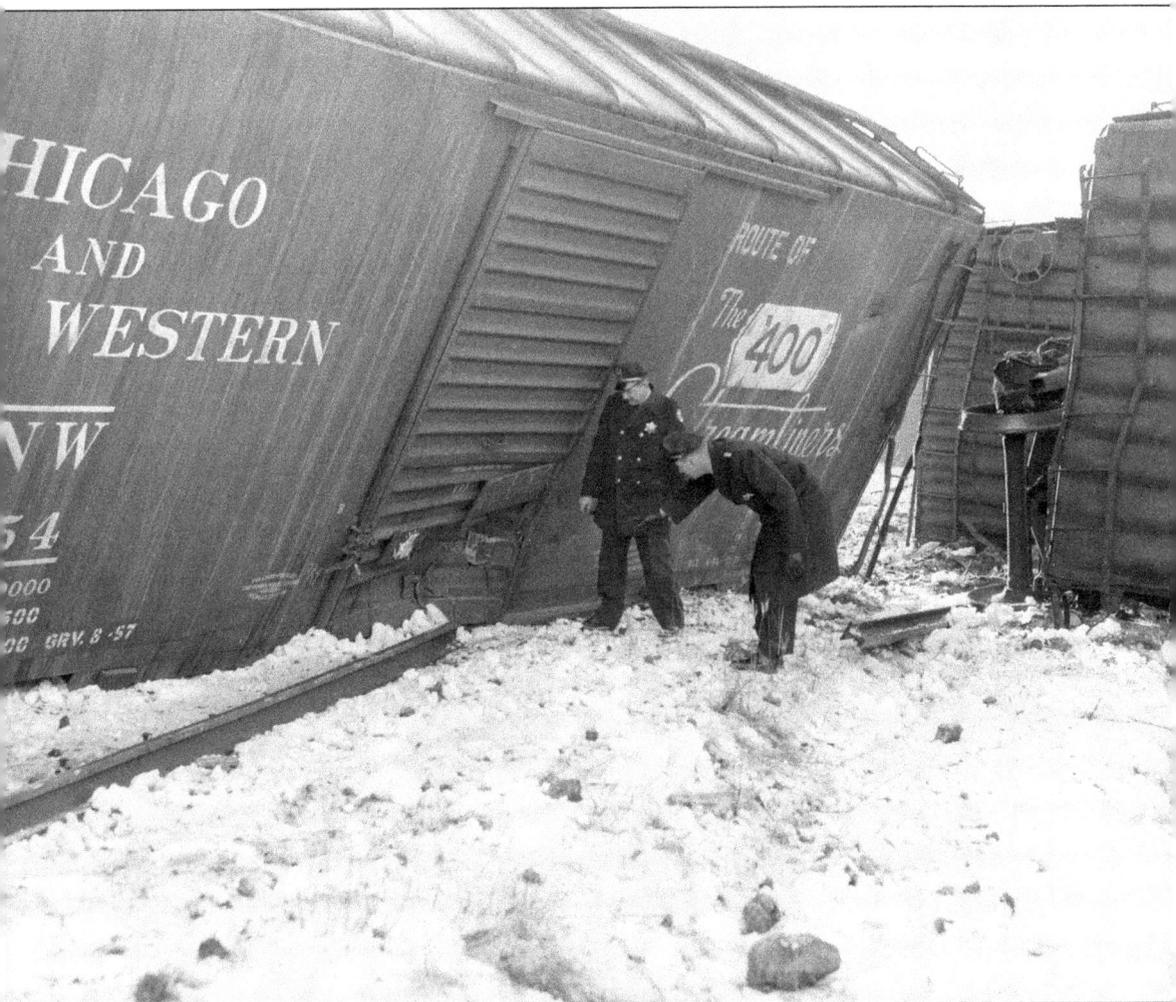

On February 25, 1965, though 8 cars of a 149-car freight train derailed at Willow Road, there were amazingly no injuries. The quick response of the fire and police departments quickly put things to right. In this photograph, officers Al Berendson (left) and Paul Bartels inspect the damage. (Courtesy Northfield Police Department.)

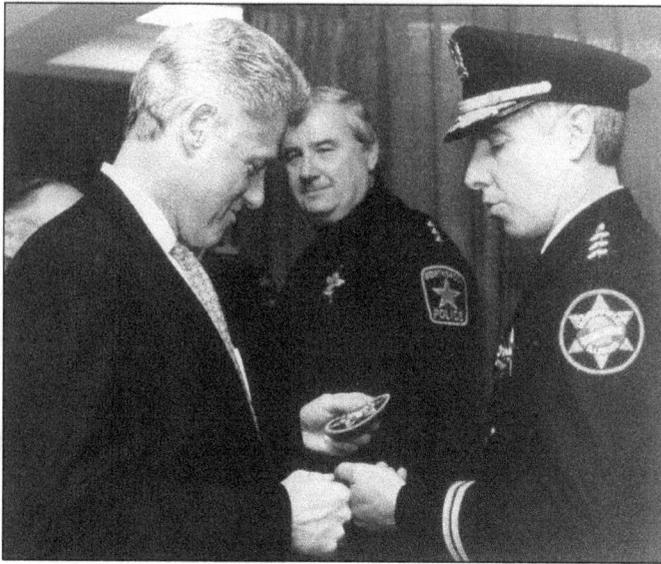

There are some interesting perks to being the president of the United States. Here, in 1997, Chief George Wagner presents Pres. Bill Clinton with a Northfield police badge during a presidential visit to the community while Chief James Wallace of the Northbrook Police Department looks on. The president made a visit in 1997 to Stanley Fields and Glenbrook North Schools to recognize their academic achievements. (Courtesy Northfield Police Department.)

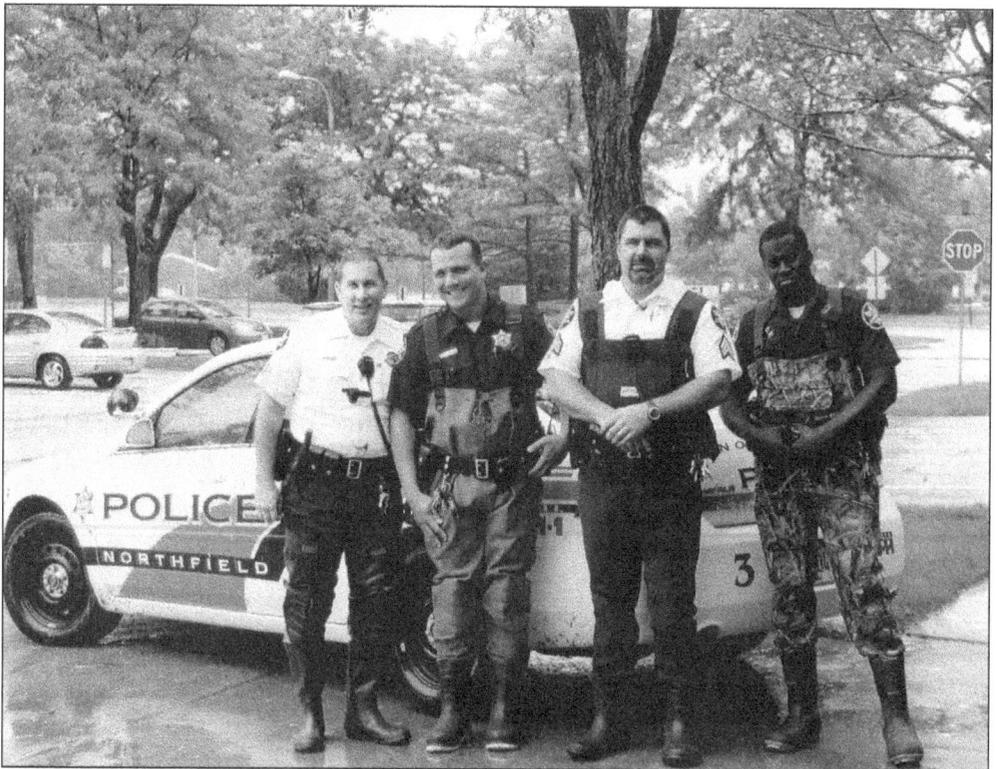

Northfield Police Department responds to a variety of emergencies. Northfield, even with the Skokie Swamp replaced by beautiful lagoons, is still subject to its share of flooding. Here, after the 100-year flood in September 2008, officers take a moment to pose for a picture. From left to right the men are Sgt. Nicola Tangorra, officer Tierney, Sgt. J. J. McCulloh, and officer Nana Owusu. (Courtesy Northfield Police Department.)

In 1937, Northfield organized a volunteer fire department. George Mau was selected as chief, with Ray Selzer as his assistant. Peter and Rich Seul were the first captains. The first order of business for the new fire department was to host a card and bunco party as a fund-raiser. Prior to this development, the Winnetka Fire Department was responsible for Northfield. Northfield firefighters won the next year's water fight with Winnetka firefighters in Fire Prevention Week. Firefighters from the two teams hosed a metal barrel hanging from a cable strung between two telephone poles. In 1956, the match was interrupted by a fire call at the Indian Hill Country Club. Winnetka firefighters returned from dousing the flames to continue their match with Northfield; Northfield again prevailed. (Courtesy Northfield Fire Department.)

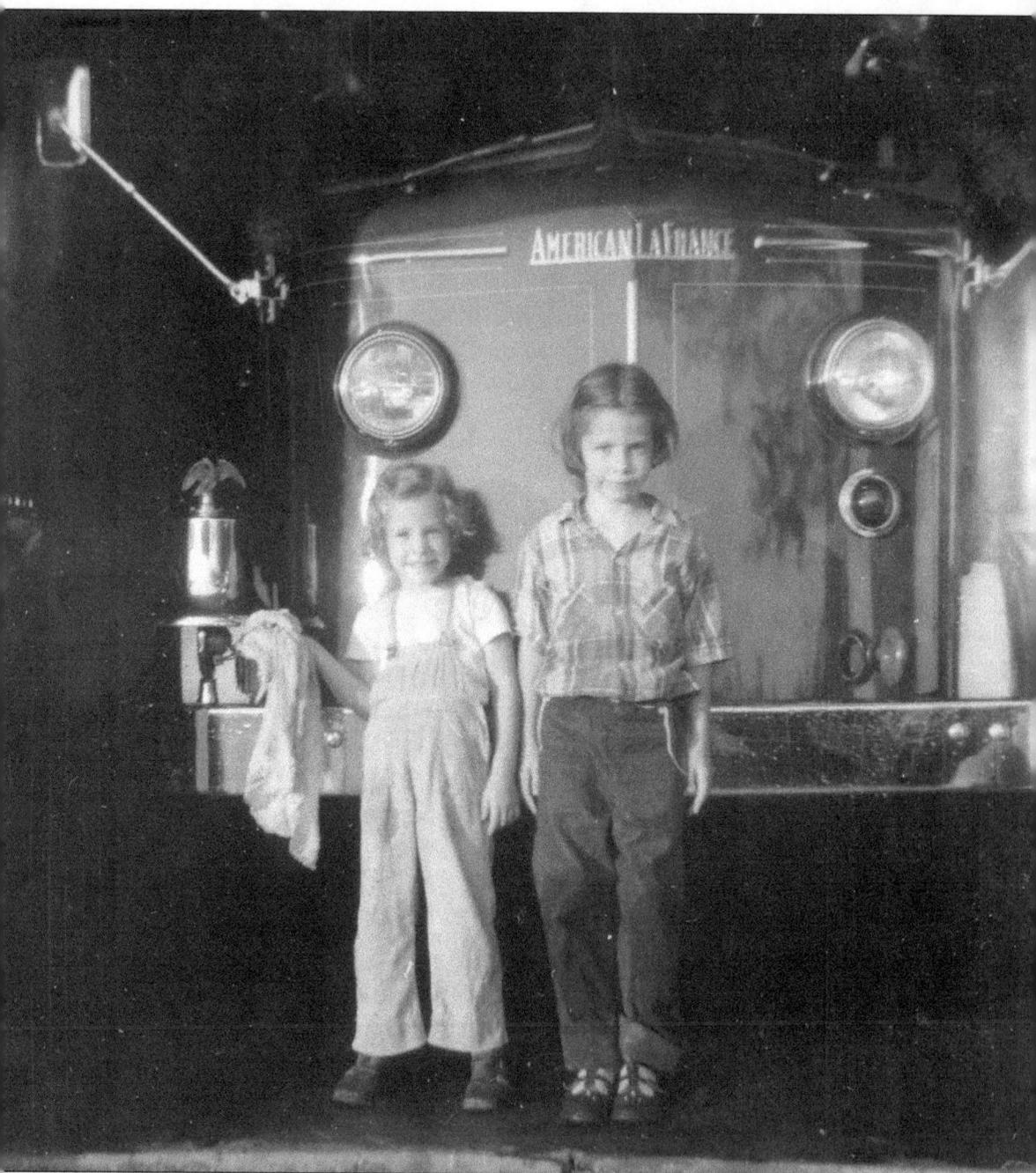

Fire Prevention Week was and is an important part of the fire department calendar. These two children are enjoying the climb up on the truck in 1955. The fire department had two trucks: one a Ford and the other an American LaFrance. (Courtesy Northfield Fire Department.)

In 1963, Pixie and Dixie rode in the lead car in the 14th annual parade, which opened Fire Prevention Week. Pixie's sign states, "Practice fire prevention all year round," and Dixie's reads, "We'd like to see you all again next year." (Courtesy Northfield Fire Department.)

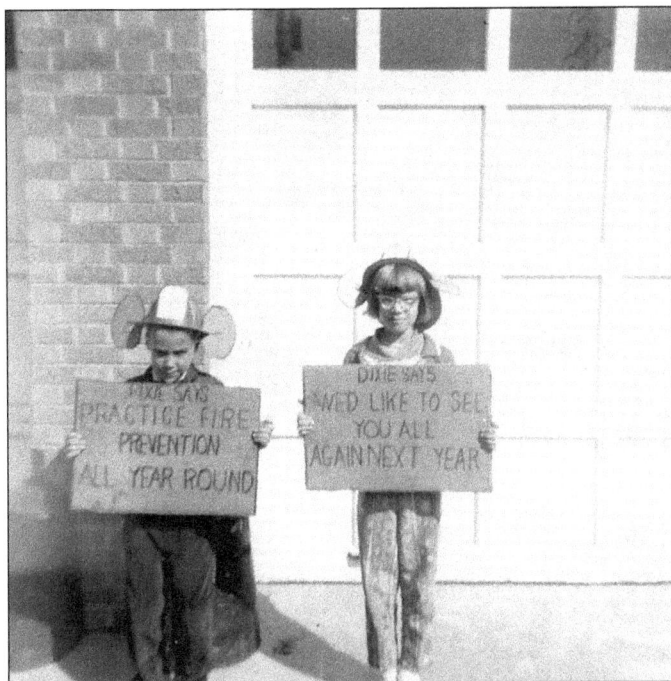

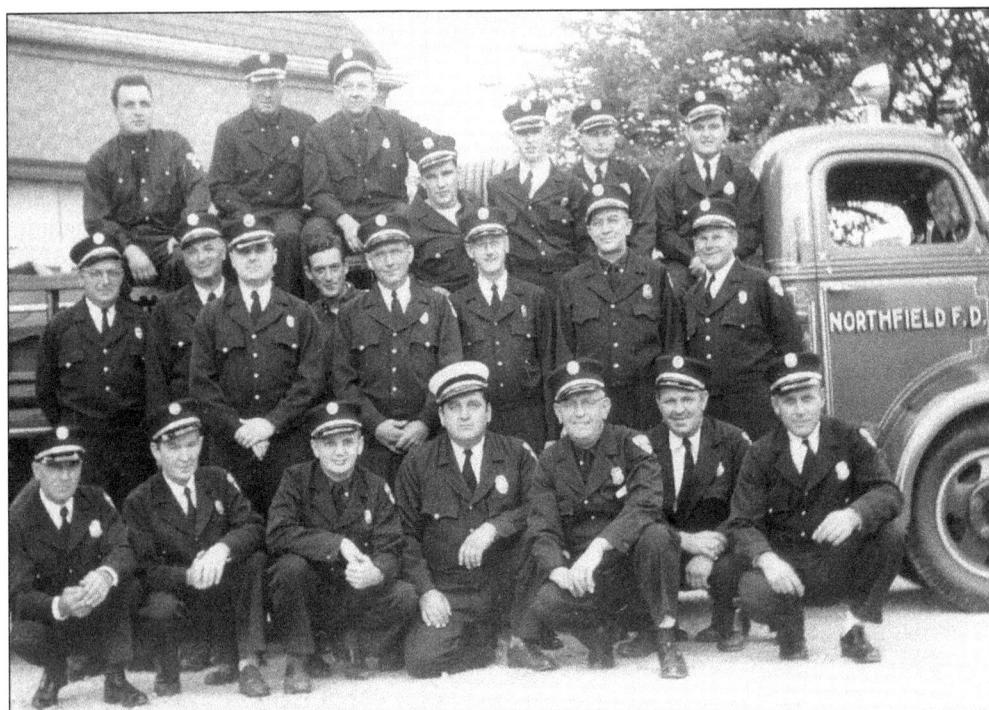

The Northfield Fire Department was under the direction of Chief Robert Levernier (center, first row). The department was a mix of volunteer and professional fighters. At one time, firefighters were paid a $1 per call. Farmers who wanted their ditches and fields burned would sometimes have some help in getting the fire started—and then firefighters would duly arrive to put out the flames. (Courtesy Levernier family.)

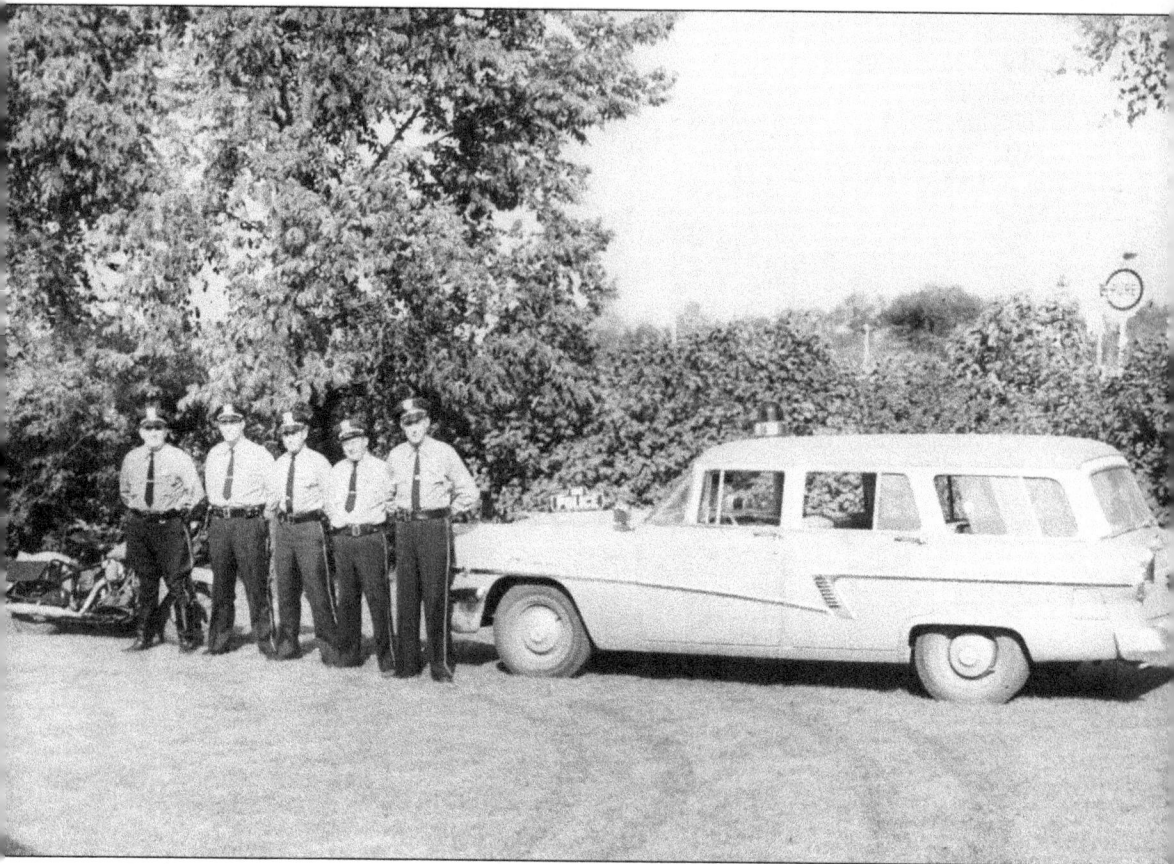

In the 1950s and 1960s, the police department had a station wagon that served as both a squad car and an ambulance. Prior to this, the village relied on private ambulance services, sometimes run by local funeral homes; in mortal situations, a trip to the hospital would be bypassed for a trip back to the ambulance's own garage. With the purchase of this ambulance, Northfield police officers were required to be trained in emergency medical response. (Courtesy Northfield Police Department.)

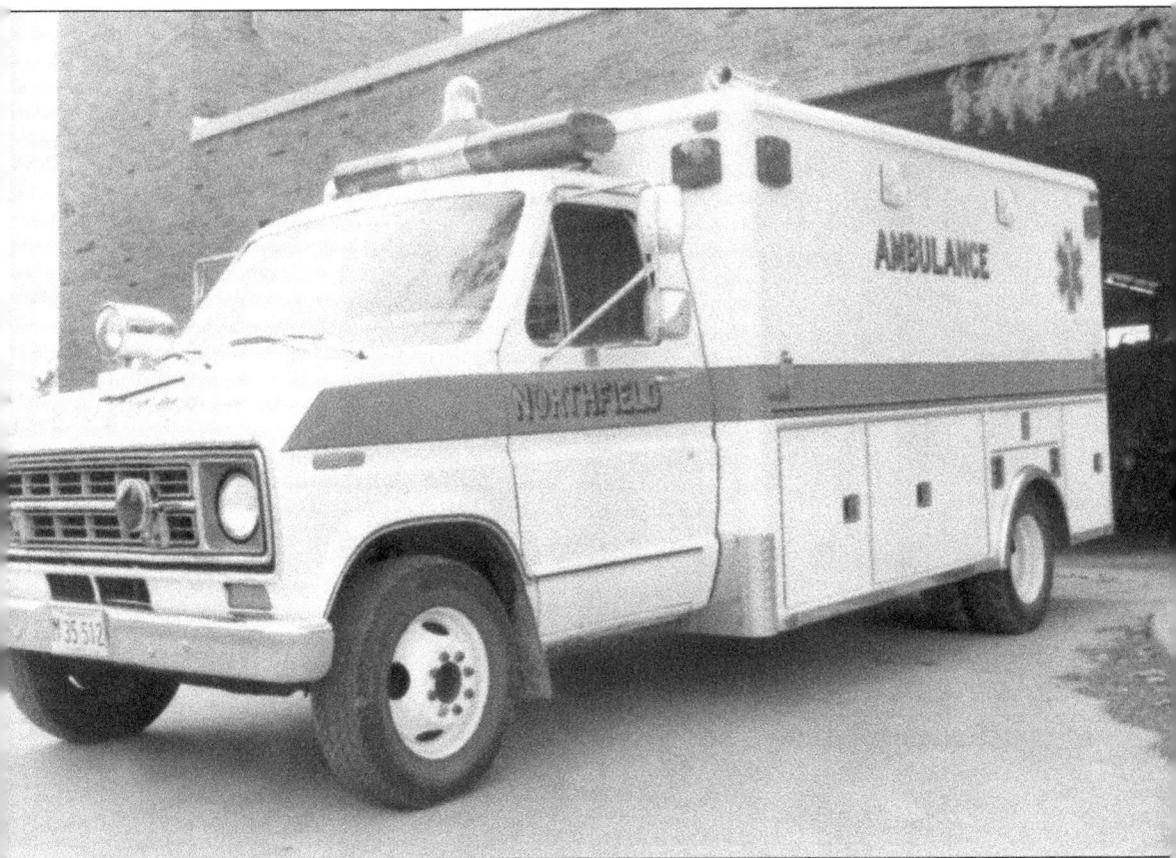

In 1978, the Northfield Fire Department purchased this Horton Ford all-aluminum modular ambulance for $32,000. Its best feature was that it was able to transport two passengers at once. The fire department took over emergency medical transport and paramedic duties from the police department. (Courtesy Northfield Fire Department.)

In 1981, Northfield's Fire Department sent a new fire truck to the community of Kalaupapa on the island of Molokai in Hawaii. Kalaupapa is best known for Father Damian's work there with exiled sufferers of Hansen's disease, otherwise known as leprosy. Paramedic Robin Pendergast, his friend Suzie Kellett, and Capt. Michael Nystrand delivered the truck and trained the community's emergency responders on its use, continuing a Northfield tradition of helping others. Nystrand would later become chief of the fire department. (Courtesy Charles Seymour.)

Five

FRIENDS, FELLOWSHIP, AND FAITH

Northfield is such a small town that the most distant relation people can have with any other residents is to be friends of their friends. Northfield residents come together in a variety of ways, beginning with the town's clubs and its churches. Through fellowship with one another, residents face their challenges and successes with equanimity.

For many years, Northfield residents had to go to other communities for worship. Churches and synagogues of every type rented space in schools or came together in members' basements. After World War II, Northfield residents built their places of worship, and they also constructed homes for organizations that provide service to its own residents and for residents of other communities. Northfield is home to the North Shore Senior Center and to the Josselyn Center. Northfield residents also like to have fun—whether at the Northfield Park District Skate Park, at the golf course of Sunset Ridge Country Club, or at a Thursday night supper at the Middlefork Tennis Club.

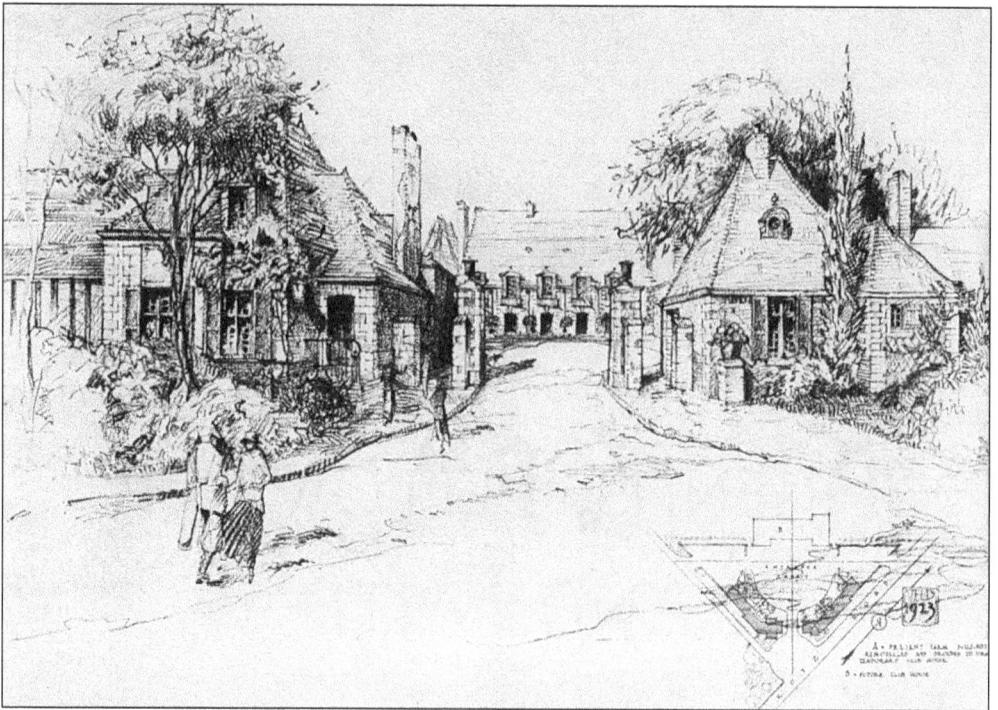

In 1923, Forest Lowrey, vice president of an oil company, organized the Sunset Ridge Country Club with nine of his friends on 132 acres of prime real estate. Membership was limited to 250 and sold out before the first clubhouse brick was laid. The raison d'etre of the club was that Lowrey and his friends complained that the local golf courses such as the Indian Hill Club were too crowded. The clubhouse doors opened on July 3, 1924, for a dinner dance. The next day, the golf course was open. Here is the first proposed design for the clubhouse. (Courtesy Sunset Ridge Country Club.)

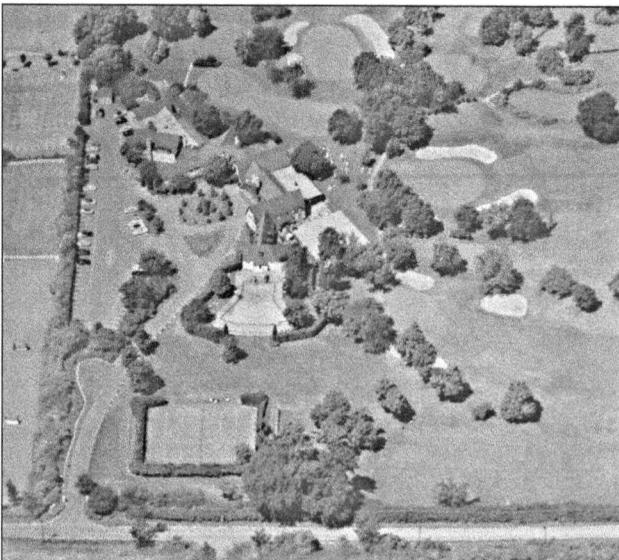

The Sunset Ridge Country Club was originally intended to be just a dining and golf club, but an aerial view of the country club taken in the early 1940s shows the range of activities club members enjoyed. At the center of the picture is the clubhouse, and just below it is the swimming pool. On the lower left-hand corner are the tennis courts, while the golf house is pictured in the upper-left corner. This picture shows just a few of the nearly 300 acres owned by the club and its members. (Courtesy Sunset Ridge Country Club and Charles Seymour.)

The Sunset Ridge Golf Course was, and still is, considered to be a very challenging course. Some members of the club who mastered the course did very well when they took their clubs on the road. Club member Virginia Ingram, pictured here eyeing a putt, tied in the Women's Western Open in 1927 and won the Chicago Women's District Championship in 1936, 1938, and 1942. (Courtesy Sunset Ridge Country Club.)

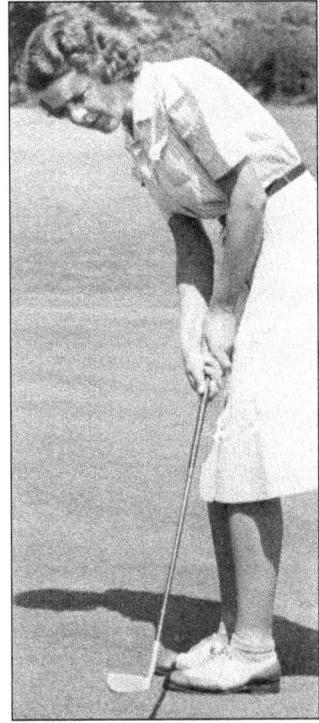

By the 50th birthday of the Sunset Ridge Country Club in 1974, the swimming pool—with its distinctive fan shape—had its own clubhouse with changing rooms and spa facilities. It was a favorite meeting place for children of the club's members. Just a few blocks away, the Middlefork Tennis Club boasted an outdoor pool, tennis courts, and a clubhouse. (Courtesy Sunset Ridge Country Club.)

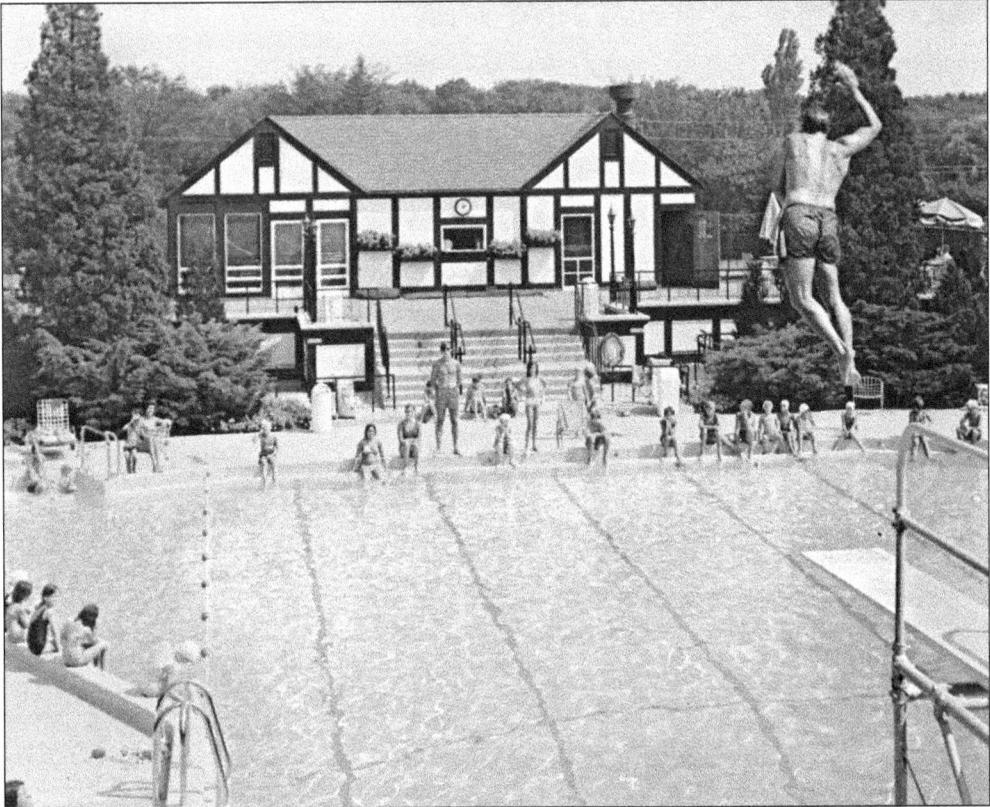

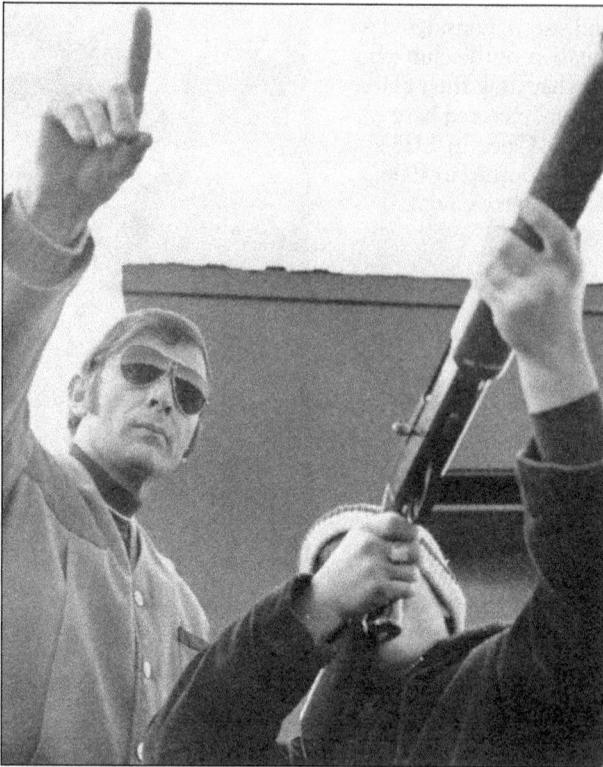

In the 1970s, Bill Chase was the manager of the shooting range. He trained club members and managed the facilities. Sunset Ridge's right to continue to maintain a skeet-shooting range is grandfathered into its deed. (Courtesy Sunset Ridge Country Club.)

Tennis was added in 1928, but the courts were problematic. In 1962, after a particularly frustrating game of golf, club member Art Henkel traded in his clubs for a racket. He headed a committee that replaced the courts with superior Har-Tru courts. In 1966, a tennis building was constructed, with locker rooms, a pro shop, and a common area. (Courtesy Sunset Ridge Country Club.)

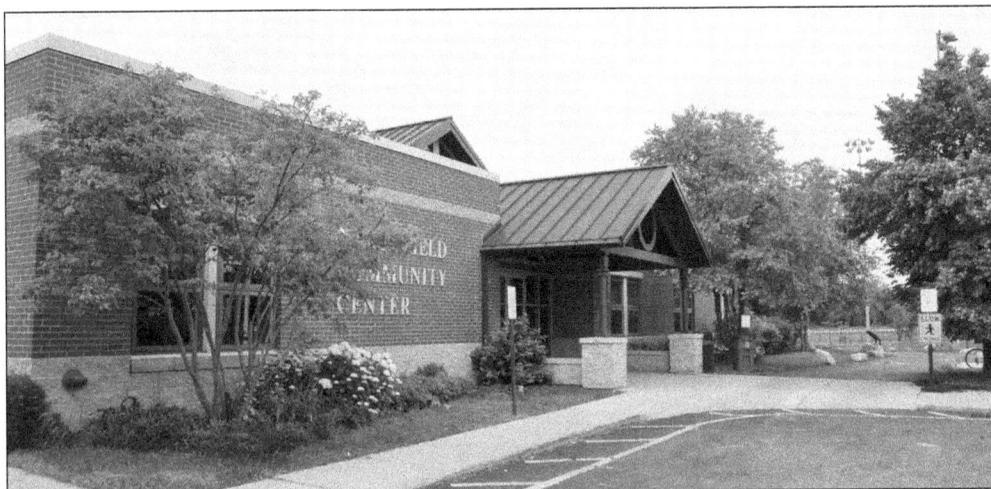

The Northfield Park District was formed in 1957. Thirty acres of land on Willow Road were purchased and named Willow Park. Five acres of that park were sold to the school district for the building of Middlefork School. The Northfield Community Center at Willow Park is enormously busy, hosting programs for both children and adults. The park also houses baseball diamonds for the Kenilworth-Winnetka Baseball League, of which Northfield is a part. (Courtesy Charles Seymour.)

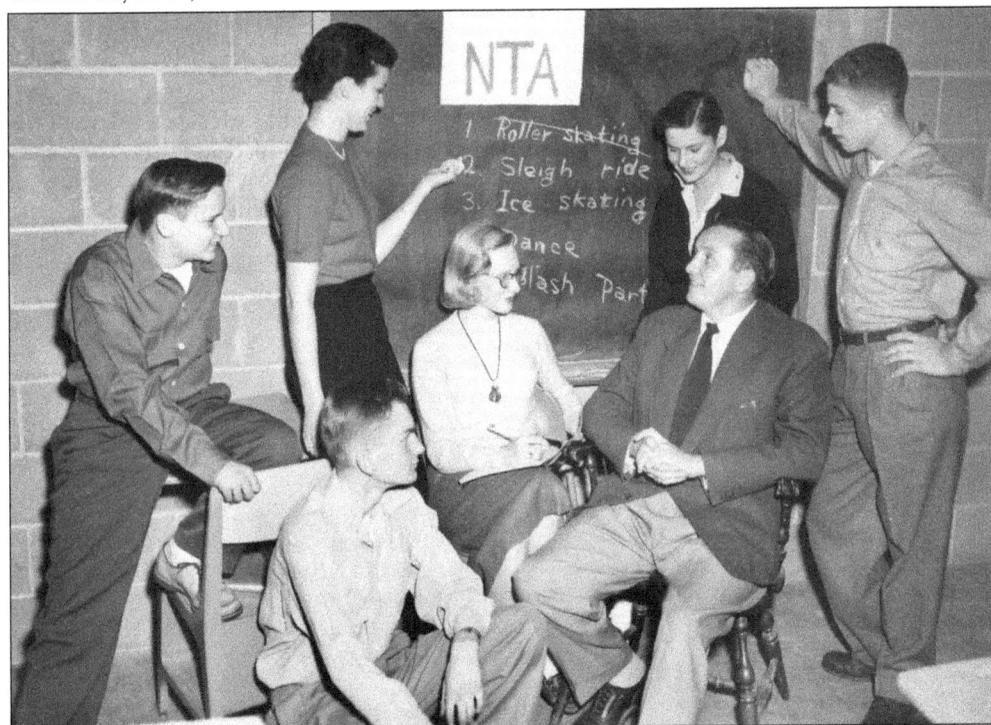

In addition to his work in the schools, Jim Clarkson took an active role in the creation of programs at the newly formed park district. He started the Northfield Teen Association, which was designed to give teenagers a place to engage in socially appropriate activities. Here Clarkson and the board members of the NTA brainstorm about possible events, including roller-skating, sleigh rides, ice-skating, a dance, and a party. (Courtesy Sunset Ridge School.)

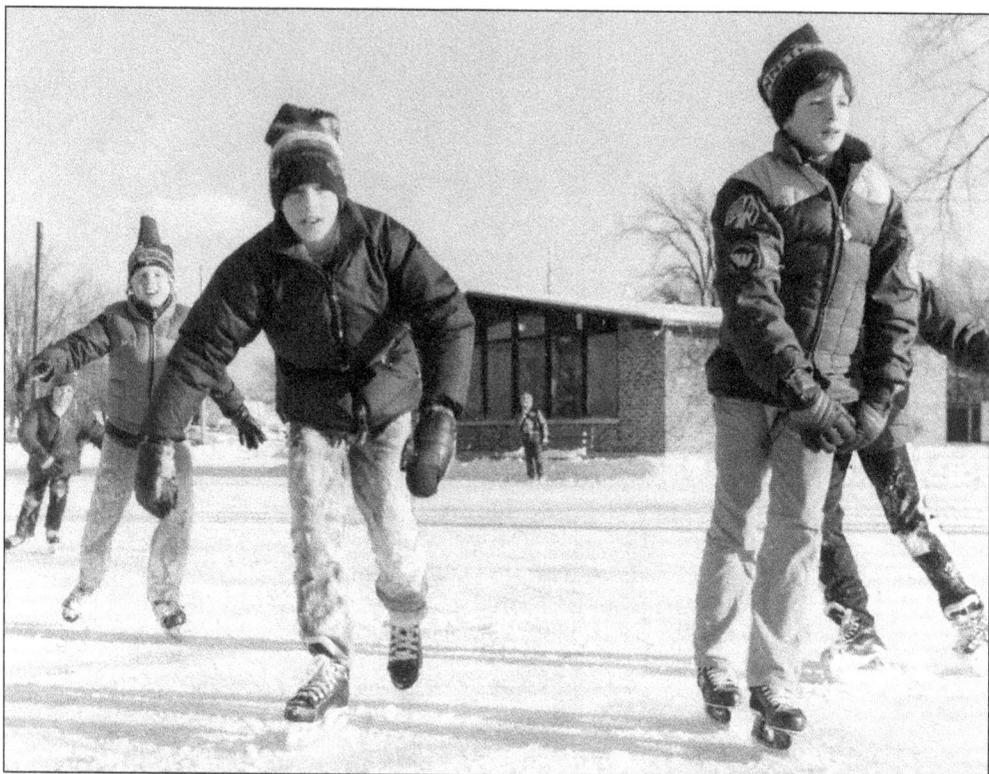

The park district acquired 3 acres directly across the street from Willow Park. This park was later named for Jim Clarkson in honor of his work at both the school and the park districts. These boys are enjoying the skating rink in the early 1980s. Little do they realize that just a few years before Northfield children who wanted to skate outdoors went to Winnetka, retracing the path of the "river people." Behind these skaters is the original warming house. (Courtesy Village of Northfield.)

In 2004, the warming house was replaced by the Clarkson Lodge, which has both indoor and outdoor fireplaces, a concession stand, and a party area. (Courtesy Village of Northfield.)

110

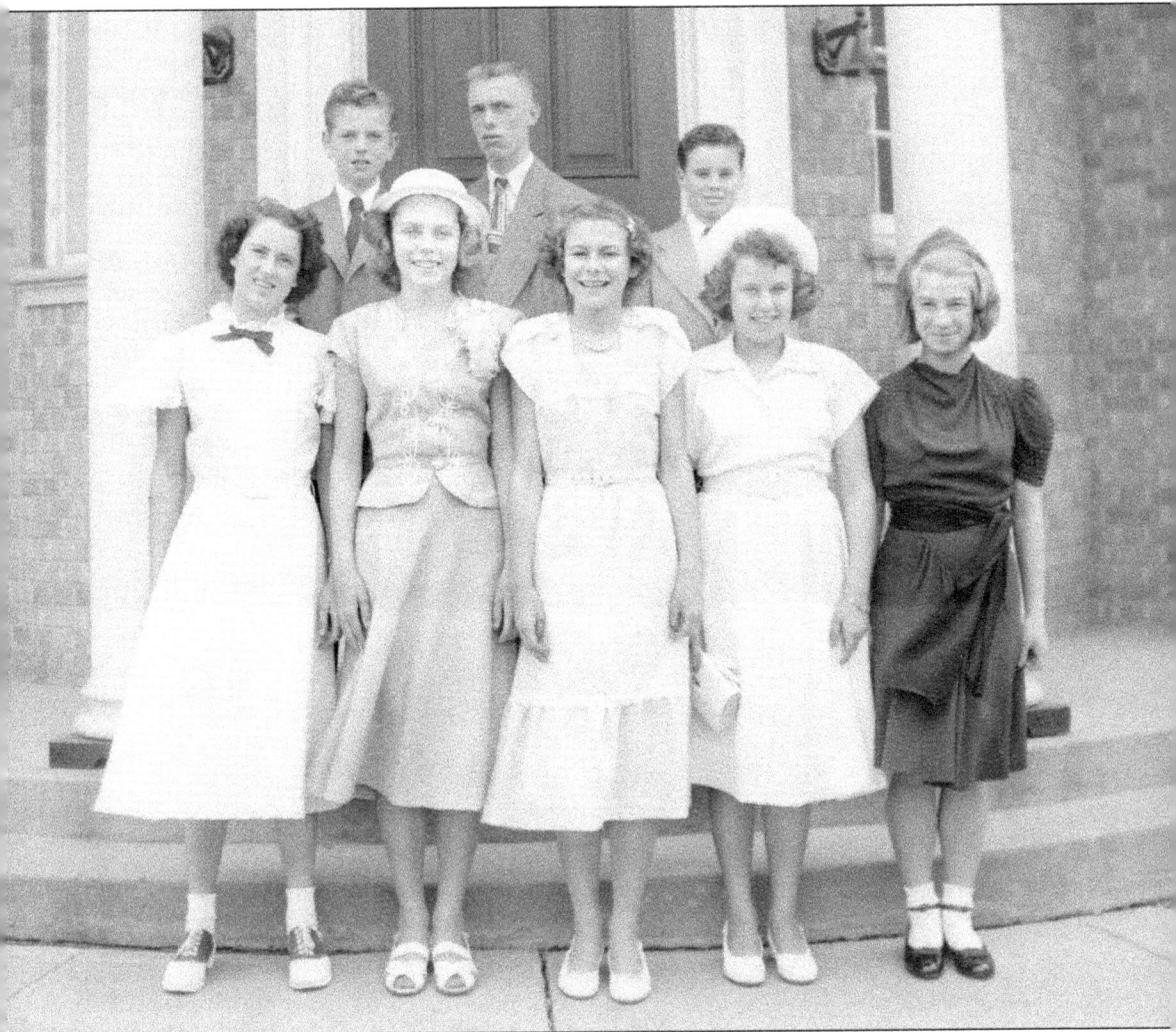

Many Northfield residents come together in their faith. The Northfield Community Church (United Church of Christ) began in 1939 as a simple Sunday school held in members' homes. Later the congregation arranged to hold services in Northfield Village Hall. Here the first Confirmation class of 1948 stands on the hall's steps. From left to right they include (first row) Marlyn Happ, Ann Kapheim, June Odegaard, Carol Lindholm, and Phyllis Clavey; (second row) George Van Valkenburgh, William Clavey, and Eric Medow. (Courtesy Northfield Community Church.)

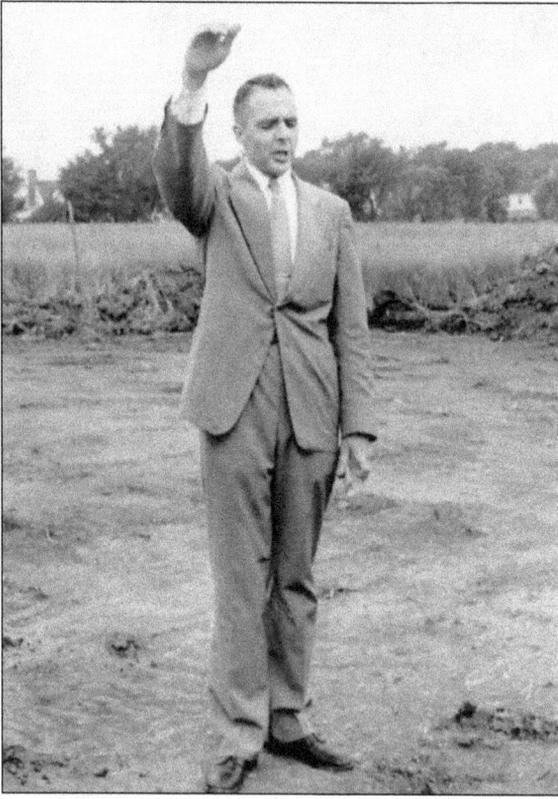

The Northfield Community Church needed to find a home for itself, and it was the first congregation to erect a building in Northfield, at the corner of Willow and Wagner Roads. Here Rev. Bruce Roberts blesses the ground upon which the church will be built. The chapel was completed in 1949 and is still a part of the building. (Courtesy Northfield Community Church.)

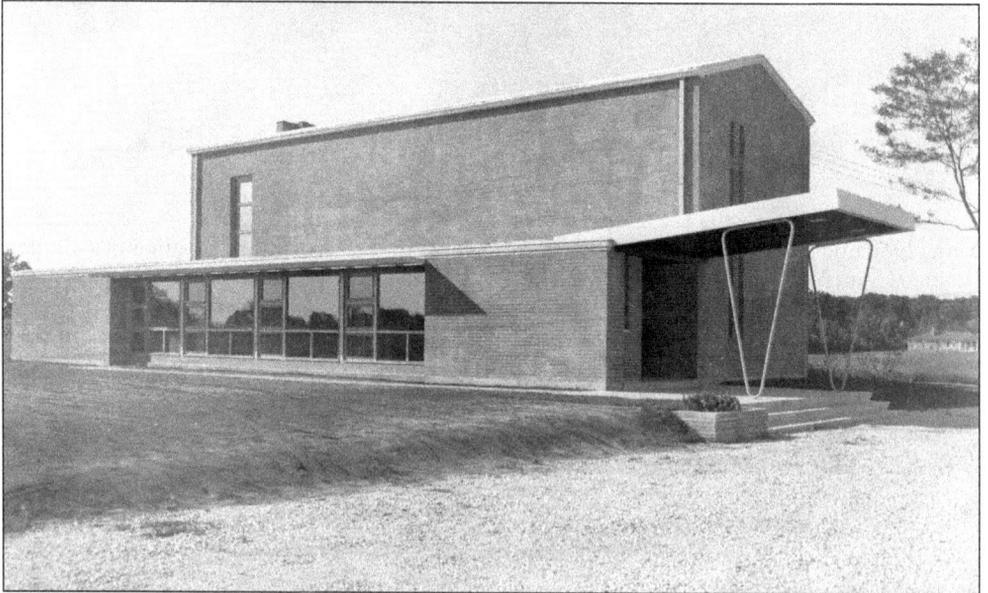

The Northfield Community Church in 1950 was a modern, sparse building, and the members were enormously proud. As the population of Northfield exploded in the 1950s, newcomers flocked to the church. Charles Johnson was asked to chair a building committee, and, together with the newly hired Rev. Webb Howard, he devised a plan for new sanctuary space and educational facilities. (Courtesy Northfield Community Church.)

112

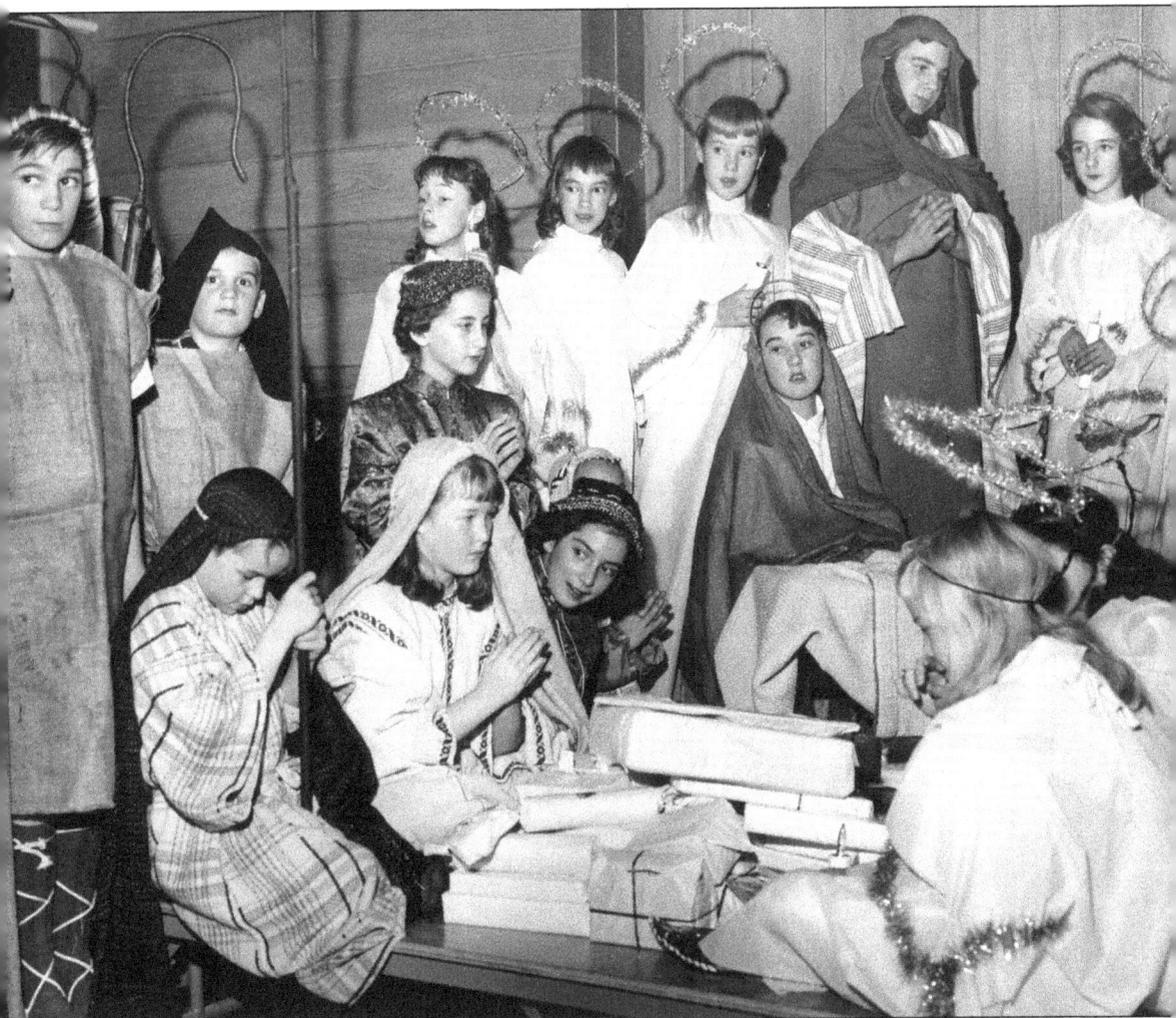

In 1963, the Northfield Community Church Christmas Pageant included shepherds, angels, and three wise women bearing gifts. The church's emphasis on children and youth education led to the formation of the Northfield Community Nursery School in 1952. The school has no affiliation with the church today but rents space in its building. (Courtesy Northfield Community Church.)

The Northfield Community Church emphasizes tolerance, inclusiveness, and the education of children. When the need developed for new space, members were often asked to give not just out of their wallets, but also to donate their labor. These children hang out at the construction site. Meanwhile, perhaps, their fathers are up on the roof laying out shingles, or their mothers are on the floor laying out tiles. The new space would be completed in 1960 under the direction of Charles Johnson. (Courtesy Northfield Community Church.)

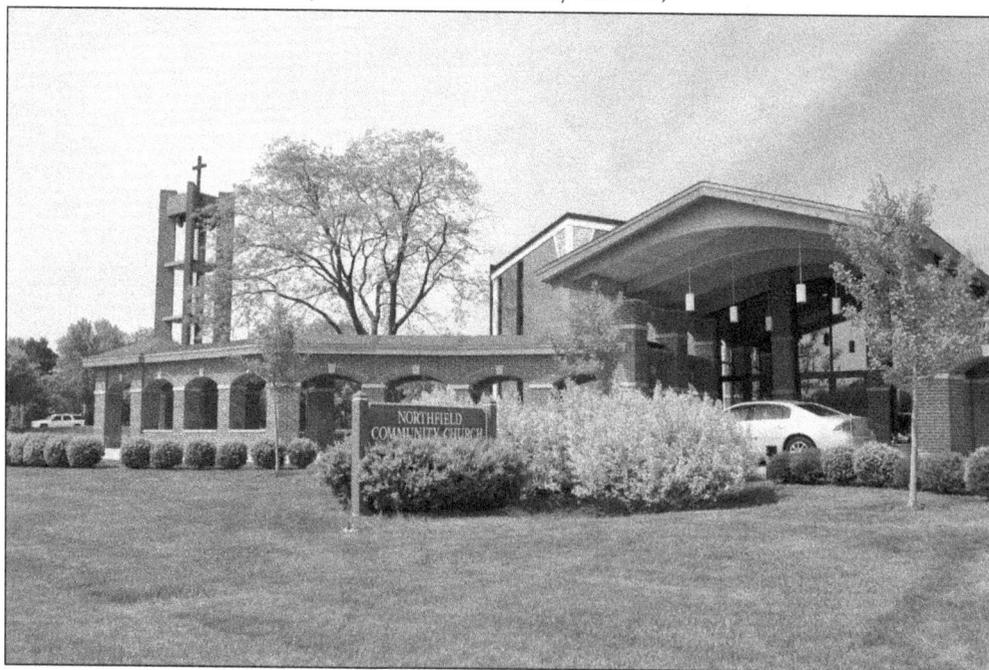

The church has added space as membership has increased, and it has incorporated a garden into an interior courtyard. Members who choose to do so can be cremated after they pass on and have their ashes buried in the Memorial Garden in the courtyard. Some members feel this is a good way to keep the connection between past, present, and future members of the church. (Courtesy Charles Seymour.)

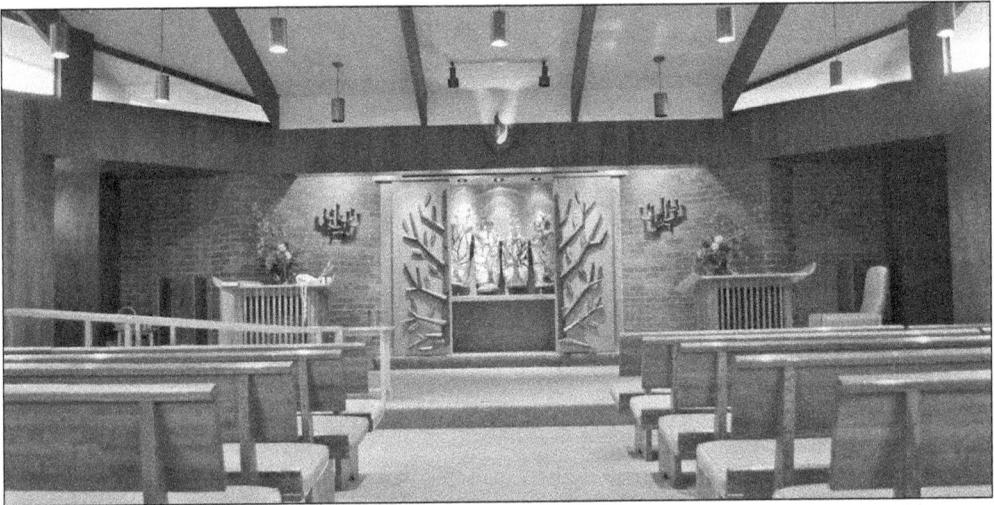

Am Yisrael was formed in 1968 as 18 families came together to found a Conservative congregation. The first services were held in the home of Al and Alice Goodman with Rabbi William Frankel agreeing to be their spiritual leader. The congregation took as its name the Conservative Congregation of the North Shore, which would be changed in 1976 to Am Yisrael Conservative Congregation of the North Shore. As the congregation expanded, services were held at the New Trier West campus. In 1974, the synagogue building was dedicated. This image shows the sanctuary with a breathtaking Aron HaKodesh. (Courtesy Charles Seymour.)

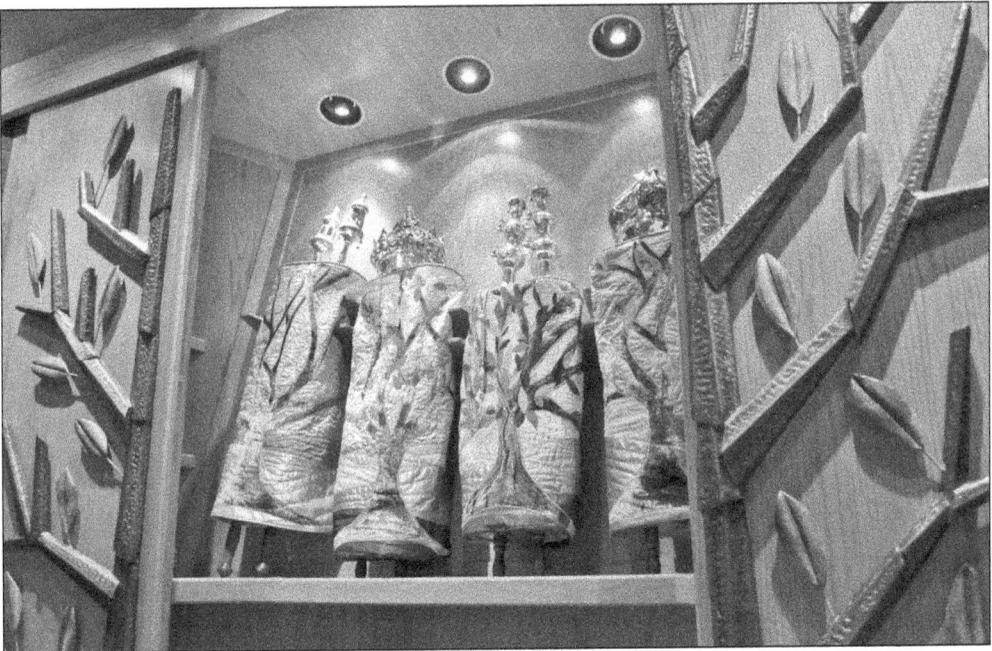

The congregation's first Torah was acquired by the Star family from a disbanded Boston congregation, and when it was brought to Chicago, it had its own seat on the plane. A second Torah is on permanent loan from the London Westminster Synagogue Czech Scroll Torah Trust. It originally belonged to the Czech community of Humpolec, which was destroyed during the Holocaust. The congregation also commissioned a Torah scroll in 2008 as part of the congregation's 40th-anniversary celebration. (Courtesy Charles Seymour.)

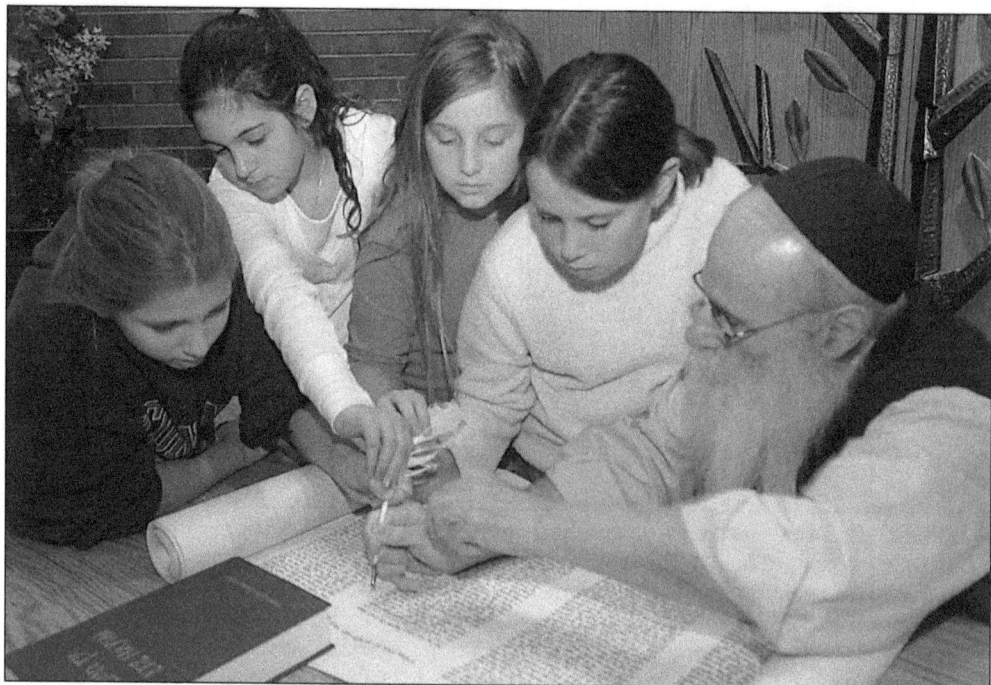

From the start, the congregation has emphasized racial and gender equality as well as a grounded education in the Jewish faith. The Religious School originally rented space from Loyola Academy and then the New Trier West campus, and later still they moved to the Harper Elementary School. The need for a permanent space for the school was clear, and in January 2001 classes began in the addition to the synagogue. Here girls from the Religious School write the new Torah under the direction of Rabbi Druin. (Courtesy Am Yisrael Conservative Congregation of the North Shore.)

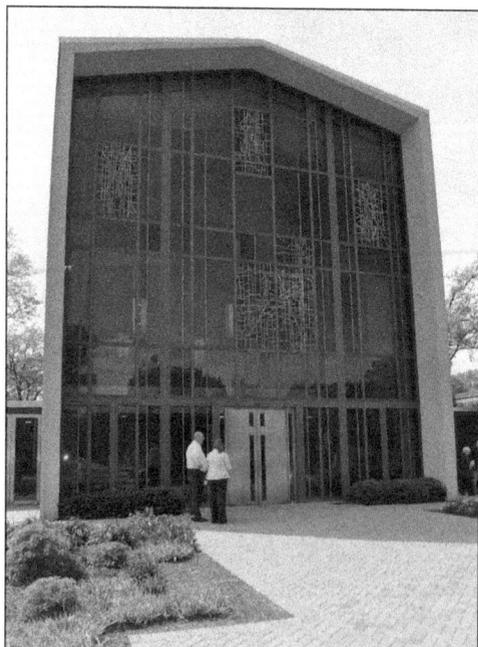

Northfield Catholics attended Sacred Heart in Winnetka, St. Joseph in Wilmette, and St. Norbert in Northbrook—but they wanted their own spiritual home. Al Levernier donated 5 acres, which he had purchased from the Wagner family. In September 1950, ground was broken at the intersection of Old Willow and Happ Roads for a church. The architect was Barry Byrne, a protégé of Frank Lloyd Wright. The church was dedicated by auxiliary bishop William E. Cousins on October 21, 1951. (Courtesy Charles Seymour.)

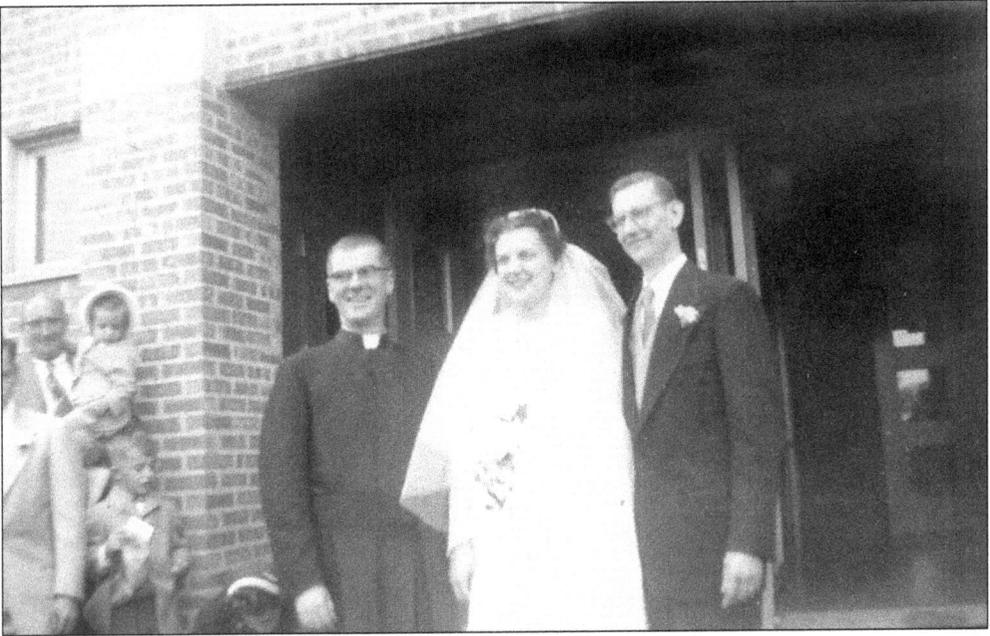

Fr. John Henry, shown here after officiating at a wedding Mass in 1953, believed that the parish needed a parochial school. He persuaded the young parish's families to raise $37,000 for that purpose at a time when the weekly collection averaged $200. With that seed money, he obtained permission from the archdiocese to build St. Philip the Apostle School. The church now leases the school to the Hyde Park Day School. (Courtesy Therese Anne Happ Selzer.)

An important part of a Catholic wedding ceremony is the prayer to the Virgin Mary by the bride. At St. Phillips, a bride—with her bridesmaid in attendance—makes her request to the Virgin Mary for a healthy marriage, a long life, and a loving family. (Courtesy Therese Anne Happ Selzer.)

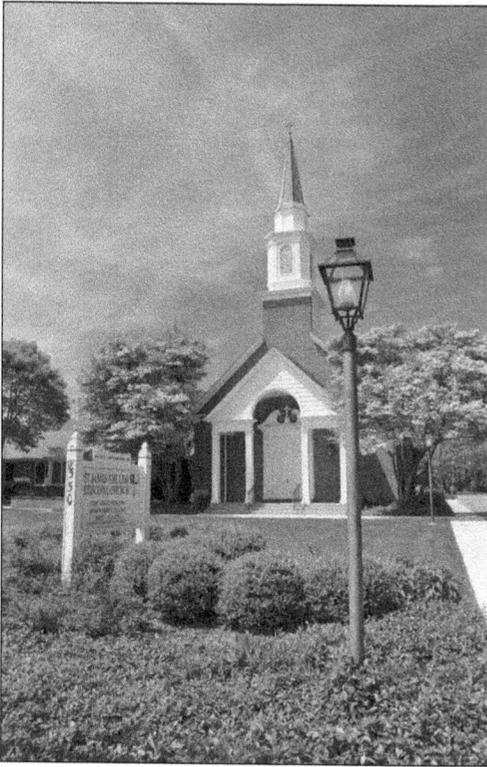

In 1959, the St. James the Less Episcopal Church was built at 550 Sunset Ridge Road. According to Scripture, St. James the Less was the son of Alpheus and Mary, the sister of the Virgin Mary. He may have been called "the Less" because he was called by Jesus after the other apostle of the same name or because of his relative youth. He is also referred to as St. James the Just because of his holiness. (Courtesy Charles Seymour.)

The Lutheran Church of the Ascension held its first services in Hubbard Woods School in Winnetka in 1958. In January 1959, the church moved to Sunset Ridge School in Northfield. In the summer of 1962, a ground-breaking ceremony was held by Rev. Harold Lohr for a building at 460 Sunset Ridge Road. When the congregation moved into its new home, the Yarnall family donated a pipe organ in memory of Thomas Yarnall. (Courtesy Charles Seymour.)

While Am Yisrael's temple is at the southern tip of Northfield, Temple Jeremiah is to the north and meets the town's border with Northbrook. Temple Jeremiah is a liberal reform congregation founded in 1959. Rabbi Allan Tarshish became the congregation's leader in 1961. After holding services in various schools and rented buildings, the congregation wanted its own space. On Saturday, September 9, 1972, Temple Jeremiah held High Holy Day services in its own building on Happ Road for the first time. Rabbi Tarshish retired in 1975. (Courtesy Charles Seymour.)

The Northfield Community Nursery School was originally founded by members of the Northfield Community Church in keeping with its history of focusing on early childhood education. While still renting space in the same building as the church, the nursery school is no longer directly affiliated with it. The school is part of the North Shore Early Childhood Council as well as the Winnetka Alliance for Early Childhood, and it frequently partners with the nearby Josselyn Center for specialized programs. (Courtesy Charles Seymour.)

In 1951, Dr. Irene Josselyn founded the North Shore Mental Health Association, which was renamed in her honor in 1960. (Courtesy Northfield Josselyn Center.)

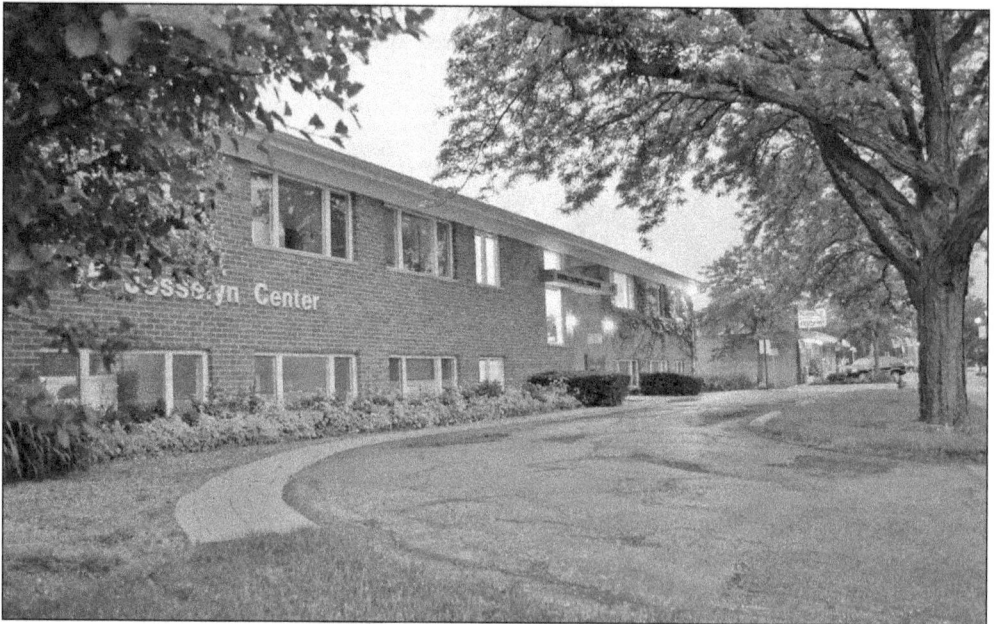

The Josselyn Center serves individuals and families in Northfield and the northern suburbs. It provides mental health services without regard of ability to pay. In July 2002, Dr. Gary D. Smith was appointed as president of the center. The Josselyn Center is particularly involved in adolescent psychiatry and family issues. In addition to traditional psychiatric services, it has an adolescent substance abuse program and a drop-in center. (Courtesy Northfield Josselyn Center.)

The North Shore Senior Center in Northfield began in 1956 as the North Shore Committee on the Older Adult at the Winnetka Community House, and it serves the entire North Shore's senior population. Today the center includes space for lectures on such topics as The Korean War and the Model A Ford. Clubs meet every day of the week, including the Friendship Circle, Photography Club, and the Profits and Pitfalls Club. (Courtesy North Shore Senior Center.)

The North Shore Senior Center facility is named for Arthur C. Nielsen Jr., who spearheaded the financing of the building. Nielsen and his father devised the Nielsen television ratings system in order to gauge audience reaction to media. The Nielsen family has made significant donations to the Winnetka Park District and to other charities in the northern suburbs. The space of the senior center is full of light and has lots of room for casual interaction. (Courtesy North Shore Senior Center.)

The center boasts an impressive fitness facility. It also offers counseling, home-delivered meals, support groups, wellness programs, and peer counseling. The center's mission statement is "to support the independence and well-being of older adults, enhance their dignity and self respect, and promote their participation in all aspects of community life." (Courtesy North Shore Senior Center.)

Six

NORTHFIELD'S FUTURE

A town sliced in quarters by the Edens Expressway and Willow Road, Northfield is a town with three different school districts serving its children. It is a town that began as a home to the Horseradish Kings and other farmers and has now become a town of people on the move. It is a town that sends its residents to Chicago for work, but it is attracting its own corporate community.

Northfield manages to thrive as a community because it still maintains its family-friendly atmosphere, whether on the playfields of Willow Park, the dining hall of the Sunset Ridge Country Club, or the backyard picnic of the Selzer family on Happ Road.

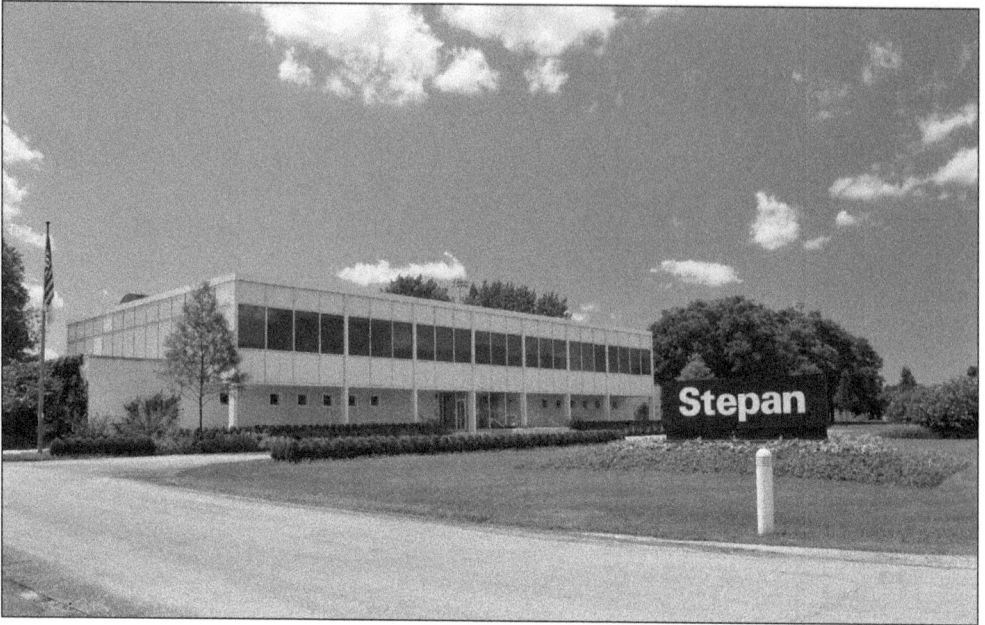

The Stepan Company, located on the frontage road next to the Edens Expressway, was founded by Alfred Stepan Jr. in 1932 with a $500 loan from his mother. Today the company is one of the country's leading producers and suppliers of specialty and intermediate chemicals to other companies to make a wide variety of end products. (Courtesy Charles Seymour.)

In the late 1980s, Kraft International Foods, Inc. negotiated with the Holy Spirit Missionary Sisters to purchase land on the northeast corner of Waukegan and Willow Roads. Kraft has since repeatedly expanded its corporate headquarters. Here, in 2002, CEO Betsy Holden (center) prepares to break ground on a third wing to the main building. (Courtesy Village of Northfield.)

Originally begun in 1922 as the American Society of Clinical Pathologists, the College of American Pathologists purchased a tract on the southeast corner of Waukegan and Willow Roads from the Holy Spirit Missionary Sisters in 1983. Where once the sisters played baseball and croquet, the institution opened its headquarters in 1989. The college provides assistance, quality assurance, and professional guidance for pathologists. Over 600 people work at the Northfield facility. (Courtesy American College of Pathology.)

The sale to Kraft, as well as the sale of much of the land on the southeast side of the corner of Waukegan and Willow Roads to, among others, Christian Heritage Academy and the College of American Pathologists, allowed the Holy Spirit Missionary Sisters to build a new convent. In addition to a main building that houses administrative offices, a chapel, dining facilities, laundry facilities, and archives, there is a campus of individual homes for retired sisters. (Courtesy Charles Seymour.)

Bess Hardware, which has been in the community since 1968, is a familiar stop on Willow Road. The family-owned hardware store is an alternative to the "big box" stores that are on Willow Road west of Waukegan in Glenview. Because of the high volume of traffic coming off the Edens Expressway, Northfield struggles with the creation of a true "downtown" where a shopper can walk and window shop. Bess is at the bottleneck on Willow Road, which is the source of contention between Northfield and the Illinois Department of Transportation. (Courtesy Charles Seymour.)

The Edens is a scant 100 yards from this hideaway in the Cook County Forest Preserve. The Skokie Lagoons are beautiful and peaceful; Northfield residents can wile away an afternoon canoeing or fishing, and they might catch sight of one of the many herons that nest on the island that is tucked at the center of this lagoon. (Courtesy Charles Seymour.)

Northfield has much potential and many challenges, but residents are resilient, tough, quick to help one another, and bolstered by their faith, their friendships, and their opportunities for fellowship. These Northfield residents posed for a picture in 1930, and they look to the future, certain that their descendants (as well as newcomers to the community) will do them proud. From left to right, they are (first row) Chuck Reinwald and an unidentified dog; (second row) Joe Braun, Lucy Bractendorf, Joe Selzer, Al Levernier, Julie Donovan, Anna Selzer, and Lucia Levernier; (third row) George Straub, Barbara Seul, Nellie Boetsch, Maggie Selzer, Annie Seul Happ, John Happ, and Colella Selzer. (Courtesy Happ family.)

Visit us at
arcadiapublishing.com